Creating DSLR Video:
From
Snapshots to
Great Shots

D1511184

Richard Harrington

Peachpit
Press

Creating DSLR Video: From Snapshots to Great Shots
Richard Harrington

Peachpit Press
1249 Eighth Street
Berkeley, CA 94710
510/524-2178
510/524-2221 (fax)

Find us on the Web at: www.peachpit.com
To report errors, please send a note to errata@peachpit.com
Peachpit Press is a division of Pearson Education

Editor: Nancy Peterson
Production editor and compositor: Danielle Foster
Development editor and copyeditor: Anne Marie Walker
Proofreader: Liz Welch
Indexer: Jack Lewis
Cover design: Aren Straiger
Cover production: Mike Tanamachi
Interior design: RHDG - Riezebos Holzbaur Design Group
Cover Image: Richard Harrington
Back cover author photo: Vanelli

ISBN 13: 978-0-321-81487-6
ISBN 10: 0-321-81487-8

9 8 7 6 5 4 3 2 1

Printed and bound in the United States of America

DEDICATION

To my wife Meghan, your patience and humor make each day a joy to live.

To my children Michael and Colleen, you make me want to be a better man.

To my family who has always supported me and blessed me with many talents, thanks for all that you do.

—Richard Harrington

ACKNOWLEDGMENTS

Bringing a book to life is a lot of work. I'd like to specifically thank the folks who provided support or gave of their talents. A special thanks to my friends and family for enduring time in front of the camera. Thank you as well to Robert Vanelli, Lisa Robinson, and Meghan Ryan-Harrington, who contributed behind-the-scenes photography to help explain the techniques discussed in this book.

Gary Adcock	Matt Gottshalk	Nancy Peterson
Adorama	Jeff Greenberg	Redrock Micro
Adobe	Mimi Heft	Lisa Robinson
Jim Ball	Frederick Johnson	Abba Shapiro
Scott Bourne	Karyn Johnson	Jeff Snyder
Kevin Bradley	Scott Kelby	Cindy Tuten
Robbie Carman	Ben Kozuch	Alec Vanelli
RC Concepcion	Peter Krogh	Robert Vanelli
Scott Cowlin	Vincent Laforet	Anne Marie Walker
Sam Crawford	Lynda.com	Mark Weiser
Creative COW	John Lytle	John Woody
Emmanuel Etim	Cheryl Ottenritter	Zacuto

Contents

INTRODUCTION — IX

CHAPTER 1: WHAT IS DSLR VIDEO? — 1

Poring Over the Footage — 2

Poring Over the Footage — 4

Why Is DSLR Video So Popular? — 6

What's Great About DSLR Video? — 7

What's Not So Great About DSLR Video? — 10

Shooting with Motion in Mind — 15

Chapter 1 Assignments — 19

CHAPTER 2: ESSENTIAL EQUIPMENT — 21

Poring Over the Camera — 22

Getting Started — 24

Choosing a Camera — 25

Memory Cards—Lots of 'em — 31

More Power for the Camera — 35

Choosing Lenses — 36

A Stable Platform — 42

Chapter 2 Assignments — 45

CHAPTER 3: SETTING UP YOUR CAMERA — 47

Poring Over the Camera — 48

Choosing a Frame Size — 50

Choosing a Frame Rate — 52

White Balancing Your Camera — 55

Choosing a Shooting Mode — 59

Adjusting the Volume — 60

Using Picture Styles or Controls — 61

Chapter 3 Assignments — 65

CHAPTER 4: EXPOSURE AND FOCUS **67**

Poring Over the Footage 68

Poring Over the Footage 70

The Exposure Triangle 72

Controlling Depth of Field 76

Setting Focus 81

Maintaining Focus 83

Using a Loupe 84

Using a Viewfinder or Monitor 86

Chapter 4 Assignments 89

CHAPTER 5: COMPOSING SHOTS **91**

Poring Over the Footage 92

Poring Over the Footage 94

Poring Over the Footage 96

Shot Types 98

Shot Angles 101

Cinematic Composition 103

Repeating Action 108

Making a Shot List 110

Chapter 5 Assignments 111

CHAPTER 6: SHOOTING IN DAYLIGHT **113**

Poring Over the Footage 114

Understanding Sunlight 116

Avoiding Lens Flares 123

Controlling the Camera in Daylight 126

Chapter 6 Assignments 133

CHAPTER 7: SHOOTING IN LOW LIGHT **135**

Poring Over the Footage 136

Poring Over the Footage 138

The Challenge of Shooting in Low Light 140

Changing Your F-stop 144

Raising Your ISO 147

Adjusting Shutter Speed 150

Shooting at Sunrise or Sunset 152

Chapter 7 Assignments 155

CHAPTER 8: SHOOTING INDOORS **157**

Poring Over the Footage 158

Poring Over the Footage 160

Using Available Light 162

Adding More Light 164

The Concept of Three-point Lighting 170

Chapter 8 Assignments 173

CHAPTER 9: RECORDING SOUND **175**

Capturing Great Audio 176

Technical Essentials of Audio 177

Microphone Pickup Patterns 179

Recording Audio with the Internal Microphone 180

Recording Audio with an On-camera Microphone 181

Recording Audio with a Lavalier Microphone 181

Recording Audio with Dual System Sound 184

Monitoring Your Audio 188

CHAPTER 10: BACKING UP AND ORGANIZING YOUR FOOTAGE **191**

A Practical Workflow 192

Choosing a Card Reader 193

Choosing Hard Drives 195

Transferring Your Footage 201

Organizing Your Footage 202

The Option of Transcoding 205

CHAPTER 11: EDITING ESSENTIALS **209**

Poring Over the Equipment 210

Choosing Editing Software 212

Essential Editing Controls 215

Syncing Sound 223

Adding Transitions 228

Adjusting Exposure and Color 230

Chapter 11 Assignments 247

CHAPTER 12: PUBLISHING AND SHARING VIDEO 249

Quality Checks 250

Outputting a Backup Copy 252

Delivering Video to the Web 253

Specific Hosts for Web Video 258

The End of the Road? 270

INDEX 271

Introduction

I truly love the power of video. It's my favorite medium for telling stories because it gives me the ability to capture life and emotion. For more than 25 years, I've been shooting video, capturing family moments on the weekend and creating television commercials, broadcast news, and web video on the weekdays.

However, the best feeling is not seeing my own work, but rather watching others catch enthusiasm and decide to become visual storytellers. Two years ago I set out to document the merger of photography and video when I co-wrote *From Still to Motion: A photographer's guide to creating video with your DSLR* for Peachpit Press. The book was well received by the pro community, but I heard from many that they needed a foundation to build on. I also talked to friends, relatives, and even perfect strangers who wanted to learn how to shoot great video on a tight budget (without having to rope their friends into being part of the crew).

To this end, I present *Creating DSLR Video: From Snapshots to Great Shots*. I set out to teach people how to make better video and short films using minimal gear and resources. The goal is to make the most of what you have and focus on building the core skills you need to succeed. Whether you're just getting started with video or you're an enthusiastic still shooter who's been at it for years, I'll guide you through how video works and help you get the best shots.

The book begins by illustrating what's so great about shooting DSLR video. You'll understand why you'd choose to shoot video on a "stills" camera as well as some of the problems to look out for. Chapter 2 then walks you through equipment choices. Whether you've bought a new camera or just want to get more from your existing gear, I'll explain how here. I also focus on what new gear is most useful as you grow into your hobby and start to invest.

In Chapter 3 you'll learn how to set up your camera properly. You'll learn important technical steps, like how to white balance for natural color, which frame rate to shoot at, and which settings produce smooth motion. Chapter 4 explains how to properly expose your shots and maintain critical focus.

WATCH SAMPLE CLIPS ONLINE

Throughout this book you'll see several instances of an icon and number superimposed on a video image.

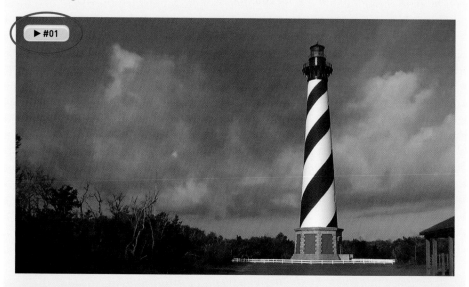

This icon indicates that I've placed a short video clip online so you can see the actual footage. To view the clips, just visit vimeopro.com/dslrfstgs/examples. You don't need to have a Vimeo account to access the videos. If you'd like to comment or post your own videos to the group, just sign up for one of the free or paid account options.

The important skills needed for composition are covered in depth in Chapter 5. You'll learn the language of cinematography and how to think about linking multiple shots into a narrative sequence.

The next three chapters tackle several common shooting scenarios. Chapter 6 provides you with strategies for outdoor shooting and working with the sun. In Chapter 7 you'll explore the opposite problem of shooting when there is very little light. You'll then learn how to control the light when shooting indoors and how to add more light in Chapter 8.

A good video is incomplete without a stellar sound track. In Chapter 9 you'll learn how to record better audio with your camera. You'll also learn about essential equipment and workflows if you want to record the best sound possible.

The last three chapters describe what happens after you shoot. In Chapter 10 you'll learn how to organize and back up your footage so it's ready to edit. Chapter 11 walks you through the essentials involved in editing video. You'll still want to pick up some dedicated training for whatever nonlinear editing software you choose, but this chapter will help you understand the creative choices you'll need to make. The final chapter explores how to publish your video so others can see it. You'll learn how to target popular websites to share online and how to export a backup copy.

Now, just turn the page to begin your journey to become a better videographer.

What Is
DSLR Video?

Whether you stumbled across the video options in your DSLR camera or specifically selected your camera with video shooting in mind, I welcome you to the world of DSLR video. Telling stories with video is enjoyable and challenging. Your camera is a great tool, but by its very nature, video is a complex medium. Throughout this book I'll focus on teaching you the most important techniques. It doesn't matter which camera you're shooting with, my goal is to help you master the skills you need to become a motion storyteller.

PORING OVER THE FOOTAGE

While visiting the Outer Banks region of North Carolina, you notice a dominant item all along the coast—lighthouses. This shot was easy to compose because there were such strong angles to work with. However, it was a tough shot to expose properly. The high-contrast, black-and-white stripes had to be balanced with the details in the sky, and the shadowy area of the trees started to lose detail. Video is sometimes very challenging to expose properly because it has less of a dynamic range than photography.

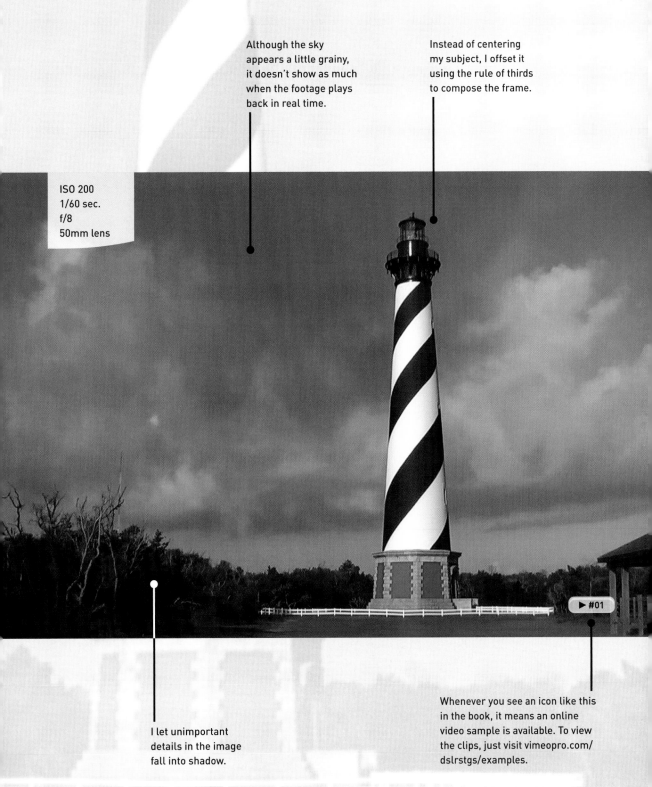

Although the sky appears a little grainy, it doesn't show as much when the footage plays back in real time.

Instead of centering my subject, I offset it using the rule of thirds to compose the frame.

ISO 200
1/60 sec.
f/8
50mm lens

I let unimportant details in the image fall into shadow.

► #01

Whenever you see an icon like this in the book, it means an online video sample is available. To view the clips, just visit vimeopro.com/dslrstgs/examples.

PORING OVER THE FOOTAGE

Our family enjoys visiting zoos, wildlife preserves, and parks. For this image, I relied on the shallow depth of field options to keep one bird in focus while blurring the busy background. By controlling my camera and lens settings, I was able to exert greater control over the final shot.

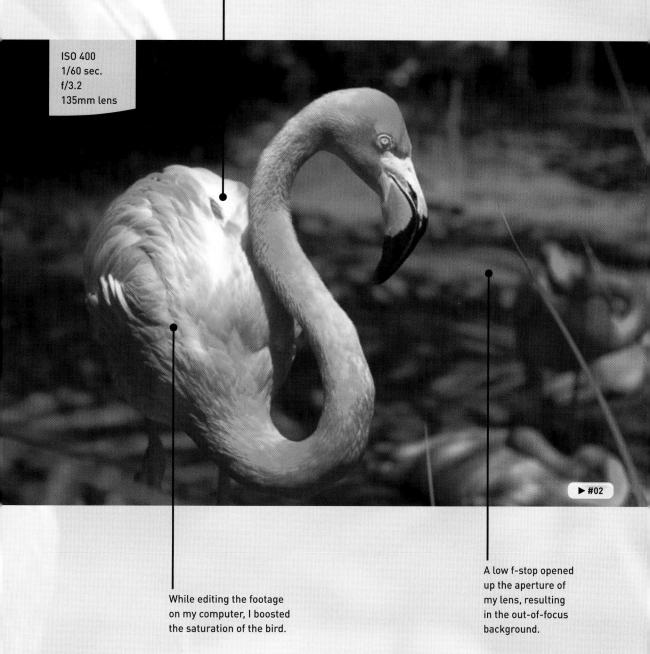

Trying to keep the subtle details in the white feathers, I was careful not to overexpose the shot.

ISO 400
1/60 sec.
f/3.2
135mm lens

► #02

While editing the footage on my computer, I boosted the saturation of the bird.

A low f-stop opened up the aperture of my lens, resulting in the out-of-focus background.

FIGURE 1.1
The addition of dedicated video buttons on most "still" cameras is a sign of video's popularity.

WHY IS DSLR VIDEO SO POPULAR?

If you pick up just about any new "stills" camera, you'll find that it probably also shoots video (**Figure 1.1**). DSLR video, or hybrid, cameras are booming in popularity. The camera you have is probably quite capable of recording great-looking video. Whether shooting is a hobby or your job, your DSLR camera is up to the task.

Here are a few reasons that have led to the rapid adoption of DSLR video:

- **Wonderful value.** Your DSLR camera can achieve incredible image quality at a fraction of the price of a traditional video camera. DSLR video cameras have found their way into the hands of everyone from doting parents to Hollywood cinematographers. Everyone agrees that these cameras can give you a great picture at a great price.

- **Convenience.** Whether you're shooting photos or stills, one camera can now do both. You no longer have to carry two cameras with you on vacation, and you can create photos and video using the same lens (**Figure 1.2**).

FIGURE 1.2
Carrying a single camera body is very convenient. Photo by Meghan Ryan-Harrington.

- **New challenges.** Many experienced photographers I know are attracted to video because it's new and challenging. If you are the type of person who finds learning fun, becoming a better videographer will also improve your photography. If photography isn't as much fun as it used to be, give it a creative jolt by mixing in some video.

- **New opportunities.** Creating video with your DSLR camera opens many doors. You have new ways to tell stories using motion. You can also reach out to more people through the use of video-sharing sites like YouTube or Vimeo, as well as social media outlets like Facebook and Twitter. If you make a living from your photography, your clients may be looking for (and willing to buy) video services from you.

WHAT'S GREAT ABOUT DSLR VIDEO?

For almost 30 years now, I've been shooting, directing, and editing video. I create video professionally, so the last thing I want to do is shoot video as my hobby. For me, photography was always my escape. It gave me the ability to step away from big group projects and focus on capturing life's intimate moments.

Well, thanks to what I can do with my DSLR camera, I now shoot video more than ever. Whether it's shots of my kids in action, capturing memories from a vacation, or producing short stories for the Web, I have a new passion for creating video.

For me, there are two major reasons I love shooting video on a DSLR. The first is aesthetics—the resulting look and feel of the footage I can acquire. The second involves the technical aspects that make a video-enabled DSLR camera so much better than other affordable (and even many not so affordable) HD video cameras.

AESTHETIC BENEFITS

For me, one of the most appealing elements of both photography and video has been the ability to tell stories using images. I really like to capture memories and share those with an audience. Sometimes they are personal stories just meant for family; other times they are television commercials viewed by a huge audience. In either case, I want the footage to look great. With a DSLR camera, getting great-looking footage is a lot easier than using other camera technology. Here are two reasons why:

- **Great control over depth of field.** If you've ever shot on a traditional video camera, you know that once you've set focus, the whole image tends to stay in focus. With a DSLR camera, you have a much bigger image sensor, which allows you more options when capturing your image. The ability to set a shallow focus lets you keep your subject as the star and blur any unwanted background details (**Figure 1.3**).

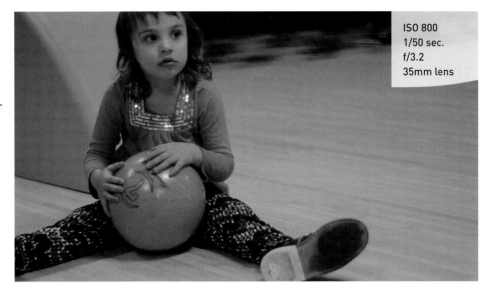

FIGURE 1.3
Opening up the aperture made the background go soft. Instead of a busy bowling alley behind my daughter competing for attention, the focus is set on her.

ISO 800
1/50 sec.
f/3.2
35mm lens

- **Filmic image.** For years, people have applied filters or effects to their video to make it look less like video. Whether it was TV news or home movies, the footage tended to look flat and boring (**Figure 1.4**). With a DSLR, you have great lens quality and a more photographic-like image (**Figure 1.5**). Also, several more controls are in the camera that you can adjust to modify the look of your footage. You'll learn more about these options in Chapter 3, "Setting Up Your Camera."

FIGURE 1.4
This shot is from a traditional video camera. The colors of the image are very flat, and the contrast ratio between the darkest and brightest areas lacks punch.

► #03

TECHNICAL BENEFITS

Although I love the look of video my DSLR camera can create, I have to admit that I also love the power it gives me to shoot in challenging situations. On a traditional video production shoot, a lot of effort is placed on lighting the scene. Many tricks are used and lots of equipment is put in place to make a better-looking image. And a professional video crew tends to range in size from 2 to 15 people. All of these expensive components have traditionally kept the cost of professional video high, and at the bare minimum has meant dragging a lot of equipment out on every shoot.

DSLR cameras are changing this situation in a few ways:

- **Lens selection.** One of the best features of a DSLR camera is that you can change its lens. You can match the lens to the shooting scenario. If you need to shoot from far away, you can attach a powerful zoom lens. If you need to shoot in low light, you can attach an affordable prime lens to the camera. Over time, you'll build up your lens collection; in fact, investing in good lenses is a smart idea (**Figure 1.6**). Currently, I have lenses that are 25 or more years old, and the good ones still produce great images. I'll explore different options for lenses throughout this book.

FIGURE 1.6
This lens is more than a decade old but still performs great for shooting video.

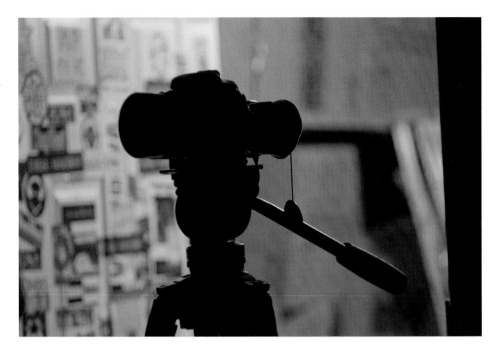

- **Low-light performance.** Compared to a video camera, a DSLR camera is *much* better at shooting in low-light conditions. You can now get better-looking images with less light (**Figure 1.7**). Although it's still best to maximize the light you have, a DSLR camera can shoot in many places that a regular video camera would fail.

- **Smaller and lighter camera.** If a camera is too heavy or bulky, you'll likely end up leaving it behind. A DSLR camera is pretty light, and if you toss a lens or two in your bag, it's still easy to carry on your shoulder. Plus, you can place the camera in lots of interesting places. I've seen DSLR cameras mounted to handlebars on bikes, used in underwater housings for scuba diving, and more.

WHAT'S NOT SO GREAT ABOUT DSLR VIDEO?

Every coin has two sides. So, although there is much to love about shooting video on a DSLR video camera, there are some drawbacks that will drive you nuts. If you're used to shooting video on a traditional video camera, these shortcomings will be par-ticularly noticeable. Be sure to pay attention to these issues as you grow and develop your shooting techniques.

AUDIO WORKFLOW

The audio recorded by your DSLR camera is usually dreadful. Your camera likely has a cheap microphone that happens to be placed right where your hand will brush against it (or even cover it). For this reason, most people add an external microphone (**Figure 1.8**) onto their cameras to improve its sound-recording abilities.

If dialogue or interviews are important, you may need to go a step further. You can record far better sounding audio using a dedicated digital recorder and a professional-quality microphone. You can merge all of these audio sources together during the editing stage. Be sure to read Chapters 9 and 11 for more on audio acquisition and editing.

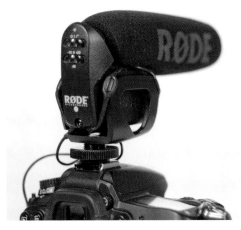

FIGURE 1.8
Using an external microphone improves the quality of the audio your camera can record.

TAPELESS WORKFLOW

In the past, video cameras shot to tape. Tape was cheap, and when the project was done, you had your original tape as a backup for your project. You could also record your finished project back to tape. Tape was easy; you could hold it in your hand and easily know what you had.

As cameras moved into the world of high definition (HD), the use of tapeless recording formats really took off. Tape takes up space and makes cameras bigger. Additionally, tape requires a lot more moving parts on a camera, which are more likely to break.

FIGURE 1.9
Be sure to stock up on enough memory cards. Photo by iStockphoto.

With DSLR video, you record to memory cards—chances are *lots* of memory cards (every three minutes you record is about 1 GB of data). You also need to use higher-speed memory cards because the video files you capture have a lot of data to quickly record. The upshot is that cards are more expensive (than tape was), and you'll need more of them (**Figure 1.9**).

Unless you have a lifetime supply of memory cards (or a *lot* of money), you'll need to transfer the files on those cards in order to keep shooting. Hopefully, you'll have enough space on the cards you have to get you through the day. But speaking from

firsthand experience, there will be times when you'll be backing up your footage while on a shoot. You might need to transfer your footage at your hotel each night while on vacation or while out and about to your laptop. In any case, you'll need to keep in mind that you'll have a lot more data to work with and will need strategies (and disk space) to deal with all that data. I cover backing up your footage in depth in Chapter 10, "Backing Up and Organizing Your Footage."

FOCUS IS DIFFICULT

A hallmark of DSLR video is shooting with a shallow depth of field (**Figure 1.10**). This look is often associated with a "film look" and is attractive but difficult to attain. DSLR cameras also lack most of the auto-focus features that are available in many consumer video cameras. Add to these issues challenges with the ergonomics and form factor, which make the camera difficult to hold when shooting video, and you'll discover that focus is tricky. Although you can adjust exposure and audio, there is nothing you can do to fix a picture that has soft focus. However, this problem can be resolved with practice and the addition of some equipment.

FIGURE 1.10
In this busy scene, parts of the shot are in focus and parts are out of focus. Adjusting the aperture of your camera will have the greatest impact on what is in focus and what is not.

ISO 100
1/60 sec.
f/2.8
50mm lens

▶ #04

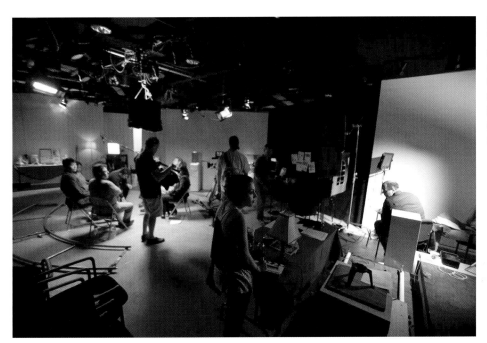

FIGURE 1.11
This is a full crew shoot for a television commercial I directed. Although we shot with a Canon 7D, we used a full lighting crew to achieve our look.

ADD-ON GEAR IS IMPORTANT

If you've never been near a professional video or film set, you'd be amazed at just how much gear is in use and the number of people needed for a successful shoot. You see, most Hollywood feature films have a huge lighting department, multiple photographers, and audio specialists (**Figure 1.11**). The DSLR camera can also have lots of add-on gear to improve its ergonomics and performance (**Figure 1.12**). You, on the other hand, probably don't have the resources to run out and buy every piece of gear or hire a full crew.

If you read some of the popular websites or read magazine articles about DSLR video, you may think you need to own several thousands of dollars of equipment, which can really be overkill. But out of the box, a DSLR camera can be a little challenging to use.

FIGURE 1.12
This DSLR camera has been converted to a film-style camera. Equipment like a matter box (for adding filters to the lens) and a follow focus (to make it easier to focus on a moving subject) complete this pro-style camera package.

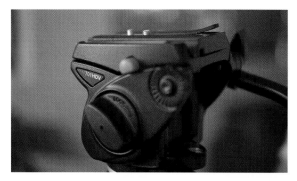

FIGURE 1.13
The use of a fluid head makes it easier to control your camera. You can attain much smoother camera movement using the right gear.

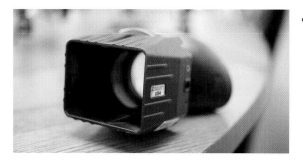

FIGURE 1.14
This loupe attaches to the back of the camera to magnify the LCD image when shooting. Photo by Lisa Robinson.

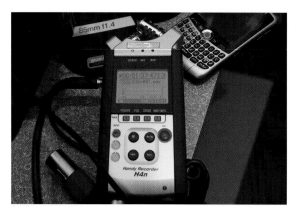

FIGURE 1.15
The Zoom H4N makes it easy to connect external microphones, as well as monitor the sound recording through headphones. See Chapter 9 for more details.

Here are three essentials that I consider must-haves:

- **Fluid-head tripod.** A tripod provides your camera with a steady platform. The use of a fluid head can help you create animated movements of the camera as the camera pans (side to side) or tilts (up and down). A shaky camera leads to soft focus and can give your audience a feeling of motion sickness. You really need a video-style tripod or to adapt your existing tripod so it uses a fluid head (**Figure 1.13**). A stable platform for your camera is one of the best pieces of equipment you can use to improve the quality of your video.

- **Viewfinder or loupe.** The screen on your DSLR camera will make your video look in focus and properly exposed (even when it's not). A small screen makes it difficult to judge image quality. A viewfinder or loupe is like a lens for the back of the camera (**Figure 1.14**) that can help you with exposure and focus. The benefits to using a loupe or viewfinder are many, and I'll discuss them in depth throughout the book.

- **Audio recording device with microphone.** "Audio is half the picture" is an adage used by video professionals. The thought is that good sound greatly enhances a story. In fact, poor audio will quickly force anyone watching your production to stop. Investing in a microphone—and possibly a dedicated recorder (**Figure 1.15**)—allows you to record much better sound.

SHOOTING WITH MOTION IN MIND

If you've been shooting photos, you've probably developed many of the skills that are used to tell visual stories. Composition skills help you frame the shot, and exposure skills ensure that the details of the image are clear. You may be a great photographer or just getting started, but if you want to shoot great video, you'll need a bit of retraining and rethinking.

With photography, you can walk away with one great shot and it's a successful shoot. With video, you'll need many great shots that match in exposure and style. What becomes important is how several shots will come together to tell a story.

THE SEQUENCING OF MOTION

Many people who start to shoot video focus intensely on just the shot. This produces beautiful images but not necessarily a story. As a beginner, you may be perfectly content to string a bunch of shots together with a music track. Sure, a montage is fun to shoot and share, but it's much harder to hold the viewers' attention, let alone communicate a message.

The biggest change for photographers and new shooters moving into video is thinking of video as a series of interconnected shots. Your goal is to not just gather a bunch of pretty pictures. Instead, you need to think about how one shot leads to the next (**Figure 1.16**). In some instances, your subject may move through a space, linking one shot to the next.

You also may need to figure out how to condense a long event into a shorter video (unless you like putting an audience to sleep). This can be done in two ways by strategically using multiple shots to convey a sequence. Some do this by carefully repeating action and changing their shot composition and position each time. Others solve the problem by shooting with multiple cameras at the same time. Composition and sequencing are explored in more depth in Chapter 5, "Composing Shots."

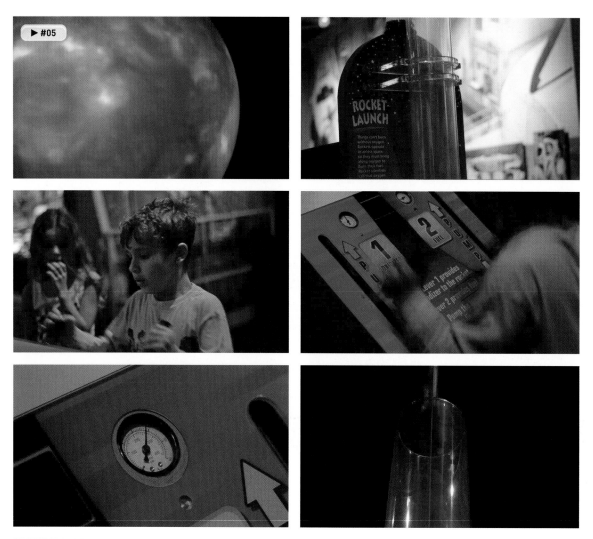

FIGURE 1.16

For this scene, I used six shots to tell the story. The first shot establishes the location at a space museum and then moves on to a close-up of the exhibit my son was playing with. The next shot establishes my son and his interest in the exhibit. A two-shot sequence builds up the drama as he pumps the handles to prime the rocket launch. The scene resolves with the rocket launch.

TIMING THE SCENE

Another challenge you'll face is time, specifically determining how long each shot in your scene should be. There are lots of details to think about when you are trying to establish shot length. You should have some idea of how long a shot should be *before* you start recording because it will affect camera movement and framing (**Figure 1.17**).

FIGURE 1.17
Make sure you think about your shot length before you record. It will make your shots more usable when it comes time to edit.

Here are a few guidelines to consider when timing your shots:

- **Do you need to cover a specific amount of time?** If you're using narration or an interview talking about a topic, you'll want to cover it with footage. If you've already written your story or interviewed your subject, review it and determine the durations you need.

- **How many angles do you want?** One of the most common approaches to add visual interest to a video is to cut from one angle of a shot to another. Try to think about how you can break a scene into multiple shots.

- **Be safe and repeat.** If you're not sure about your footage (and even if you think you are), try recording the scene a few times. Just as you might take a few photos "for safety," try recording each video shot a few times. This will protect you from issues like soft focus and give you more choices when you start to edit your video together.

- **Leave handles.** When shooting, be sure to leave five seconds of usable padding on each side of a shot (the start and end). This means roll a little before you start your pan or tell your subject to start moving (and don't press Stop as soon as the shot ends). This extra footage is often needed for transitions or minor timing adjustments. It's also a good idea to let the camera roll for a second so you have a stable shot that is free from the vibration of the start and stop of the Record button.

Chapter 1 Assignments

I hope that you're excited by the opportunities and challenges ahead. Shooting video is fun, and I'm sure you'll enjoy the process. It's time to get familiar with your camera so you can move on to the fun stuff in upcoming chapters.

Download Your Camera Manual

Because it would be impossible to cover all cameras in this book, I can't address every unique setting on your camera. It's a good idea to find your camera manual as a digital file and store it as a PDF on your laptop, tablet, or phone so you can quickly look up information in the field.

Shoot Under Different Conditions

Take your camera with you into different environments and try shooting with it. Get familiar with shooting outdoors and indoors, as well as in daylight and evening light. You'll explore all of these shooting situations in depth throughout the book, but it's good for you to have some firsthand experience at the outset (especially with the hard parts, like exposure and focus).

Start "Watching" Movies and Television

Going forward, start to pay more attention to the films and television shows you watch. Look at how multiple shots are connected to make scenes. Look at how long each shot is onscreen. By carefully watching, you'll begin to see how video and film is made.

Share your results with the book's Vimeo group!
Join the group here: vimeo.com/groups/DSLRVideoFSTGS

Essential Equipment

It's important to understand the role equipment plays in capturing great footage. You'll quickly discover that you'll depend on having some key pieces of equipment and the knowledge to use them to create great shots. If you put the right tools in the wrong hands, you'll get subpar results. And if you put the wrong tools in the right hands, you'll still get poor results. The magic really starts to happen when the right tools for the job are placed in the hands of someone who knows how to use them.

PORING OVER THE CAMERA

While shooting at the beach, I decided to put my monopod to good use. I wanted a platform that would help me get a more stable shot (without having to lug a tripod with me). Once there, I decided to use the monopod to extend my reach. By setting the f-stop to a higher aperture, I had a wide depth of field. I then lifted the camera up from a tight shot of the sand bucket to a wider shot to show more of the sandcastle construction.

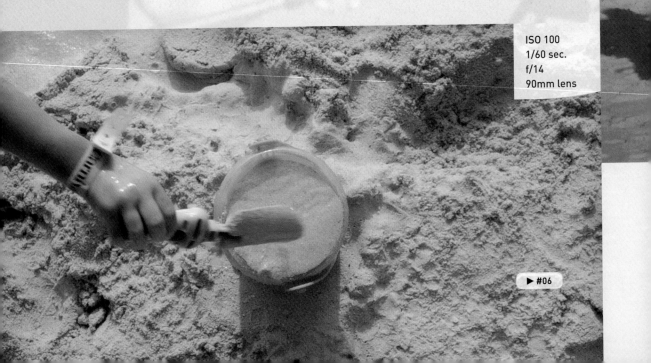

ISO 100
1/60 sec.
f/14
90mm lens

▶ #06

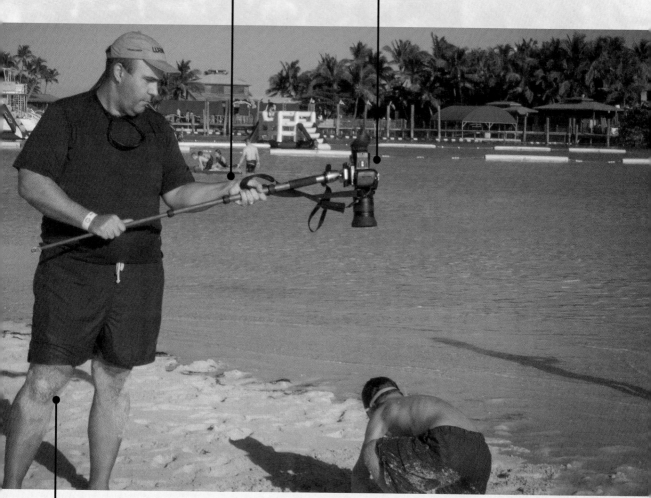

Holding the monopod with two hands produced a smoother lifting motion.

Setting the f-stop to f/14 made it much easier to maintain focus while moving the camera.

Bending at the knees and waist enabled me to more easily control the lift of the camera.

Photo by Meghan Ryan-Harrington.

GETTING STARTED

Out of the box a DSLR camera can shoot pretty good video (audio, on the other hand, not so much). But which camera you use (or buy if you don't have one) should depend on several factors. In this chapter I'll first explore the features that really matter when using a DSLR camera to shoot video. Next, I'll talk about the most useful items to add to your camera kit (like camera support) (**Figure 2.1**).

FIGURE 2.1
Using a monopod helped me stabilize my shot, which was useful because I was shooting from a distance. The use of a loupe also helped me better judge my exposure and focus. A monopod is very similar to a tripod but has only a single leg. It is useful for reducing camera bobbles and shakes.
Photo by Meghan Ryan-Harrington.

▶ #07

ISO 160
1/60 sec.
f/9
78mm lens

I'll also talk about two items you'll burn through quickly: memory cards, which you'll rapidly fill up as you shoot video, and batteries, which you'll run down more quickly shooting video than you would stills. Then I'll discuss tripods and lenses. You can always enhance your shooting by getting a stable shot or changing focal length using a different lens.

Don't think you need to run out and spend more money to start. Just think about investing wisely in your hobby over time. I'll try to help you evaluate which equipment helps the most. Let's explore some essential equipment.

CHOOSING A CAMERA

If you haven't bought a video-enabled DSLR yet, I'd like to offer some advice on which features matter most (if you've already bought your camera, be sure to look for these options or consider them when you upgrade to a new camera). Which camera you choose is largely a matter of personal preference. The most important detail to remember is to test the camera before purchasing it. This might mean borrowing a friend's camera or heading down to the local camera/electronics store to give it a spin.

EXISTING INVESTMENT

When buying a new camera, you should first think about any investment you've already made. If you've already invested in digital photography gear, you may already have lenses from a certain camera manufacturer. It's not uncommon for good lenses to cost as much as a camera (some cost even more). If you've already bought into one type of system or manufacturer, you may want to build upon your existing investment.

FIGURE 2.2
Make sure the camera feels comfortable and balanced in your hands. Photo by Lisa Robinson.

ERGONOMICS

If you read online websites or talk to salespeople in stores, it's easy to believe that you need to buy the latest and greatest camera. But all those features don't matter if the camera doesn't feel right in your hands (**Figure 2.2**). The grip needs to feel comfortable and the body sized right. If it's too big

and heavy, you'll fumble with the camera; too small and you'll constantly feel like you're about to drop it. Consider these factors:

- **Size.** The body you choose should fit your hands well. If the body is too small, your hands will get in the way of the controls. Conversely, if the body is too big, you'll find the body difficult to hold.

- **Weight.** Entry-level DSLR cameras tend to be rather light, which is great for portability. However, if you use a large lens, the cameras can become front heavy and difficult to hold. Higher-end and pro cameras tend to be heavier and work well with bigger lenses. Be sure to choose a camera that you can afford *and* that feels comfortable.

ON-CAMERA LCD SCREEN

When you shoot video on a DSLR camera, you won't be using the eyepiece or view-finder. Instead, you'll be using the camera's LCD screen to compose the shot and check focus (**Figure 2.3**). Here are few simple criteria to use when choosing a camera body and LCD screen:

- **Size.** The larger the LCD screen, the better. A large screen makes it easier to see your footage. Most DSLR cameras have screen sizes of up to 3.5 inches diagonally.

FIGURE 2.3
The LCD screen provides a preview of your footage when shooting. This is typically called *Live View*. Photo by Lisa Robinson

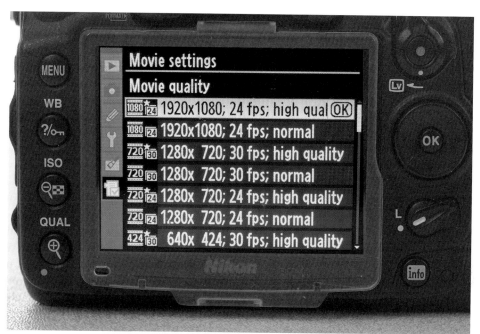

FIGURE 2.4
Most DSLR cameras offer multiple recording modes and even quality settings for recording video. Pictured here is the Nikon D7000.

- **Resolution.** A large LCD is useless if it doesn't have a clear picture. Camera LCDs are measured in dots or pixels. A higher number indicates a higher resolution and therefore more clarity.

- **Brightness.** When you're recording and reviewing video, you'll be using the LCD screen. So, make sure you choose one that is bright enough to see (even in outdoor lighting).

- **Flexibility.** Some DSLRs offer viewfinders that you can angle for easier viewing because sometimes you'll want to shoot from an angle other than eye level. Whether you want to get a low-angle, point-of-view shot or hold the camera above the crowd at a concert, a swivel LCD can help you achieve shots that would otherwise be impossible.

RECORDING FORMAT

Different cameras record video to different formats. Typically, you won't have a choice within the camera; rather, the format will vary between camera models and manufacturers. The trend has been that the newer the camera, the higher quality the video files are that are written to the memory card (**Figure 2.4**).

When capturing video, the original signal created by the camera sensor is heavily compressed. This process is typically handled by a codec (compressor/decompressor). The

camera applies compression to make the files smaller; when the video is played back on the camera (or your computer), it is decompressed into a full signal. This process is not exclusive to DSLR cameras. All video cameras apply some form of compression.

Why is compression important? Well, chances are that you'll want to edit your video clips together into finished productions. To edit your footage, you can use entry-level software like iMovie or Adobe Premiere Elements, or more professional tools like Final Cut Pro X or Adobe Premiere Pro. So, it's important to make sure that your camera's compressed file format is compatible with the editing software you want to use. Otherwise, you'll likely need to perform time-consuming steps to convert all of your footage before you can use it. You'll explore the conversion and editing processes in more detail in Chapters 10 and 11.

The three most common formats used by video DSLR cameras include:

- **H.264.** The H.264 format is one of the most commonly used video formats on the market. It is used for capturing video and delivering it to the Web. The Canon 7D and the Nikon D7000 cameras (as well as many others) use this format.

- **AVCHD.** The AVCHD (Advanced Video Coding High Definition) format is owned jointly by Sony and Panasonic. It is used on a variety of cameras, such as the Panasonic Lumix GH2.

- **Motion JPEG.** The Motion JPEG or Photo JPEG format is an older format that was first adopted in early Nikon cameras that shot video. This format is not as broadly supported by video editing tools and has subsequently been dropped in favor of H.264. You should avoid this format if possible.

RECORDING LENGTH

One way in which DSLR video cameras differ from traditional video cameras is their limits on recording time. Your camera can only record video for a finite amount of time before it needs to be stopped and restarted (**Figure 2.5**). This limitation can vary between camera models (often ranging from 5–20 minutes).

The primary reason for the recording length limit is the way that memory cards are formatted. Most DSLR cameras shoot to memory cards using the Windows FAT32 file system. This system can't write files bigger than 4 GB, so recording time is capped to fit into smaller files.

If you plan to shoot events like sports or concerts, a longer file length can be useful. It is generally recommended that you don't overshoot anyway (because it makes editing more difficult). But if you need long record times, make sure you consider this limit when choosing a camera.

FIGURE 2.5
Record times will
vary based on the
camera manufac-
turer as well as
the frame rate and
recording quality
chosen.

HOW TO WORK AROUND RECORD LENGTH LIMITATIONS

The limits on recording long files can really be a drag. This is especially true if you're recording lengthy events like interviews or performances. Here are a few tips for when you do need to record long segments:

- **Plan breaks**. If you're recording an interview, estimate how many questions you can ask during the record window. You can always start and stop the camera between questions or during a gap in the performance.

- **Minimize downtime**. If you reach a recording limit for either an individual recording or overall on a card, try to minimize downtime. Be sure to have another memory card erased and formatted so you can do a quick swap and just keep shooting.

- **Stagger coverage**. If you're shooting an event like a concert or a performance, it is common to set up more than one camera (for multiple angles). But don't start or stop them all at the same time. By making sure that at least one camera is rolling at all times, you'll always have something to cut to.

SENSOR RESOLUTION

When you shop for a DSLR camera, much of the discussion will focus on the sensor size and resolution (**Figure 2.6**). Talk to any salesperson, and it seems like the megapixel wars will never end. A few years ago, an 8-megapixel camera was considered high end; now you can find that resolution in cell phones.

FIGURE 2.6

The sensor in your DSLR is a complex device that has benefits for shooting photos and video. Be sure to carefully read camera reviews when you're shopping because not all sensors are created equal.

Extra megapixels are great when it comes to printing large photos. But anytime you're shooting video on a DSLR, you'll only be using a fraction of the available pixels on the sensor. For example, the 18 megapixel Canon T3i has a max resolution of 5184 x 3456 pixels when taking still photos. But when shooting video at 1920 x 1080, your effective megapixel count is only 2.1 megapixels!

Because you'll likely use the body you choose for both stills and video, choose a camera body that meets the megapixel requirements for your still images and don't worry about sensor resolution for video.

SENSOR SIZE

Another area that is a dividing line when it comes to choosing a camera is the size of its sensor. Higher-end professional cameras often use a full-frame sensor, which matches the size of a 35mm film frame (**Figure 2.7**). But why does it matter what size the sensor is?

As a general rule of thumb, the larger the sensor the more control you'll have over depth of field (DOF). The depth of field defines the distance between the closest and farthest object in a shot that appear to be sharp. Often when shooting photos and video, people choose to create a very shallow depth of field. The shallow depth of field look is often equated with film-style shooting, and it can be used artistically when designing shots. Additionally, a DSLR camera when combined with a good lens can shoot significantly higher-quality video under poor lighting conditions because the larger sensor can capture more light.

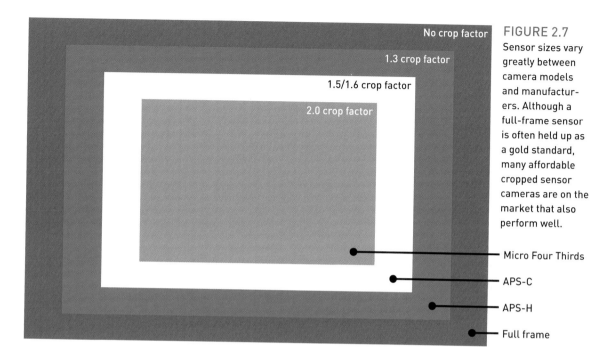

FIGURE 2.7
Sensor sizes vary greatly between camera models and manufacturers. Although a full-frame sensor is often held up as a gold standard, many affordable cropped sensor cameras are on the market that also perform well.

So you're thinking, just buy a big sensor, right? Well, that's easier said than done. Full-frame sensors tend to be found only on the most professional DSLR cameras.

The lenses used on these cameras also tend to be more expensive. When choosing a camera body, purchase the best you can afford.

When the sensor is not full size, it is typically referred to as *cropped*. Cropped sensors are more common than full-frame sensors, and cropped factors can be useful for video. For example, you can get a much longer reach with your lenses without having to purchase extremely expensive telephoto and super telephoto lenses.

MEMORY CARDS—LOTS OF 'EM

When you start shooting DSLR video, two facts will become clear. Memory cards are the fuel for your engine, and your engine runs hot. Essentially, when shooting video, you are capturing between 24 and 60 still images each second. Although these aren't high-resolution, raw files, the file sizes do add up quickly. So, be sure to keep in mind that your storage will run out quicker in the video world.

CROPPED SENSORS EXPLAINED

Cropped (or smaller) sensors multiply the focal range of any given lens (**Figure 2.8**). The focal range of a lens is based on a 35mm frame. For example, if you purchase a 50mm lens, it will act as marked. But if you put that 50mm lens on a body with a cropped sensor, the effective focal range is multiplied due to the smaller sensor size. On many Nikon cameras, the crop factor of 1.5 will make the 50mm lens behave as if it is a 75mm lens.

Here are some common crop factors that are used in cameras today:

- **1.5**. This crop factor is employed by Nikon for its entire DX lineup, like the D7000 and D3100.
- **1.6**. This crop factor is used by Canon for its APS-C bodies, like the 7D and the Digital Rebel series.
- **2.0**. This is a large crop factor ratio that's used by Micro Four Thirds image sensors, like the one featured on the Panasonic Lumix GH1 DSLR.

FIGURE 2.8
A cropped sensor will make a lens perform differently. The cropped sensor magnifies the image, giving it a different effective focal length.

HOW MANY CARDS

The number or cards you need is really a matter of personal choice. Typically, a DSLR video camera consumes about 5.5 MB a second, which means 330 MB each minute or about 1 GB every three minutes. If you are covering a long event (such as a 90-minute performance), you'd want a 32 GB card. It's a little different than shooting stills, isn't it?

Using the preceding ratio, you should have a good idea of how much storage to buy. The key here is to learn restraint. Don't just roll all the time. Choose to shoot video when your subjects or scenes look good (even going so far as to practice a shot). Remember to stop the camera from time to time. If you're traveling on vacation, you may want to bring a laptop and a portable hard drive so you can off-load cards and back up your data.

CHOOSING A FORMAT

The format your camera records will often be chosen for you. Some cameras support multiple card slots (even types), but most will give you only one option. The most common formats in use are CompactFlash (CF) and Secure Digital (SD) cards (**Figure 2.9**):

- **CompactFlash cards.** The CF format is a mainstay for professional digital photographers. These cards tend to be the most robust and sturdy, and less prone to accidental damage. Originally, CF cards were also significantly faster than early SD memory cards. When comparing costs per gigabyte, CF cards are typically more expensive than SD cards. CF cards tend to be offered in higher capacities with faster transfer speeds than SD cards.

FIGURE 2.9
Although the CompactFlash format took the early lead in both speed and capacity, Secure Digital cards have caught up in most cases with the newer high-capacity formatted cards (SDHC). Image courtesy Lexar.

- **Secure Digital cards.** SD cards are most common in consumer electronic devices—in everything from music players and photo frames to GPS units. Also, they are becoming increasingly common in DSLR cameras. It's important to choose the new Secure Digital High Capacity (SDHC) format because of its higher capacity and transfer speeds that are fast enough for recording video. Make sure your card reader is rated for using SDHC cards because many older card readers are not.

TWO CAMERA SLOTS?

Some camera manufacturers offer a CF and an SD slot. In this case you can often choose to route your video to one slot and stills to the other. This makes organizing your footage a bit easier.

DEMYSTIFYING CARD SPEEDS

Recording video on your DSLR requires that data constantly be written to storage. This means you'll need fast storage that can keep up with the data rate of your DSLR camera. If your memory cards are inferior, the video may stutter (called *dropping frames*). In many cases a second-rate card can lead to video that doesn't record at all.

Unfortunately, manufacturers (and marketers) make the whole process entirely confusing. You'll find all sorts of creative language used to make memory cards sound faster than a rocket and more reliable than your dog. Such jargon can really get confusing when you're shopping for storage that's fast enough for video files.

In the simplest terms, you'll want to choose a fast card. But what do the different card speeds really mean? For video, you'll want a card that's at least 133x. Usually, though, you'll want cards rated at 300x or faster. Faster cards mean faster transfers to your computer and are less likely to cause a camera to overheat.

Another easy way to tell which cards to use is how they're labeled. For CF cards, look for a UDMA (Ultra Direct Memory Access) rating (**Figure 2.10**). When choosing an SDHC card, look for Class 10 or higher.

FIGURE 2.10
If your DSLR uses CF cards, make sure they carry a UDMA rating so they're fast enough to handle video.

MORE POWER FOR THE CAMERA

How many DSLR camera batteries do you own? If the answer is less than three, you should probably plan on picking up more. You see, when you're shooting video, your camera will need much more power than you usually use when just shooting stills. The reason is that the LCD panel's Live View function is a big drain on batteries. Additionally, when shooting stills, your camera only records for a few bursts, but with video it works much harder.

BATTERIES AND CHARGERS

Your camera likely came with one battery and one charger. Well, prepare to take your credit card back out. You might be used to capturing hundreds or even thousands of shots using a single battery when shooting stills, but when shooting video, you can drain a single battery in just a couple of hours (**Figure 2.11**).

So the question is how long do you want to be able to shoot? If you're just taking a few shots at a time, one battery might do it. But do you really want to miss that perfect shot because of a dead battery? Just as you likely have a spare tire for your car, you should keep at last one spare battery.

FIGURE 2.11
Consider purchasing additional batteries and an extra charger to help you meet the more demanding power requirements for shooting video on your DSLR.

If you plan to spend long days shooting (such as vacations or making an independent film), more batteries are in order. I carry four batteries and two chargers so I can have two batteries charging and two with me at all times. Less is fine too, but a spare battery is critical.

WALL POWER

If you'll be shooting from a stationary position (such as at a concert or a child's play), it might be a good idea to carry and use an AC adapter. Many DSLR cameras offer an optional unit that you can purchase (typically priced between $60 and $150). You can look for units from the same manufacturer as your camera or third-party sellers (just be sure to read the reviews first). If you plan to use wall power, consider using an extension cord to extend your reach.

CHOOSING LENSES

When you bought your DSLR camera, it may have included one lens, which is often referred to as a kit lens. This is a great starting point, but it's only a starting point. To shoot in different conditions, you may find that you need to build up a collection of lenses (**Figure 2.12**). When it comes time to choose lenses, there are an amazing number of choices: wide, telephoto, fast, slow, specialty, cheap, and expensive. So, how do you decide which lenses are the best choice for your kit? Let's look at some of the determining factors.

LENS MANUFACTURER

When purchasing a lens, one of the first decisions you'll have to make is whether to buy a lens made by the same manufacturer as your camera. This is often called an *original equipment manufacturer (OEM) lens* (**Figure 2.13**). OEM lenses tend to be more expensive than those made by third-party manufacturers. However, an OEM lens often works better because it's designed to take advantage of all the features your camera offers.

Third-party lenses are a valid choice too. Sigma, Tokina, and Zeiss are just a few of the dozens of non-OEM lens manufacturers. Third-party lenses are typically either cheaper than their OEM equivalents or they offer unique features (sometimes at a premium cost).

FIGURE 2.12
One of the most versatile lenses in my kit is my 28–300mm lens. It's a great "tourist lens" that I can often use to shoot with outdoors all day long. Having multiple focal lengths makes it possible for me to carry a single lens on day trips.

FIGURE 2.13
I recommend starting your lens search by looking at OEM lenses from the manufacturer of your camera body.

It really doesn't matter which brand you choose (although OEM lenses usually have higher resale values when you trade in). Essentially, a good performing lens is a good performing lens. You can read detailed reviews of lenses at Digital Photography Review (www.dpreview.com). Make sure that when comparing OEM and third-party lenses of the same focal length and aperture, you also compare them for build quality and sharpness.

APERTURE

When you look at a camera lens, you'll often see its aperture labeled as an f-stop. This number describes how wide the aperture is on the lens (where light passes through). The lower the number, the wider the aperture (**Figure 2.14**).

A lens with a low f-stop is said to be "fast." The faster a lens, the better it performs in low light. Another advantage of a fast lens is that at wider apertures (f/1.8, f/1.2, and so on) you can use a shallow depth of field look. This is often called *bokeh*, and you can use it artistically to control where viewers look in your shots. You'll learn a lot more about bokeh in Chapter 4, "Exposure and Focus."

The only major drawback for fast lenses is price. But even though fast lenses are expensive, having at least one in your bag is essential for photo and video work. I recommend using lenses that have an aperture of f/2.8 or larger. If your scenes will have quite a bit of light available (for example, when working outdoors), an aperture of f/4 should work just fine, and those lenses have the benefit of being cheaper.

FIGURE 2.14
You'll often find the maximum aperture for a lens written on the front. Remember that many zoom lenses change their aperture as you change their zoom level. Photo by istockphoto/ rKIRKimagery.

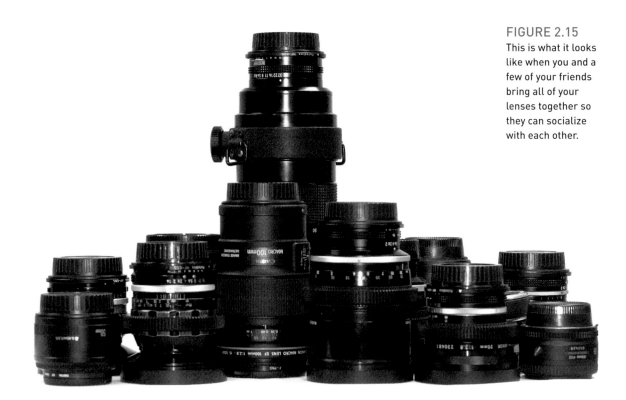

FIGURE 2.15

This is what it looks like when you and a few of your friends bring all of your lenses together so they can socialize with each other.

FOCAL LENGTH

The longer the focal length on a lens, the closer the subject appears. Having a range of focal lengths can become important so you can properly compose shots in your scene (**Figure 2.15**). Unlike with photos, you can't really crop and scale video without a significant loss in quality.

Here are the focal ranges I like to have in my bag:

- **10–35mm.** Lenses in this range are best for wide-angle shots. In video work these lenses are great for taking in lots of action in a scene or for establishing the location of a shoot. A wide-angle lens helps you see the big picture (but does require you to be close to the action).

- **50–100mm.** Lenses in this focal range are often used for portrait shots and interviews. One of the first investments to make for your kit is a 50mm lens (often called a *nifty-fifty*), which is an affordable addition. You can get a great lens for about $100 that will work well in low light and has a shallow depth of field (which looks great for interviews).

- **200mm or greater.** Long telephoto lenses are ideal for shooting from a distance. They are also useful to capture close-up action shots.

ZOOM LENSES VS. PRIME LENSES

When choosing a lens, you have a major functional choice to make. A *prime* lens offers only a single focal length, whereas a *zoom* lens provides a variety of focal lengths. There are many reasons to choose one over the other. In fact, many photographers carry both types in their bags.

WHEN TO USE ZOOM LENSES

If you want the greatest flexibility when shooting, a zoom lens works well. By turning the zoom ring, you can quickly change between focal lengths (**Figure 2.16**). These quick changes can really come in handy when you're shooting at live events. A zoom lens is also useful when you want to avoid changing lenses or have a limit on how much you can carry.

A DSLR zoom lens behaves differently than a traditional video lens in two ways:

- **Shakiness can occur.** Because the zoom controls aren't motorized, it's very difficult to get a smooth zoom, so don't zoom while recording. Use the zoom option to recompose your shot between takes.

- **Exposure may change.** As you adjust a zoom lens, the aperture may change. Most zoom lenses have a range of aperture settings. For example, I love using my Nikon 28–300mm lens when I am out for a day with the family. However, the f-stop will change between 3.5 when shooting at a wide angle and 5.6 when zoomed in. These changes in exposure are caused by the lens physically changing in length as I rotate the zoom controls.

FIGURE 2.16
A zoom lens adds versatility when you need to quickly compose shots. Photo by Meghan Ryan-Harrington.

WHEN TO USE PRIME LENSES

If you are shooting video on a DSLR camera for the aesthetic benefits, you should strongly consider shooting with prime lenses (**Figure 2.17**). From a quality point of view, there are two major benefits: A good prime lens with a wide aperture of f/1.2 to f/2.8 allows you to shoot in existing light or low-light environments more easily. Primes are universally faster than zooms due to the way they are manufactured.

Additionally, prime lenses generally have fewer moving parts and fewer glass elements than zoom lenses. This means that the image tends to be sharper and the lens significantly lighter.

Using a prime lens for shooting interviews or portrait shots is a great choice. You can set the lens to a wide aperture (a lower f-stop) and really use the shallow depth of field. You'll explore prime lenses more in Chapter 4.

FIGURE 2.17
Prime lenses tend to be cheaper than their zoom counterparts, although they require you to physically move the camera to change composition. For this shot, I chose a 50mm lens for shooting in low light.

WHAT ABOUT USED LENSES?

There is absolutely nothing wrong with using used lenses. Many of the lenses in my kit were bought from photography friends who were upgrading. Others are older prime lenses bought from reputable camera stores. It is perfectly acceptable to build your kit anyway you see fit. In fact, many old lenses are very solid and work well on modern cameras. If you are unsure about a used lens, you can take the lens to a camera shop to have it evaluated.

You can even adapt lenses to work on different manufacturers' cameras. Many companies make adapters that allow you to mount a lens from one manufacturer on a body from another. Adapters from companies like Fotodiox and Novoflex are good quality, well built, and fairly inexpensive.

Although adapting a lens may sound like a perfect solution, you should be aware of two major drawbacks: First, you won't get any autofocusing capabilities. Fortunately, this is not the biggest deal for video because you'll focus manually in most cases. Second, the camera will need manual control rings for aperture and focus, which is fairly standard on old lenses.

A STABLE PLATFORM

When you shoot photos with a DSLR, hand holding the camera is pretty easy. With each click of the shutter you're essentially freezing motion. Unfortunately, this doesn't translate well to video because the form factor of a DSLR camera is not designed well for handheld video shooting. When recording video, you capture *every* movement of the camera. Unless you want your viewers to feel motion sickness, you'll need to take corrective actions.

USE A TRIPOD

One rule that is drilled into those studying videography and cinematography is to *use a tripod*. Creating a steady shot while shooting video is more difficult than you might think, and viewers will notice every wiggle, bump, and cup of coffee you drink. It cannot be said enough times—use a tripod (**Figure 2.18**). Sure, there'll be times when you'll need to break this rule and put the camera in motion, but you can't go wrong with a steady shot.

FIGURE 2.18
A tripod prevents unwanted camera movements that can distract the viewer. Photo by Lisa Robinson.

DO YOU OWN A PHOTO TRIPOD?

You may already own a tripod from your photography hobby. However, a photography style tripod may not be exactly right for video (**Figure 2.19**). Does the tripod head have a handle that you can move? Is it easy to perform smooth pans and tilts to follow the action? In many cases you can replace the head of the tripod to convert it from photo style to video style.

FIGURE 2.19
The tripod on the left is a classic photo tripod that is designed to be locked down. The video tripod on the right can be panned and tilted while recording. Photos by Lisa Robinson.

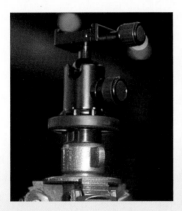

SELECTING A FLUID HEAD

The most important part of a tripod is the head, which is where the camera attaches and where controls exist to help reposition the camera. Small, still photography heads are limiting when it comes to smooth movement. They can typically be unlocked, repositioned, and then locked to hold their place.

However, a video tripod head usually has springs (**Figure 2.20**) that help balance the tripod head to prevent unwanted movement. When properly calibrated, you should be able to let go of the camera head without the head tilting one way or another.

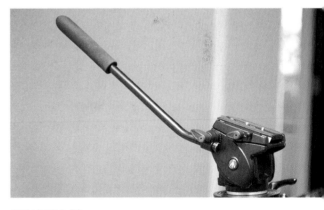

FIGURE 2.20
The handle on the fluid head tripod makes it easier to smoothly pan and tilt the camera. Photos by Lisa Robinson.

The cost of tripod heads varies wildly, which is often due to how much weight the tripod is designed to carry. For DSLR cameras, you can often get by with affordable tripod heads. Models like the Manfrotto 501HDV and 701HDV Video Head start at around $140.

Consider some of these options when shopping for a tripod head:

- **A sliding base plate.** Being able to slide the camera forward and backward on the tripod head is useful (especially if you change lenses). This is essential to balance the camera and prevent unwanted tilting.

- **Adjustable tension controls.** Many tripod heads allow you to tighten or loosen resistance to create smoother movements when panning or tilting. Having enough tension can also prevent unwanted drifting when you stop moving the head.

- **Ball leveling.** You'll often find a bubble level built into the tripod head. Many tripods let you loosen the head a bit and adjust it so the camera can be leveled without having to adjust the tripod legs.

SELECTING A TRIPOD

The fluid head you select will need a set of legs to rest on. Tripods legs come in all sizes, heights, and weights. Often, the manufacturer of your fluid head makes a matching line of tripod legs. You may also be able to reuse the legs on a photography tripod.

Here are a few options to consider:

- **Tripod material.** Tripod legs are made of a variety of materials (based on weight and durability). Heavier steel and aluminum tripods are meant for durability but can be a drag to carry around. Lighter materials, such as carbon fiber, are very popular.

- **Tripod height.** Although it impacts cost, you can choose how many stages you want in your tripod. The stages determine the height range of your camera. Two-stage tripods are the most common. They allow for a lens height in the range of approximately three feet to six feet. If you need to shoot at live events or from a distance, a three-stage tripod can help you shoot over a crowd.

- **Tripod stability.** Many tripods offer a spreader bar to increase stability. The spreader bar might be located at the base or part way up the legs; it connects all three legs to each other. When you set the spreader, it allows you to securely raise or lower the camera beyond its normal height range. The spreader creates additional stability and keeps the tripod sturdy.

As a beginner, you won't have to spend much money on a tripod. As you improve, you may find the need to upgrade your tripod.

Here are a few tripod head manufacturers to consider:

- **Sachtler** (www.sachtler.de)
- **Cartoni** (www.cartoni.com)
- **Miller** (www.millertripods.com)
- **Manfrotto** (www.manfrotto.com)
- **Gitzo** (www.gitzo.us)

Chapter 2 Assignments

The key to success is to get comfortable with the equipment you already have before you run out and spend more money. These three exercises will help you familiarize yourself with your gear's capabilities.

Change the Recording Format of Your Camera

Access your camera's menus and try to change its recording format. I highly recommend sticking with a 24p frame rate for maximum versatility and a cinematic look. Choose 1920x1080 if it's an option; otherwise, choose 1280x720.

Run Your Battery All the Way Down

Get familiar with how long a fully charged battery will last. Drop a fresh battery in your camera, and then turn on the Live View monitor. Keep recording until the battery dies and the camera shuts off. Note approximately how long you can shoot on a single battery. Use this information to decide how many batteries you'll want to keep in your camera bag.

Practice with a Tripod

Take some time to get familiar with your tripod. Adjust the tension knobs on your camera and practice smoothly repositioning the camera to frame new shots.

Share your results with the book's Vimeo group!
Join the group here: vimeo.com/groups/DSLRVideoFSTGS

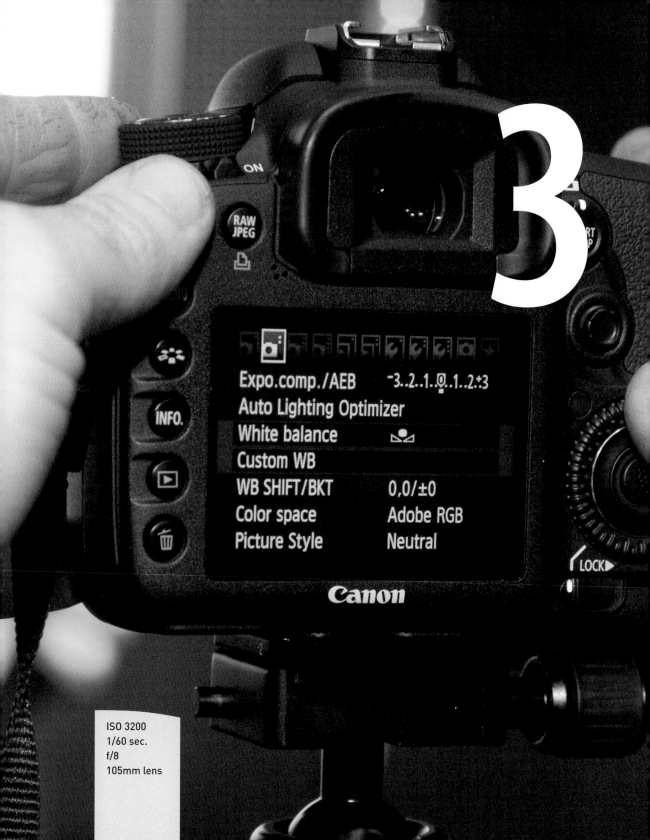

3

Expo.comp./AEB ⁻3..2..1..0..1..2.⁺3
Auto Lighting Optimizer
White balance
Custom WB
WB SHIFT/BKT 0,0/±0
Color space Adobe RGB
Picture Style Neutral

Canon

ISO 3200
1/60 sec.
f/8
105mm lens

Setting Up
Your Camera

A DSLR camera is more like a personal computer than you might think. It's capable of calculating adjustments based on the available light and action in the scene; it can adjust and control how the camera's lens performs. In fact, most DSLRs have several features that allow you to take complete control of your camera.

Of course, those features require you to work through a menu system that makes setting up your TV set look easy. You'll find a complex menu system coupled with a series of dials and buttons. Oh, and every camera model is different (even two from the same manufacturer).

Oh good, you're still reading. Although configuring your camera's features sounds complex, there are only a few key settings you need to worry about. In this chapter you'll learn about every critical option. You may need to hunt or peck (or actually break out your camera's user manual). But I'll do my best to streamline what you need to look for.

Photo by Lisa Robinson.

PORING OVER THE CAMERA

Properly configuring a camera for shooting video requires adjusting several options within the camera. These include adjusting the shutter speed for natural-looking motion as well as the aperture and the ISO to achieve a proper exposure. This level of control can typically only be attained when shooting in Manual mode.

The shutter speed is set to 50, which produces smooth motion when paired with a 24 frames per second shooting rate.

The aperture is set to f/4.5, which is a standard speed on many zoom lenses.

An ISO setting of 250 works well under most outdoor lighting situations.

CHOOSING A FRAME SIZE

The first choice you need to make when setting up your camera is which frame size to shoot. Frame size is simply a description of how big the recorded image is. Unlike still photography where sizes and settings can vary quite a bit, usually there are only two high-definition (HD) video standards you can choose (**Figure 3.1**).

The two HD standards you'll encounter are:

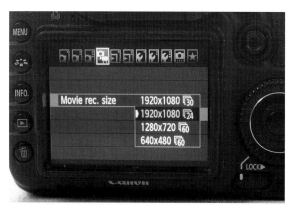

FIGURE 3.1

This chart illustrates the size differences between the two HD video sizes as well as standard definition video.

- **1920x1080.** You should strongly consider shooting using this larger HD standard (often called 1080p or Full HD). It will give you the best possible resolution that HD video supports. This frame size is the most popular for HD and matches the resolution of most HD televisions.

- **1280x720.** Cameras that record with a resolution of 1280x720 (often called 720p) are also perfectly capable of recording beautiful images. Although this is not the highest resolution, it is still considered high definition. Many first-generation DSLR video cameras only support this resolution.

STAY BIG

Although DSLR cameras often offer standard definition video (sizes like 640x480), I recommend avoiding the lower quality formats.

When you look at your camera's menu (**Figure 3.2**), you may find that your camera only offers one of these two frame sizes. Fortunately, both are acceptable for modern HD video production. The reason the video industry adheres to standards is to ensure that images recorded on cameras will be able to be edited and played back in a consistent manner.

Be sure that you look at the options supported by your editing system. Additionally, note that shooting and editing 1080p will place heavier demands on your computer, storage, and camera. If you're only producing video for the Web or for sharing at home, it's best to choose 720p due to the smaller frame sizes and better performance on older computers.

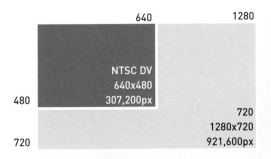

FIGURE 3.2

The Canon 7D can shoot two sizes of high-definition video and one standard-definition size.

Chart illustrating the relative frame dimensions of different video formats, showing the total number of pixels for each.

UNDERSTANDING ASPECT RATIO

When discussing video, you may hear the term aspect ratio, which refers to the relationship between the width of an image and its height. For video, you'll often see aspect ratio specified in one of two ways: using whole numbers like 16 x 9 or in a decimal ratio such as 1.78:1.

Natively, your DSLR camera probably shoots video using a 3 x 2 (1.5:1) aspect ratio. This ratio does not match the standards set for HD video. You'll notice when recording video that the Live View or display on the back of a DSLR camera will show a letter-boxed or ghosted area (**Figure 3.3**).

FIGURE 3.3

The gray bars indicate parts of the shot that are not written to the video file. This is due to differences in aspect ratio between the camera's sensor and a television screen.

This masked area is not part of your recorded shot. Be sure to pay attention when composing your shots. Unlike photography, it is not possible to crop a video shot after shooting without a significant loss in visual quality.

FIGURE 3.4
One second of video is actually 30 still images recorded in rapid succession (when recording at 30 fps).

CHOOSING A FRAME RATE

When you record a video file, you are essentially creating a container to hold multiple still images, or frames, that are captured in rapid succession (at a constant interval). The rate at which you capture these still images is called the *frame rate*.

Video works because of a concept called *persistence of vision*, which identifies how the human brain can connect a rapidly shown series of still images to perceive motion (**Figure 3.4**). The human eye starts to see smooth motion at about 8 frames per second. However, motion really starts to smooth out at rates of 24 frames per second and higher. For video on a DSLR, your camera will typically support multiple frame rates (**Figure 3.5**). When describing video, this frame rate is measured in seconds (and may contain a decimal value):

- **60 fps (59.94 fps).** Standard frame rate for 720p HD used in the United States and other NTSC (National Television System Committee) based countries. NTSC is a set of video standards used in the United States and a few other countries.

- **50 fps.** Standard frame rate for 720p HD used in Europe and other PAL (Phase Alternating Line) based countries. PAL is a set of standards for video used in Europe and other parts of the world.

- **30 fps (really 29.97 fps).** The most common frame rate for broadcast in the United States and other NTSC based countries

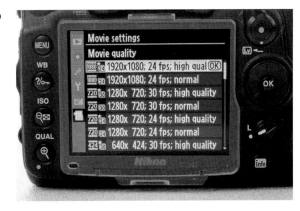

FIGURE 3.5
The Nikon D7000 supports several frame rates to choose from.

- **25 fps.** The common video frame rate used in Europe and additional markets around the world that are based on the PAL standard.

- **24 fps (can also be 23.98 fps).** A rate that closely matches that of motion-picture film.

DON'T SEE A FRAME RATE?

If you can't find a desired frame rate, you might have to tweak the camera settings. Some cameras allow you to switch between NTSC and PAL modes. This can affect the available frame rates and sometimes even frame sizes.

It is important that you minimize mixing frame rates in a video editing project because it can lead to extra rendering time and jerky footage. Choosing a frame rate is often dictated by what you intend to do with the footage:

- If you want a motion-picture film look, 24 fps is very popular. This rate works well for Web, DVD, and Blu-ray distribution.

- If you are shooting footage that's destined for traditional broadcasting, 25 fps for PAL or 30 (29.97) fps for NTSC is a common choice.

- If you want to achieve slow-motion effects, overcranking is the way to go. With overcranking, the camera records at a higher frame rate, and you can stretch the clip in postproduction to make smoother slow-motion effects.

WHY DOES VIDEO LOOK DIFFERENT THAN A PHOTO?

When you look at the video your camera records, it may not look as clear or rich as the photos you've taken with the same camera. The reason for this quality loss is due to a few factors (**Figure 3.6**).

First, the total resolution of a video file is much lower than a still photo. This means that the more you enlarge the image, the lower its visual quality. Video files are about 2 megapixels in size—well below the quality taken by a still camera (and even a cell phone).

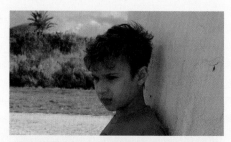

Second, the video recorded by the camera has a great deal of video compression. This is used to lower the data rate and therefore the size of a file. The goal is to make the file size small while maintaining acceptable visual and auditory quality. Without compression, most video cameras wouldn't be able to record video formats. Because the video is written to memory cards, it must be made smaller than the original file.

If you think about the file size difference between a raw photo and a JPEG file, compression starts to make sense. A raw file can easily be ten times larger than a JPEG file for each photo. If you then multiply that larger size by 24–30 frames per second, it becomes very evident why compression is used.

Third, the amount of information used to represent color is much less in a video file. Most raw photos are captured with 16-bits per channel color. Video, on the other hand, is recorded in only 8-bits per channel. Additionally, most of the color data is discarded when the video file is compressed.

FIGURE 3.6
The top image was shot as a photo. The center image is an uncorrected video file, and the bottom image is a color corrected video clip. The still photo looks better because it was shot in a format that captured much more image data and color information. It was also shot using a slower shutter speed to let in more light.

WHITE BALANCING YOUR CAMERA

One of the most important settings on your camera that you need to choose is a white balance. This control allows you to set the overall color (or tone) for the scene. White is used as a reference point because it is the perfect blend of all the color channels. When a camera is properly set up, a white object will appear neutral with no color cast. Ideally, you should set your white balance correctly before shooting in a location, but you have some flexibility to fix your footage afterward in your editing application.

USING AUTO WHITE BALANCE

By default, your camera is probably set to use an automatic white balance (some-times called AWB). The way that auto works is that the camera will analyze the frame and create an automatic setting that attempts to neutralize any color shift. This set-ting works pretty well for indoor shooting where lighting is consistent.

With that said, I am not a big fan of auto white balance. When shooting using this setting, your camera can be sensitive to other factors, such as a passing cloud or someone walking through the frame. Instead, it is a better idea to switch to a preset or even create your own.

USING A WHITE BALANCE PRESET

The presets on your camera will vary depending on the model and manufacturer. However, they are usually easy to understand when you think about them (**Figure 3.7**). Typically, the presets are named for the type of lighting they work best with (**Figure 3.8**):

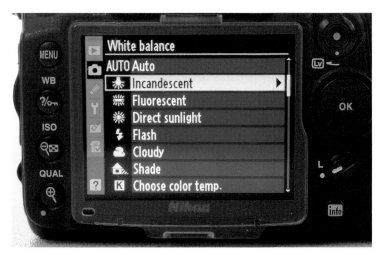

FIGURE 3.7
The list of white balance presets are named for the lighting conditions they're designed for.

- **Daylight or Direct Sunlight.** This option works best for general shooting under daylight conditions where the sun is readily visible.

- **Shade.** This option is used when shooting in sunlight and your subjects are in the shade. It tends to make the image more orange to compensate for the bluish tones of the shaded areas.

- **Cloudy.** This setting is similar to daylight but compensates for the sky having some cloud cover (which cools down the color temperature). Many prefer this setting because it is a little warmer.

- **Tungsten or Incandescent.** This white balance setting is designed for shooting indoors with standard lightbulb illumination.

- **Fluorescent.** This setting works best when shooting under standard fluorescent tube lights. However, some lights are daylight balanced, which would require you to switch to the daylight setting.

- **Flash.** You won't use this option when shooting video because you can't use a flash.

Manual White Balance

Cloudy

Fluorescent

FIGURE 3.8
The same scene shot with different white balance settings produces very different results.

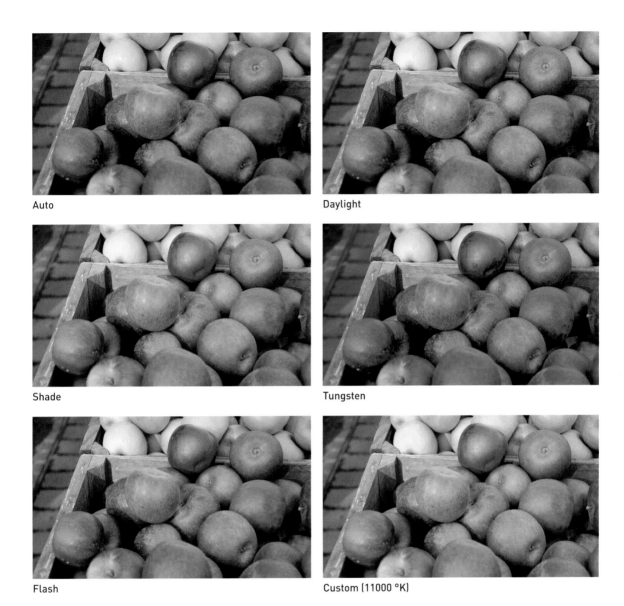

Auto

Daylight

Shade

Tungsten

Flash

Custom (11000 °K)

MANUALLY SETTING WHITE BALANCE

Sometimes, you'll want to manually set the white balance on your camera. For example, you might want to compensate for when multiple lighting sources are mixed together. You may also want to make a change to make a shot warmer or cooler for artistic purposes.

Table 3.1 lists the typical color temperature for different kinds of light. These temperatures can be used to adjust white balance in the camera.

TABLE 3.1 Color Temperatures for Light Sources

TEMPERATURE	SOURCE
1,700K	Match flame
1,850K	Candle flame
2,700–3,300K	Incandescent lightbulb
3,400K	Studio lamps
4,100K	Moonlight
5,000K	Horizon daylight
5,500–6,000K	Typical daylight, electronic flash
6,500K	Daylight, overcast

USING A REFERENCE IMAGE TO SET WHITE BALANCE

If memorizing a bunch of temperatures is too difficult and you aren't happy with a built-in preset, it's time to make your own preset. This is typically useful when shooting in a location that has mixed lighting (such as sunlight through a window combined with bulbs from inside).

The exact process will vary from camera to camera, but typically the process involves doing the following.

1. Shoot a reference photo with something white in it. The white should fill most of the frame. The subject can be a sheet of paper or a more accurate calibration target.

2. Choose the custom white balance option in your camera's menu.

3. Select the reference image so the camera can calibrate itself (**Figure 3.9**).

4. Visually inspect the preset's result and ensure that skin tones and key details in the shot look natural.

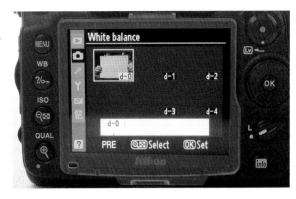

FIGURE 3.9
Using a reference image lets you accurately set the white balance. In this case, a piece of white paper is used to help the camera properly measure color.

CHOOSING A SHOOTING MODE

Your DSLR offers several different shooting modes (**Figure 3.10**) to assist you in getting the right image. When shooting stills, I'm a big fan of Aperture Priority mode, which offers a great balance of control and lets me set the depth of field manually. Other shooting conditions may call for Program or Shutter Priority mode to properly expose the scene.

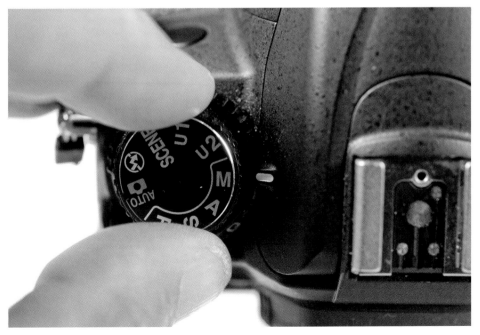

FIGURE 3.10
Choosing the right shooting mode is essential for getting proper exposure and the correct shutter speed.

Unfortunately, these modes don't work when shooting video. You'll need to switch your camera to Manual mode if you want the best results. This means you'll have to tackle all of the decisions about how to set up your camera. Don't worry; you'll learn these settings throughout the next several chapters.

Why do you have to do all the work? Well, let's examine the decisions you'll need to make. Your shutter speed options are very limited when shooting video (typically between 1/50 and 1/100 of a second). Otherwise, the video will have stuttering or blurring motion.

Setting the aperture, on the other hand, is one setting you'll want to take precise control over. Aperture has a huge impact on exposure and focus; as such, you'll need to choose a setting that is visually pleasing and one that gives you adequate control (more details about aperture are in next chapter).

So, welcome to Manual mode. It takes a little getting used to, but it will make you a better photographer. After a few bumps along the way, you'll get the hang of it and be less dependent on your camera and more on your eyes and brain.

ADJUSTING THE VOLUME

It's important that your camera be set to the correct audio levels when recording. If the levels are too low, you'll hear lots of background noise when you boost the audio during editing. If the levels are too high (loud), you'll hear popping or clicking. It turns out that when recording digital audio, you have less flexibility than older analog methods (like when recording to tape). Because the audio is basically a binary one or zero, it only has two possible values. Once you cross the 0 dBFS threshold on your volume meter, you will experience distortion or clipping.

The volume controls offered in cameras vary greatly from manufacturer to manufacturer. The most limited only allow for the audio to be on or off, which is undesirable because the camera will try to just run in Auto mode (called Automatic, Automatic Gain Control, or ACG) (**Figure 3.11**).

FIGURE 3.11
If your camera offers another choice besides Auto, always use it. I typically find that the Medium or Standard option works best.

Auto mode tends to lead to a lot of variance in the audio recording and whooshing of background noise due to sudden rises in between dialogue or in between primary audio. It is also problematic because the camera tries to make all sounds the same volume. As a result, you lose perspective as to how close an object is to the camera (which often serves as a point of view for those watching).

The solution is to adjust the recoding levels based on your scene. If your camera offers volume controls, use them. For many DSLR cameras, this may only be a Low, Medium, or High setting. However, many camera manufacturers are beginning to address user feedback and have been improving the audio controls in newly released cameras. Be sure to read Chapter 9, "Recording Sound," for more on working with microphones and controlling your audio recording (**Figure 3.12**).

USING PICTURE STYLES OR CONTROLS

Many DSLR cameras offer controls that influence how the camera processes the image. These controls let you perform tasks like boosting contrast or adding more saturation to the image. At first glance, the use of Picture Styles, or Controls, can be very appealing.

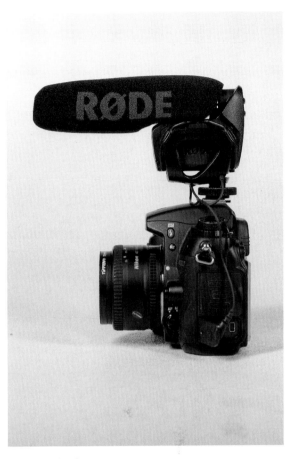

FIGURE 3.12
The use of external microphones and other audio devices is covered in Chapter 9.

WHY USE PICTURE STYLES OR CONTROLS?

The use of Picture Styles, or Controls, is a great way to make your footage look good right in the camera, especially if you're concerned about being able to post the video online with less color correction or editing. Essentially, you can obtain a better sense of "what you see is what you get."

Pictures Styles offer a number of presets that help improve your video. Some allow you to enhance the contrast in your scene (**Figure 3.13**). Others can be used to create a black-and-white image; you can also use them to boost colors. These presets are best learned through experimentation because there is a tremendous amount of variation between manufacturers.

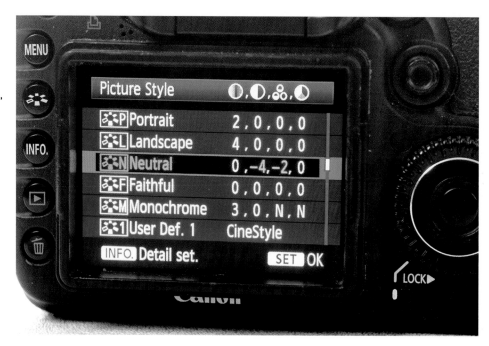

Typically, your camera will ship with a small collection of Picture Styles built in. **Table 3.2** lists the standard options from Canon and Nikon.

Typically, many more options are available from your camera manufacturer's website. They can be loaded onto a camera memory card and then accessed via your camera's menu system. Even a few third-party styles exist, such as the Technicolor CineStyle (http://bit.ly/technicolorcinestyle), which can be used on Canon EOS cameras.

Some manufacturers even provide end users with a utility to create their own styles. For example, Canon offers a free download of its Picture Styles Editor (www.canon. co.jp/imaging/picturestyle/editor/index.html). Nikon also offers a similar workflow with its View NX software.

TABLE 3.2 Picture Styles for Canon and Nikon Cameras

NIKON	CANON	EFFECT
Standard	Standard	The default setting provides sharp contrast and works well because it does not seek to emphasize any particular details over others.
Neutral	Neutral	Attempts to produce colors that most closely match the original scene. This is the correct preset to use when you plan on using the color grading tools in your editing software.
Vivid	Faithful	Attempts to create colors that are faithful to the original, yet well saturated. It works well for photos shot in outdoor lighting.
Portrait	Portrait	Works best for skin tones. It attempts to keep a wider range of color in the skin to show its translucency and depth.
Landscape	Landscape	Has a greater impact on hues ranging from blue to green. It also tends to boost colors beyond what they actually looked like in the scene.

WHY NOT USE PICTURE STYLES OR CONTROLS?

Although these presets seem pretty appealing at first glance, the problem is that their use limits future flexibility. For example, if you shot with a monochromatic style that stripped out all color, that color is gone. Making a black-and-white image in your nonlinear editing software takes only seconds, so why not do it there instead, especially because you can change your mind?

Even if you just use certain options like Standard or Vivid, you can record an image with too much color or contrast. And the last thing you want to do is compress the histogram of image data too much. Although a punchy image with rich blacks and bright whites looks attractive, it can lose details in the shadows or highlights (Figure 3.14).

It is better to shoot a flatter image that is more evenly exposed. Styles like Flat or Neutral tend to work well because they capture the most information about the image.

FIGURE 3.14
The image with
styles looks more
dramatic (top), but
less information
is captured by the
sensor. It is gener-
ally better to shoot
flat or neutral (cen-
ter). You can then
easily adjust the
shot with color and
exposure correction
in your nonlinear
editing application
(bottom). In this
case, a Curves and
Saturation adjust-
ment were added.

Chapter 3 Assignments

Now that you know the essential settings that matter, it's time for you to set up your camera correctly. Take the time to check your settings, and you'll have a better shooting experience.

Choose Your Frame Size and Rate

Decide on the frame size and rate that works best for you. Try shooting a few clips with each setting for test purposes. Bring that footage into your editing application and see if your computer can properly handle all frame rates and sizes.

White Balance Manually

Explore how to manually set the white balance on your camera. Have your subject hold up a white piece of paper, and then use that as a reference to set the white balance. You may need to look up the specific steps on how to do this for your camera model (see "White Balancing Your Camera" for an overview of the process). Shoot footage with this custom setting. Then switch to a few of your camera's presets and compare the shots.

Test Your Styles

Become familiar with the built-in shooting styles or profiles offered by your camera. Try shooting a few scenes using different styles. Also, be sure to use a flat or neutral style or profile. Save this footage to use when you read Chapter 11 "Editing Essentials," so you can analyze it using your editing software tools.

Share your results with the book's Vimeo group!
Join the group here: vimeo.com/groups/DSLRVideoFSTGS

Exposure
and Focus

When you start to get serious about shooting great-looking video on your DSLR, you'll likely begin to disable several of the automatic features on your camera. Additionally, you'll likely be attracted to the more artistic capabilities, like a wider range of contrast and shallow depth of field. Of course, these artistic options can quickly become frustrating limitations without a solid foundation of knowledge combined with a good deal of practice.

PORING OVER THE FOOTAGE

While shooting in the desert outside Albuquerque, New Mexico, I decided to capture the sunrise. Although the mountain range provided some interesting shots, I was drawn to the local vegetation. The light levels were a little low because I was shooting at dawn. So, instead of worrying about contrast levels in the camera, I shot "flat." Making sure the image was in focus and exposed for the middle of the histogram, I was able to capture highlights *and* shadows. In postproduction, by using a Curves adjustment (see Chapter 11, "Editing Essentials"), boosting the contrast was easy and added a more dramatic *punch* to the image.

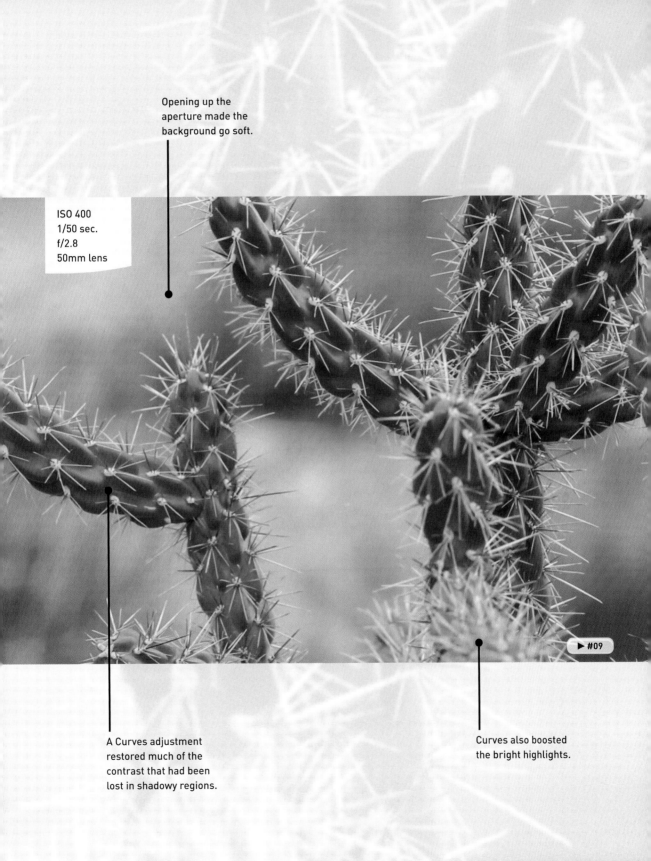

Opening up the
aperture made the
background go soft.

ISO 400
1/50 sec.
f/2.8
50mm lens

▶ #09

A Curves adjustment
restored much of the
contrast that had been
lost in shadowy regions.

Curves also boosted
the bright highlights.

PORING OVER THE FOOTAGE

Shooting against a bright sky is always tough, especially with video. Unlike with a raw photo, it's difficult to recover the highlights and lift the shadows. For this shot, I composed the shot so the sun was not in the frame. I then carefully metered the shot (by looking at my histogram on camera). I exposed so the tree and the sky were not over- or underexposed. This allowed me to darken the sky and lighten the tree in my editing application for a better end shot.

Image before color correction.

ISO 100
1/60 sec.
f/11
28mm lens

A Vibrance adjustment brought out the colors in the image.

▶ #10

A slight lift to the shadow areas with a Curves adjustment.

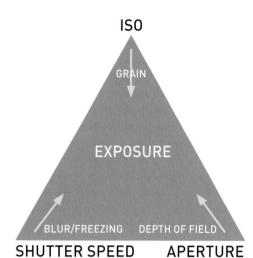

ISO

GRAIN

EXPOSURE

BLUR/FREEZING DEPTH OF FIELD

SHUTTER SPEED APERTURE

FIGURE 4.1
By combining the three primary elements of photography—ISO, aperture, and shutter speed—you can achieve proper exposure.

THE EXPOSURE TRIANGLE

An essential concept in photography is the exposure triangle (**Figure 4.1**). Three settings in your camera affect how your camera exposes an image: ISO, aperture, and shutter speed.

If you're used to shooting in Automatic mode, you may have never adjusted these properties. However, if you've used Aperture or Shutter Priority mode, you've started to dabble with manual control.

When shooting video, you'll likely need to shoot entirely in Manual mode and take precise control over all three properties to get the exposure you need. Even if you think you've mastered exposure for your DSLR when shooting stills, keep reading. Getting the correct exposure for video is more complicated because of video's limitations.

SHUTTER SPEED

The first property you'll set is the side of the triangle with the least flexibility. The shutter speed controls how long your camera stays open when you take a photo. It has a similar function in video because it greatly impacts how much light comes through. The shutter speed also controls the amount of motion blur in an image (**Figure 4.2**).

To simulate a filmic image, you need to use the optimum shutter angle to accompany the 24p frame rate in a DSLR. You can use this simple formula:

one second ÷ (frame rate x 2)

▶ #11

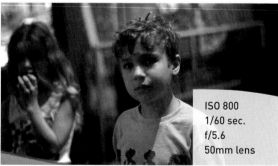

ISO 800
1/60 sec.
f/5.6
50mm lens

FIGURE 4.2
The camera was locked down on a tripod and properly exposed for this shot. When my son is moving quickly, the shutter speed emphasizes the motion blur; when he's moving slowly or holding still, he's much more in focus.

For example, when shooting 24 fps, you would set your light meter to a 1/48 second exposure time (you may only have 1/50 as a choice). At 30 fps, you would use 1/60 of a second. Following this guideline will help ensure that the motion blur created by the camera looks natural.

Can this rule be broken? Of course. There are two instances in which you will break this rule:

- If you want to take on a more stylized approach to your video, you can change the shutter speed. A long shutter speed creates more motion blur and streaking. A shorter speed creates more of a hyperaction look with staccato movements.

- If all else fails and you can't get the exposure you need, you can change the shutter speed to let more (or even less) light into the camera. However, this change should only be made after you've exhausted the available aperture and ISO options.

APERTURE

An easy way to think of aperture is as a window. The bigger the window, the more light you let into your camera (**Figure 4.3**). Easy enough, right? Of course, a lower number for the f-stop means a bigger opening (which can seem backwards at first).

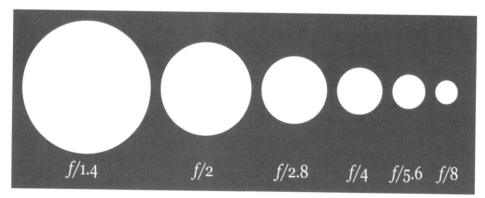

FIGURE 4.3
The lower the f-stop, the wider the aperture. A wider opening lets more light into your camera. Image from Wikimedia Commons. Image by Cbuckley and Dicklyon.

The advantage of having a lower f-stop means that you have more control over how much light gets into the camera. This sounds easy; just use the lowest number, right? Well, it's not that simple. Here are a few details to consider:

- The more you open the aperture, the shallower the depth of field. When shooting with an f/1.4 lens, you can literally have a person's nose in focus while the ears are out of focus.

- A lens with a lower f-stop is often more expensive. Most kit lenses have f-stops that range from f/4 to f/6. On the other hand, professional zooms can get as fast as f/2.8 and professional prime lenses (fixed focal length) can get even faster.

- Cheaper zoom lenses change their f-stop as you move through the zoom. This can lead to an exposure change in the middle of a video shot if you attempt to use the zoom options.

Typically, I'll use aperture as my first control for exposure. After I've locked in my ISO, I then adjust my aperture to achieve a proper exposure. Often, aperture can be used to control the depth of field in an image (how soon the image starts to go out of focus). For many, this shallow depth of field is a desirable aspect to shooting on a DSLR.

BUY AT LEAST ONE PRIME LENS

When you bought your DSLR, it probably came with a zoom lens that easily lets you get a wide range of coverage with just a quick twist of the wrist. So, why on earth would you go back in time and pick up a prime lens that only offers a single focal length?

It's all about aperture.

Most prime lenses (**Figure 4.4**) offer apertures that open as far f/1.2 to f/2. These wide openings let in a lot more light, which is truly useful when shooting in existing light or low-light environments.

Prime lenses are universally faster than zoom lenses and typically are much cheaper as well. This is due to the way the lenses are manufactured. Prime lenses have fewer moving parts and elements than zoom lenses.

Having a prime lens or two in your kit will really come in handy in the following situations:

- When you need to shoot in very low-light conditions

- When you want to shoot with a shallow depth of field to blur your background or give the video a more filmic look

FIGURE 4.4

The AF Nikkor 50mm f/1.8D lens from Nikon is an affordable prime lens for Nikon cameras. It also offers manual aperture and focus rings, which provide flexible controls while recording video.

ISO

Your camera has an ISO setting that controls how sensitive its sensor is to light. The lower the number, the less sensitive the sensor is. For most cameras, an ISO setting of 100 is considered the base setting. This ISO works well when shooting under bright lights or sunny days.

As lighting conditions change, you can bump up the ISO setting to 200 or 400 to deal with mixed lighting or overcast days. Higher ISO settings, like 800, 1250, and even 1600, can be used for nighttime and low-light shooting. Many newer DSLR cameras offer even higher ISO settings.

However, it's important to remember that cranking up the ISO is literally like turning up the volume. As the signal is amplified, the amount of visible noise increases (**Figure 4.5**). For still workflows, this noise can often be cleaned up with filters. For video, you're out of luck. Too much noise will result in a grainy image with dancing pixels. Be sure to test your camera and determine how high of an ISO setting you're comfortable using.

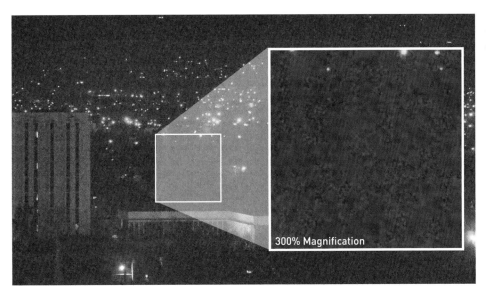

300% Magnification

FIGURE 4.5
The noise becomes very visible in this low-light image. In this case, an ISO of 6400 was used; however, it produces an unusable image. Be careful not to boost your ISO too high when shooting in low light, or visible noise will ruin the shot.

A STAIR STEP PROBLEM

I've found that many cameras have ISO settings that often stair step each other. This means that the noisiness of the image can vary greatly between settings. If a particular ISO looks too noisy, try dialing down one (or even up one). Certain ISO settings on your camera will perform better than others; the only way to know is to test your camera. You can really only see the noise on a larger screen like your computer or a television.

CONTROLLING DEPTH OF FIELD

If you've watched feature films, commercials, or music videos closely, you'll notice that focus is often used creatively to control the viewers' attention. Sometimes the camera will start out of focus and then slowly roll into clarity to reveal a subject. Other times the camera might rack in-between a person in the foreground to then find a person farther in the background.

A driving force in the popularity of DSLR cameras for video is the image sensor superiority these cameras offer. The large sensors allow for greater control in depth of field. When used properly, your footage can take on more cinematic qualities.

WHAT IS BOKEH?

You've likely noticed that the way your camera blurs objects is different than how your eyes behave. In fact, there's actually a Japanese word for this stylized blurring. It's called bokeh (pronounced *boh-kay* or *boh-kuh*).

What's the big deal? Well, many find the use of blur appealing. It can also be quite useful when you want to keep the focus on your subject and let the background go soft. The blurring often appears most in the brightest areas of an image (such as headlights or small lights in a skyline). However, bokeh can be used to simplify just about any background.

There are two ways to easily create bokeh in an image:

- Using a prime lens or a very fast zoom lens, you can open up the lens wide. Using a low f-stop (typically f/2.8 or lower) can really bring out a bokeh blur (**Figure 4.6**).

- Using a longer (telephoto) lens, you can compress the action of your shot. Instead of being close to your subject, move farther back and zoom in. This can create isolation due to a shallow depth of field (**Figure 4.7**).

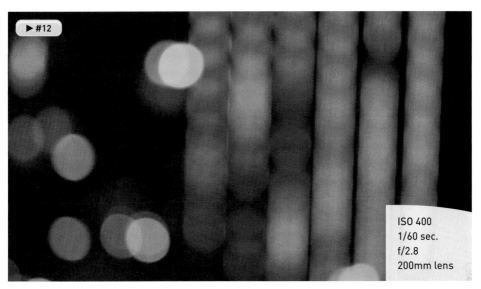

FIGURE 4.6
A theater marquee in San Jose, California, combined with passing traffic turns into an abstract shot when the camera is thrown far out of focus.

ISO 400
1/60 sec.
f/2.8
200mm lens

▶ #12

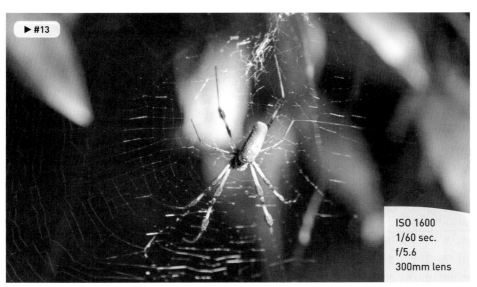

FIGURE 4.7
While hiking through a forest on Grand Bahamas I came across an intricate spider web. The scene was very low light, and my zoom lens was not very fast. By zooming all the way in from a greater distance, I threw the background out of focus and simplify it, which really helped the strands of the web to stand out.

ISO 1600
1/60 sec.
f/5.6
300mm lens

▶ #13

THE IMPACT OF LIGHT AND MOTION ON FOCUS

The greatest challenge you'll face when shooting DSLR video is focus. Even top pros find focus tough when dealing with moving subjects (**Figure 4.8**) or a moving camera. In fact, on a professional movie set, there's often a focus-puller who is dedicated to helping with this complex task.

FIGURE 4.8
While shooting on an overcast day, the effect of motion on focus is easy to see. Faster moving subjects like the biker are the most out of focus, whereas stationary objects are clearer. For this image, the camera was also handheld, so the inherent image shake further softened the shot.

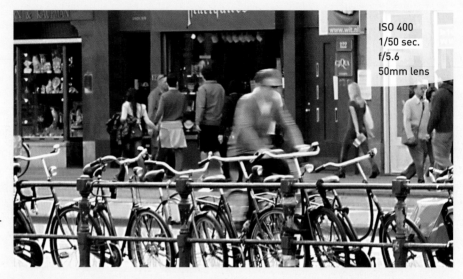

ISO 400
1/50 sec.
f/5.6
50mm lens

You'll need to learn how to balance exposure and movement while trying to maintain focus. If you're shooting subjects in motion, you'll need to pay close attention to how much light you have for the shot. The best option is to always try to have enough light available.

The less available light, the wider an aperture you'll need. The more you open the f-stop to let in light, the shallower the depth of field. This makes it more difficult to keep your subject in focus and can lead to subjects falling out of focus as they move (or the camera moves). We'll explore particular approaches to common problems in Chapters 6, 7, and 8.

FOREGROUND AND BACKGROUND

If you want to properly use bokeh or a shallow depth of field, you need to think about your foreground and background, and how you compose your shots. I'll explore composition in Chapter 5, "Composing Shots." For now, here are a few simple techniques you can try:

- When setting up an interview, portrait, or talking head, don't position the subject against a wall. Instead, look for a more open space. Try shooting in a long hallway, a conference room, or even just through a doorway. Stacking the scene works well to create depth (**Figure 4.9**).

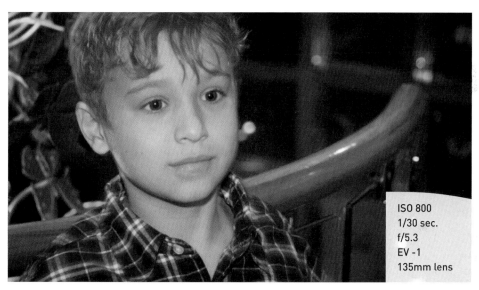

ISO 800
1/30 sec.
f/5.3
EV -1
135mm lens

FIGURE 4.9
Positioning my subject at the top of a staircase allowed me to compose the shot so there were areas in the background that stretched off into the distance (and became defocused).

- If you're shooting a large crowd or busy event, tweak the aperture settings on your camera. Open the aperture a bit and set your focus so the front of the group is in focus and the back starts out soft. As people move through the scene, they'll reveal themselves (**Figure 4.10**).

- If you're recording two people talking to each other, increase the distance between them. Then try using a zoom lens and adjust your zoom level to taste. This lens will make the two people appear close to each other but set one of the two more out of focus than the other.

FIGURE 4.10

By zooming in from a greater distance, as well as shooting at an angle, I created a well-defined focus plane for this shot. People farther away are out of focus but reveal themselves as they move towards the camera.

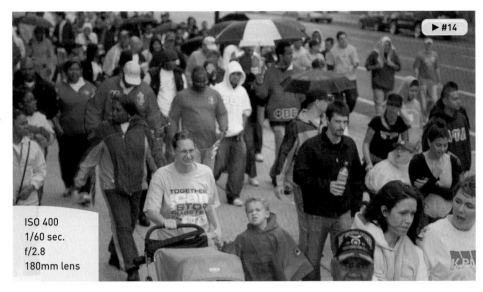

▶ #14

ISO 400
1/60 sec.
f/2.8
180mm lens

RACK FOCUSING

As you become more experienced, you'll want to try *rack focusing* (changing your focus from one object to another while recording). For example, you might want to go from a focused image to a blurry one as an animated transition. Or you might want to keep a moving subject in focus as the subject walks through a shot. Just keep in mind that rack focusing is not easy to do.

Modern lenses are actually more difficult to rack focus because lenses manufactured today are designed to autofocus more quickly. To do this, manufacturers set the lens so the focus ring only needs a small turn to move through all the focus positions. This feature is great for shooting stills because it's much faster to shoot when the camera is in control. But it makes it more difficult for video.

For this reason, I seek out older lenses for my video kit. Stopping into just about any local camera store, you'll find a used department with older prime lenses. Many of these lenses have focus rings that turn almost a full 360 degrees, which makes focusing by hand much easier because the ring is not as sensitive. If you can't find an older lens that matches your camera (often a problem for Canon shooters due to changes in the lens mount system), you can purchase an adapter ring. If your lens has physical rings to control both aperture and focus, you can use an adapter from companies like Fotodiox or Novoflex (**Figure 4.11**).

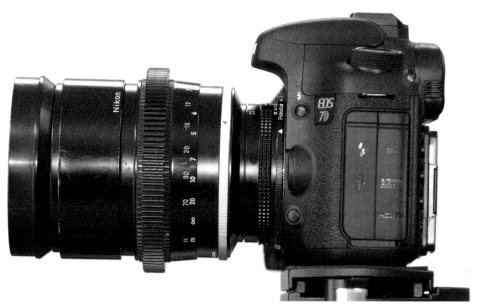

FIGURE 4.11
An older Nikon prime lens is attached to a newer Canon 7D using an adapter ring from Fotodiox. Lenses need manual aperture and focus rings to work properly with the adapters.

SETTING FOCUS

Knowing that you appreciate the role of focus (as well as the challenges associated with it), it's time to get practical. Making sure your shot is in focus is a critical step. Ideally, you'll check focus before you record. Trying to adjust focus in the middle of a shot can leave portions of your footage unusable.

TAKE A PICTURE

One of the easiest ways to make sure your footage is in focus is to let the camera do it for you. Most lenses support the ability to autofocus while still being manually adjusted. Hold down the camera's shutter release halfway to engage the autofocus ability. Doing this before you turn on your LCD's LiveView feature is usually fastest, but you can typically still do this once the LCD is active.

When you have focus, you can start recording. Better yet, shoot a still photo first. The image will be a much higher resolution, which can come in handy if you need to make physical prints. Additionally, the photo will capture useful metadata about the camera and lens settings that the video will not. A photo provides information about exposure, f-stop, aperture, ISO, shutter speed, and more. This is a great way to learn from your mistakes as well as successes.

ZOOM, ZOOM, AND CHECK

If want to check focus, you need to take a few extra steps. Just turning on the LCD and glancing at it won't cut it. The small screen makes everything look more in focus because it can't show you all the pixels at once. The reduced image size creates the illusion of a sharper image.

If you want to really see what is in focus, you'll need to zoom, and then zoom some more. If you're using a zoom lens, zoom in as tight as possible on your subject. Zooming in on an area like the eyes works well; a button on a shirt works well too. You'll then need to digitally zoom.

Typically, you'll find a Zoom button (look for a magnifying glass with a plus symbol in it) on your camera. Pressing it will enlarge the image on your screen and only show you part of the image (**Figure 4.12**). You may need to use the command dial to navigate around the zoomed in pixels. Find the detail area that you want to focus on.

FIGURE 4.12
Zooming in on your LCD can help you check focus before you roll a video shot.

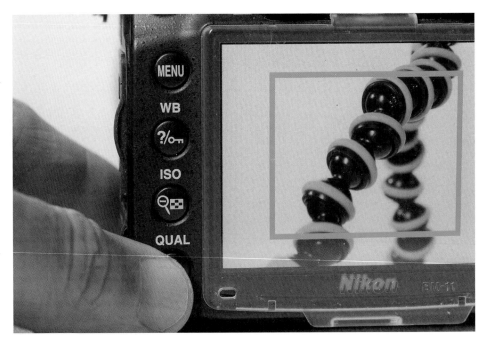

You can then use the focus ring on your camera to tweak the focus. Make minor turns to find the ideal focus. If needed, adjust the aperture and ISO settings of your camera to refine the depth of field. When you're satisfied, you can either press the Zoom Out button or just press the Record button to roll the camera.

MAINTAINING FOCUS

If you're shooting a stationary subject from a stationary camera, focus is pretty dang easy. But when one object starts to move, it gets a bit more difficult. If both the subject and camera are set in motion, you begin playing a game of chase that often leaves the shot slightly soft with rack focuses as you try to find the subject clearly.

THE MYTH OF AUTOFOCUS

If you read the marketing materials that accompany most DSLR cameras, they promise useful autofocus features. Just turn on the intelligent tracking in your camera and the camera will lock on a face, follow your subject, and keep the subject in focus. Sounds great, right? In theory, yes.

Unfortunately, these controls are pretty useless in practice. Relying on autofocus will result in the camera making continuous adjustments. Chances are it will latch onto the wrong subject. Pan or tilt the camera just a little and suddenly the camera may start searching for focus.

Film and video professionals do not use autofocus when shooting video. Sure, it's fine to engage autofocus to lock in a clear shot before rolling, but don't expect the camera to maintain focus for you. It just doesn't work; even the best systems make your video look amateurish and jarring.

PRACTICING FOCUS

So how do you get shots that are in focus? The same way that you get great composition—practice, practice, practice. With time, you'll get the hang of things. Turning your focus ring will get easier with time. You'll master the small adjustments needed to smoothly transition between focus points.

Of course, there's nothing wrong with practicing a tough shot either. A film or video pro will often rehearse a complex shot, having the subject stand on certain marks or move through a location slowly. Additionally, don't be afraid to repeat a shot a few times. Getting multiple "takes" improves your chances of getting the right footage and gives you choices when you sit down to edit.

CHANGE YOUR F-STOP

The more you open your aperture, the more light you allow into the camera. That's good news when shooting in low light except that the depth of field gets shallower. If you're having a hard time focusing, close down the aperture. Switching to f/8 is immensely easier to focus than f/1.4.

Of course, making a change in aperture will dramatically change your exposure. To compensate, you can make these changes (which are in order of preference):

- **Add more light** to the scene. Use video or available lights, change locations, open the blinds, and so on. All of these actions will give you more light to work with.

- **Change your ISO** to increase the sensitivity of your camera. Many modern DSLR cameras can shoot at ISO 1200 or even 1600 without introducing too much noise.

- **Lower your shutter speed** to allow more light to reach your camera sensor. If you don't have a lot of action in the scene, switching from 1/50 or 1/60 to 1/30 will dramatically increase the light without much impact on image quality.

USING A LOUPE

As a still photographer, you're probably used to squinting into the small viewfinder for hours on end. The proper use of a viewfinder lets you accurately compose a shot. Most viewfinders also offer useful overlays to judge exposure and provide other technical information about the shot you're about to take.

Unfortunately, when shooting video on your DSLR, the viewfinder stops working because the camera's mirror must stay up when capturing video. I discussed the importance of the camera's LCD in Chapter 2, "Essential Equipment." A good LCD can go a long way, but the addition of one critical piece of gear—a loupe—can dramatically improve your ability to judge focus *and* exposure.

Several manufacturers sell loupes that magnify the image on the back of the LCD panel. The loupes typically enlarge the image two to three times, making it much easier to see critical focus (**Figure 4.13**). A loupe helps you see just how much of your shot is (or is not) in focus. Some viewfinders attach using a series of bands, whereas some attach to a snap on the frame. Others attach to the bottom of your camera or to the hot shoe plate on top (where an external flash would go). Each manufacturer takes its own approach and offers several compelling reasons to explain why its loupe is the best.

FIGURE 4.13
Here I'm using a Zacuto Z-Finder to better judge exposure and focus when shooting. The bright sun at the beach caused a lot of light pollution, which made seeing the camera's LCD unassisted more difficult.

Here are a few additional benefits to using a loupe:

- A loupe can block out light pollution, making it easier to judge exposure and contrast.

- A loupe can make the camera more stable by creating an additional point of contact with your eye. This can lead to less camera shake, especially for handheld shooting.

- Some viewfinders even contain a diopter, which can help adjust for minor vision issues or when an eyeglass wearing shooter takes off his glasses.

A good loupe costs between $100 and $400. The addition of a loupe can be thought of as investing in a lens for the back of your camera. Here are a few recommended manufacturers:

- **Zacuto Z-Finder.** www.zacuto.com

- **Hoodman Cinema Kit Pro.** www.hoodmanusa.com

- **LCDVF.** www.kinotehnik.com

- **Cavision MHE3Q-P.** www.cavision.com

A SWIVEL LCD

Your DSLR may offer a swivel LCD, which can be very useful when you're not holding the camera at eye level. For example, you can angle it downward when holding the camera over your head to shoot a concert or an event. When shopping for a camera, make sure the LCD has proper contrast and color fidelity when you hold the camera at an irregular angle.

USING A VIEWFINDER OR MONITOR

To truly see how your video looks, you'll want to look at it in a 1:1 viewing environment. In other words, one pixel in the footage file equals one pixel on a screen. This is pretty easy to do when you edit after shooting but takes some extra steps to do while shooting.

WHY MONITOR EXTERNALLY?

Even film and video professionals use external monitors when on set or on location. Other crewmembers, like the director, art director, or makeup artist, also need to check fine details in how the subject and sets look. In fact, the director of photography will often walk over and double-check that the shot is meeting the technical requirements for focus and exposure. After all, the LCD and built-in viewfinders of even professional cameras can too easily hide flaws in the video signal.

Your camera likely includes an HDMI port that's capable of sending out a high-quality digital signal. You can connect this port to a computer display, television, professional monitor, or electronic viewfinder to see what you're shooting on a larger or higher-resolution screen. This makes it much easier to judge focus and exposure.

USING A MONITOR

Many computer monitors and television sets include an HDMI port. This makes it convenient to use an off-the-shelf computer display or television for a relatively low cost, and by using the HDMI connection, you can see your image on a screen that is much larger than the camera's LCD. Although the color and exposure of these screens are not 100 percent accurate, they do provide better guidance on how the shot will look.

Many pros and serious enthusiasts also invest in a dedicated field monitor designed for DSLR video workflows. These are often lightweight (made from materials like aluminum) and measure 6–10 inches. Companies like Marshall Electronics and SmallHD offer battery-operated monitors that are designed to attach to a camera's hot shoe for easy mounting and use in the field. These monitors vary greatly in price and often offer professional features to help with focus and exposure via onscreen overlays.

GET A LONG CABLE

Make sure you get a very long HDMI cable or an extension cable. You'll want to avoid putting the camera's HDMI port under tension. Also, long cables are easier to snake out of the way to prevent any accidentally tripping, which can send both a person and a camera flying.

USING A VIEWFINDER

Most professional video cameras include a high-quality electronic viewfinder (EVF) for checking image quality while recording. These devices offer screens similar in size to a camera's LCD but use much higher-quality screens with denser pixels. As with a high-resolution screen (like a "retina display") on a smart phone, these screens make it much easier to see fine details.

High-quality EVF screens can often be combined with a loupe to create a truly professional monitoring solution (**Figure 4.14**). With a true viewfinder, you can clearly see exposure and focus. EVF screens often include easy-to-access buttons that turn on overlays to assist with exposure, focus, and composition.

FIGURE 4.14
The Zacuto Electronic Viewfinder, combined with Zacuto's loupe, creates a complete monitoring solution.

Although EVF screens are not cheap (typically ranging from $400–$800), they make a big difference in the type of video you shoot. I find that investing in a loupe and an EVF is comparable in price to buying a new lens. Spending money on the back of the camera often has a bigger impact on the quality of images you acquire than buying another lens for the front of your camera.

Chapter 4 Assignments

Learning how to master exposure and focus is the subject of several chapters in this book. When recording video with your DSLR, you'll find that these two technical hurdles can be quite challenging. Take the time to practice these skills repeatedly because you'll always find challenges ahead.

Experiment with the Exposure Triangle

Try different combinations of ISO, aperture, and f-stop with your camera in Manual mode. Attempt to achieve a proper exposure while experimenting with the depth of field options your camera offers.

Record a Shot with Bokeh

Set your camera's aperture as wide open as possible. Then try racking focus until you can create bokeh. When you have the basics down, move on to blurring a background while leaving a foreground subject in focus.

Manually Set Focus

Using the camera's LCD panel, set your zoom lens to magnify your subject. Then, using the Magnify buttons, increase the magnification on the LCD panel. Using the focus ring, try to manually focus your camera.

Share your results with the book's Vimeo group!
Join the group here: vimeo.com/groups/DSLRVideoFSTGS

Composing Shots

The act of composition is the actual framing of the shot. How you compose the frame has a great impact on how a viewer perceives information. A tight shot can convey an emotional response, whereas a point-of-view shot can place the viewer into the action. You'll find that the art of cinema has several shot types to choose from and even its own language to help those involved in creating film and video.

An additional challenge to pay attention to is how shots lead into each other. Professional filmmakers rarely string a bunch of shots into a pretty montage. Rather, they plan out a sequence of different angles that helps tell the story.

Well-defined diagonal lines lead the plane into the hangar and guide the viewer's eyes to the primary subject. Photo by Alex Lindsay.

PORING OVER THE FOOTAGE

Changing the angle of the camera can really make a difference in a shot. This shot is from the Las Vegas strip. With all sorts of neon signage, I wanted to simplify the frame. Placing my camera at the base of the sign gave me a clear sky and let me fill more of the frame. I particularly liked the way the signs created strong lines that would intersect at a dramatic angle. An additional benefit of this angle is how the animated arrows on the signs pointed upward as they rippled on and off.

The neon arrows
animated upwards and
created a motivated
framing angle for
the shot.

► #15

ISO 800
1/60 sec.
f/2.8
50mm lens

Shooting from the
base of the sign
created drama and
allowed me to fill
more of the frame.

PORING OVER THE FOOTAGE

The use of strong angles can guide a viewer's eyes through a scene. This shot takes a simple environment and adds drama. The lines in the wood intersect with the edges of the receipt. The camera is off center as well as tilted to add additional perspective to the shot.

The bending of the image through the water adds an interesting twist to the shot.

ISO 800
1/50 sec.
f/2.2
50mm lens

▶ #16

Angling the camera and the receipt created a compelling sense of angles within the frame.

PORING OVER THE FOOTAGE

This shot is a much simpler scene at a farmer's market in Washington, D.C. Here I wanted to put the viewer into my shoes. I positioned the camera at eye level above the produce and tilted down. While shooting the scene, several shoppers' hands reached in from all sides to examine the produce.

Shooting downward created a point-of-view shot that placed the viewer at the farmer's market.

ISO 400
1/50 sec.
f/5
58mm lens

▶ #17

I positioned my camera at a slight angle to maintain diagonal lines for increased drama.

SHOT TYPES

With film and video productions, a series of multiple shots are often used for each scene—a process referred to as *getting coverage*. Combining multiple angles can tell the story best (by letting you show interesting details or emotions). Using multiple shots lets you control the pace of action through editing. The different angles can also be used to cover up mistakes or condense a long interview.

Through the years, these shots have developed a language of their own. Knowing the most common shot types and their associated terminology allows crew members to communicate easily with each other on set. It's essential that you frame a shot right when you shoot it because video is a low-resolution medium. Unlike with photography, you cannot crop video after the fact.

DON'T JUST ZOOM IN PLACE

It's important to move the camera from time to time when taking multiple shots. If you merely zoom from a wide shot to a tight shot (which is often called a jump cut), the resulting edit will feel abrupt. For the smoothest editing, be sure to physically move the camera when changing composition. Change your shot? Then you better shuffle your feet and move to a new location.

MASTER SHOT

The most common shot to shoot first is the master shot (**Figure 5.1**). This shot is wide enough to see the location and all subjects who are involved in a scene. If the piece is scripted, the entire scene is shot in one take from a locked position. Additional angles (especially close-ups) are then shot and intercut with the master shot during editing.

FIGURE 5.1
Seeing the entire location helps give the viewer a sense of the environment. Photos in this series by Doug Daulton, Alex Lindsay, and Richard Harrington.

FIGURE 5.2
The wide shot might be tighter than the master shot and is designed to show one or more subjects from head to toe.

WIDE SHOT (WS)

A wide shot (**Figure 5.2**) is useful to show the entire subject. With a person as the subject, this usually means seeing from the top of the person's head to the bottom of the person's feet.

FIGURE 5.3
Although still relatively loose, this composition is a little more intimate than a standard wide shot because it lets you better see body language and facial reactions.

MEDIUM WIDE SHOT (MWS)

A medium wide shot (**Figure 5.3**) is usually used with a standing subject. The lower frame generally cuts off the subject at the hips or just above the knees. This shot is very common and even works well for small groups of subjects.

FIGURE 5.4
For a medium shot, the subject and the location are given equal weight.

MEDIUM SHOT (MS)

A medium shot (**Figure 5.4**) typically frames the subject from the waist up. Usually, there is enough room in the shot to see hand gestures and arm movement. If multiple subjects are in the frame, the shot can be classified as a two-shot or three-shot medium shot.

MEDIUM CLOSE-UP (MCU)

With a medium close-up (**Figure 5.5**), the bottom of the frame passes through the midpoint of the chest. You can still see the setting, but the shot is more intimate. This shot is also called a *bust shot* because it matches the composition of classic bust sculptures from the art world.

FIGURE 5.5
A medium close-up is often used as framing for an on-camera interview.

CLOSE-UP (CU)

You'll use close-up shots (**Figure 5.6**) to capture facial expressions and other details. A close-up shot can also be used to show a subject's hands or interaction with an object in the scene. The goal is to isolate the subject and minimize (or even remove) the background.

FIGURE 5.6
Using a shallow depth of field setting makes this close-up shot even more effective.

SHOT ANGLES

You need to pay attention to not only to your composition when framing shots, but also the angle and height of the camera (**Figure 5.7**). By adjusting where the camera is positioned in relation to the subject, you can impact the viewer's perception of the subject.

FIGURE 5.7
To get more variety between shots, I zoomed and moved the camera to the right as well as changed the height and angle of my tripod.

EYE LEVEL

For most documentary, news, or other "factual" coverage, eye-level recording is standard (**Figure 5.8**). Because this is how most people see the world, it is the most comfortable angle for viewers to watch from.

FIGURE 5.8
My subject is lower than my eye level, so I adjusted the height of the camera to place the viewer at the same height as a child.

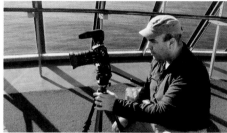

HIGH ANGLE OR OVERHEAD

If you place the camera above the subject, it looks down on the action (**Figure 5.9**). This often creates a sense that the audience is more powerful than the subject and can lead to a sense of detachment. However, it can be used effectively when creating point-of-view shots.

FIGURE 5.9
Looking down on the golf club, ball, and hole felt natural because it matches the memory and experience of the viewer.

LOW ANGLE

A low angle shot (**Figure 5.10**) places the camera below the subject, which can make the subject look more important or add drama to a scene.

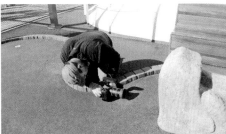

FIGURE 5.10
Placing the camera on the ground to get this shot added visual interest to the scene.

FIGURE 5.11
Canting the camera at a slight angle, I was able to better frame the subject, who was deeply focused (and bent over) a golf ball.

DUTCH ANGLE

Sometimes the camera is canted at an angle, which is called a *Dutch angle* (**Figure 5.11**). Typically, the angle is between 25 and 45 degrees (enough that it seems intentional, but not so much that it's dizzying). This effect causes horizontal lines to appear at an angle. Dutch angles are meant to convey tension or psychological uneasiness. Some styles of production, like music videos, use them often, whereas documentary and instructional videos use them less frequently.

CINEMATIC COMPOSITION

Be sure to think about composition before pressing the Record button on your camera. Earlier in this chapter you learned common framing techniques. But in videography, movement influences the composition.

The framing you choose will often need to vary throughout the shot. If the subject is moving, you'll need to adjust your framing. In the following sections I offer four useful rules that I find essential when designing compelling shots for a video or film project.

FIGURE 5.12

When you want to create a relationship between a subject in your video and the subject's environment, be sure to pay attention to eye lines.

EYE LINE

The eye line is basically where your subject is looking in the frame (**Figure 5.12**). For interviews, your subject's eye line may vary a bit. Normal framing is to have your subject look slightly off camera (towards an interviewer who traditionally stands next to the camera). Having a subject look directly into the camera is usually reserved for situations like on-camera spokespeople or newscasters.

If more than one person is in your scene, you may need to think about where people are looking in relation to each other. Often, you'll want viewers to feel as though both subjects are looking at each other (or perhaps the same item). To do this, you need to line up the subjects' gaze with the object being gazed at. This is largely done by framing, which influences how a viewer interprets eye lines. Always try to incorporate a little "look room" by leaving a bit more space on the side the subjects are facing. In other words, try to avoid centering the subjects in most cases and frame them so the more open side of the frame is on the same side as their eyes.

RULE OF THIRDS

As a photographer, you're probably familiar with the rule of thirds concept (**Figure 5.13**). Essentially, three vertical and three horizontal lines that are equidistant divide the screen, creating nine sections on the screen (like a tic-tac-toe board). The intersections of these parts serve as reference points that can be used when framing a shot. The common belief is that points of visual interest naturally occur at one third or two thirds of the way up (or across) the video frame. These points often work well for positioning objects in the frame.

FIGURE 5.13
The subject of the
portrait and the
object in the scene
are placed using
the rule of thirds.

If you're framing a portrait-style shot, consider framing the shot so the eyes of the subject are placed at the left or right intersection. This is the most traditional framing for an interview, because it easily allows for a weighted area of the screen to be empty of a subject and show the background. Of course, as with all rules, the rule of thirds can be broken. Just be sure you are consciously deciding to ignore or break the rule.

180 DEGREE RULE

When shooting two or more people in a scene (or even dominant objects), you need to be mindful of the 180 degree rule (**Figure 5.14**). This rule draws an imaginary line through the scene; one that should not be crossed. By keeping the camera on one side of the frame (essentially up to a 180 degree arc), eye lines remain constant. This lets the viewer feel more comfortable and makes the relationship between subjects clearer.

When you start a scene, try to draw a virtual line through the scene. It's up to you to decide where to place the line originally, but you shouldn't change it once you start rolling. If the camera physically crosses the line for a consecutive shot, the direction in which your subjects are looking or moving will seem to flip in the camera. This can be very disorienting to the audience and should generally be avoided.

FIGURE 5.14

This diagram shows the 180 degree rule. If the camera moves beyond a 180 degree arc, the characters will appear to switch places on the screen.

From the Wikimedia Commons by grm_wnr with Inkscape. This file is licensed under the Creative Commons Attribution ShareAlike 3.0 License.

SEQUENCING SHOTS

Shooting video is much more than capturing the action in one long shot. Most finished videos will contain a collection of shorter shots edited together (**Figure 5.15**). These shots are intercut and switch every few seconds. There are several reasons for using this approach:

- **Visual interest.** Most viewers have come to expect faster editing paces (just look at a film cut in the 1950s compared to a new release). The speed at which you switch angles and composition during an edit may be dictated by genre or personal tastes, but one wide shot just won't work for most viewers.

- **Technical necessity.** You may need to hide something in the scene with an edit. It might be an exposure change as you go from indoors to outdoors. Or perhaps you need to minimize a continuity error, such as your subject doing an on-camera demonstration slightly differently the second time through.

- **Emotional impact.** Changing angles and composition has a profound effect on the viewer. Knowing when to go in for a close-up or cut to a reaction shot is a learned skill, but one that is essential to building an exciting video that's enjoyable to watch.

FIGURE 5.15
Instead of shooting one long, continuous shot as my children explored the Swiss Family Treehouse, I took several shorter shots to create a more compelling story.

REPEATING ACTION

So, if you need to cut all your angle shots together, how do you pull it off? The most common approach to getting adequate coverage is to repeat the action of the scene. This means shooting the scene and then asking your subjects to repeat what they were doing (**Figure 5.16**). You should then change your composition and move your camera to a different position.

Here are a few ways to plan your coverage:

- If you're shooting a scripted or narrative video, you'll likely repeat the scene several times. You should first shoot the master shot to get coverage all the way through, and then move the camera around and get "insert" shots of key moments to cut in.

- If you're recording an interview or a live-action demonstration, you should shoot all the way through. Along the way, make mental (or even actual) notes of "pickup" or "insert" shots and go back and get them to add in.

- If you're shooting an action scene, ask your talent to freeze or hold. When you get to a desired cut point, pause the action. Quickly move your camera and recompose your shot. Then let the action continue. Even if you can't freeze the scene, you may still be able to reposition quickly enough and edit out the rough spots for a more condensed video.

USING MORE THAN ONE CAMERA

Sometimes there's no way to properly shoot a project without having more than one camera. Live event situations, such as a concert or wedding, are examples. Or you might be shooting a one-time event like a sports competition or a rocket launch. There will be times that getting another take or moving your camera to a new position will be impossible.

In these circumstances you'll want to shoot with more than one camera and place each camera at a different angle to get coverage. Perhaps you can borrow a friend's camera or team up with a friend or colleague to share footage and coverage duties. You might also have an older camera that you can set up on a locked tripod while you use your other camera to shoot insert shots.

To make the editing of shots from more than one camera as seamless as possible, be sure to match all the camera settings as closely as possible. Choose the same frame size and frame rate for each camera. Try to match the shutter speed and the white balance settings as well.

FIGURE 5.16
By having my son play through each hole twice—as well as using the word freeze—I was able to get proper coverage of the scene.

MAKING A SHOT LIST

You might think that the best Hollywood directors are creative geniuses; however, they have a more important character trait in common. They are great planners who aren't afraid to intensely analyze a script or a location and map out the best angles to tell their stories.

For a successful shoot, it's a great idea to build a detailed plan. Your goal should be to think about the scene or location ahead of time. Try to list all the shots you'll need and determine the number of shots and style of shots you want to shoot. Be sure to identify elements like the location and participants, and then specify the angles you'll need.

By making a detailed shot list, you can literally check off shots as you shoot. Typically, I use a spreadsheet application like Apple Numbers or Microsoft Excel. I can then sync the list to my phone and read it on the go. When it comes time to edit my footage, the shot list helps me identify the shots I have to work with. The extra planning at the outset will dramatically speed up *your* editing as well.

Chapter 5 Assignments

Now that you've learned the language of cinema, it's time to put the knowledge into action. You'll quickly discover that taking the time to actually think about composition (as well as study it) will dramatically improve the quality of your shooting and editing.

Shoot Each Shot Type

Evaluate a location and attempt to shoot each shot type listed in the chapter. Try moving the camera between each shot, but follow the 180 degree rule discussed in this chapter as well.

Change Your Angle

Try shooting the same shot from different angles. Start at eye level, and then move your camera higher and then lower in the frame. Analyze how the shooting angle changes the feeling of the scene.

Make a Shot List

Watch an episode of your favorite TV show. Create a shot list for a few scenes. Look for patterns within the show and analyze how the cinematography affects your enjoyment of the story being told.

Share your results with the book's Vimeo group!
Join the group here: vimeo.com/groups/DSLRVideoFSTGS

Shooting in Daylight

When it comes to shooting outdoors, it can be quite challenging. You can't overpower the sun, so you need to learn to work with it. You'll need to position your camera and your subjects so the light is attractive and enhances the scene (instead of ruining it).

Of course, nothing is ever easy: The sun will move across the sky; objects like trees and buildings or even a passing cloud will obstruct the sun; the sun's color temperature will vary depending on the time of day you're shooting; and the position of the sun will change based on geography and the date. Therefore, you must learn to respect and work with the sun when shooting in daylight.

PORING OVER THE FOOTAGE

The top image of my son in some pretty intense shadow shows a split screen before and after I applied color correction to the image. I used a Levels adjustment to lift the exposure a bit and a Saturation adjustment to boost the color. Both adjustments are standard in nearly every video editing application. The area above the red line shows the image with the filters applied; the area below shows the original image. Remember to get the image "close" in-camera; then you can "finish" it when you edit.

Using a tripod helped me stabilize the shot when zoomed in from a distance.

Photo by Vanelli.

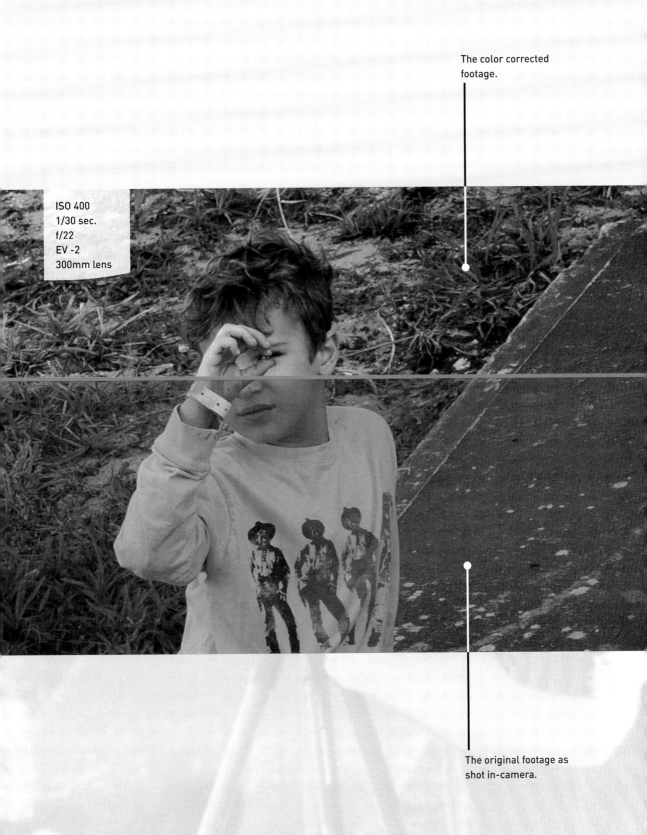

ISO 400
1/30 sec.
f/22
EV -2
300mm lens

The color corrected footage.

The original footage as shot in-camera.

UNDERSTANDING SUNLIGHT

No matter how good a photographer you are, you can't completely control the way the sun affects your footage. It moves in your scene (more quickly the closer you are to sunrise or sunset). It also can vary greatly in quality and quantity. The longer you're shooting in one location, the more aware of the sun you'll need to be (**Figure 6.1**). Changes from shot to shot can become jarring when you edit the footage together because visual continuity can be broken.

FIGURE 6.1
Finding a consistent exposure of the bright sky and shadowy sidewalks required a balancing act. Keeping my exposure in the middle to avoid clipping highlights or shadows was especially important because this was a tilted shot. Bottom: Positioning myself so the tree blocked the sun reduced the chance of lens flares on my camera. Photo by Vanelli.

ISO 100
1/100 sec.
f/16
50mm lens

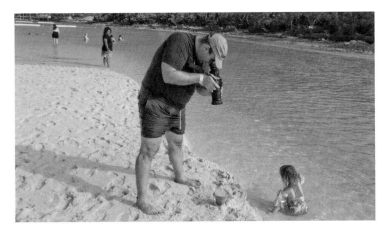

ISO 100
1/60 sec.
f/11
28mm lens

WHAT IS SUNLIGHT?

Without revisiting too much material from your grade-school, earth science class, let's review what sunlight is. Essentially, sunlight is a range of electromagnetic radiation given off by the sun. This radiation is filtered through the earth's atmosphere and is obvious to the eye as daylight. Depending on the season as well as time of day, the amount of light visible will vary greatly.

The light can be directly visible as a source (although framing the actual sun directly in your camera for too long can potentially damage your camera's sensor). The sunlight can also be diffused by clouds or reflected off natural and human-made surfaces. And of course, sunlight creates shadows that you must be aware of (**Figure 6.2**).

WHAT IS COLOR TEMPERATURE?

Light can actually be measured in terms of temperature; the common unit is degrees Kelvin (**Figure 6.3**). The scale ranges from the color of a candle (around 1900K) to that of a deep blue sky (around 10,000K). Typically, the average color temperature for outdoors at noon is approximately 5600K.

FIGURE 6.3
The Kelvin scale is a useful way to describe the temperature of light.

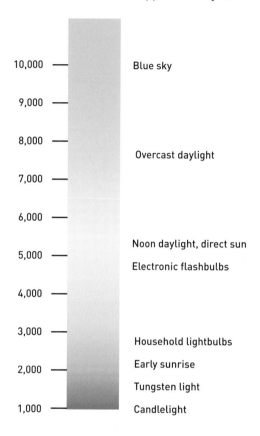

10,000 —	Blue sky
9,000 —	
8,000 —	
	Overcast daylight
7,000 —	
6,000 —	
	Noon daylight, direct sun
5,000 —	
	Electronic flashbulbs
4,000 —	
3,000 —	
	Household lightbulbs
	Early sunrise
2,000 —	
	Tungsten light
1,000 —	Candlelight

When you move from indoor light to outdoor light, your eyes automatically compensate for the color shift. All you'll perceive is an overall change in light levels. Your DSLR camera, however, cannot compensate for the change. Whether you're recording stills or video, you'll see potentially dramatic color shifts if your camera isn't calibrated correctly.

Recall that you learned about custom white balancing in Chapter 3, "Setting Up Your Camera." You may need to take precise control while shooting video in daylight to adjust your color temperature slightly while shooting to account for changes like clouds and shade. Also, keep in mind that white balancing a shot during the video postproduction stages is very easy.

CHOOSE LOCATIONS WISELY

When choosing where to shoot your video, you'll want to give some thought to where you put your subjects (**Figure 6.4**). Try to find a place that is slightly out of direct sunlight, for example, under an overhang or under the shade of a tree or tall building. This will potentially diffuse the light. Don't put your subjects in the shadows; instead, look for a place that is out of harsh light. Shooting under an overhang can provide an exposure approximately four stops less than direct sunlight. This will keep your subjects comfortable and make them look better.

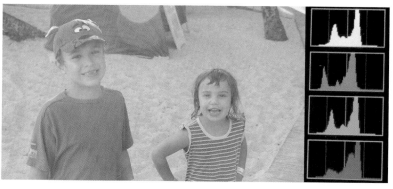

FIGURE 6.4
The first location is overexposed due to too much light. The lens flare has washed out the image as well. The middle image is a better location, but I've exposed for the sky, causing the subjects to fall into shadow. The final image is closer to a correct exposure for the subject and can be finessed during editing.

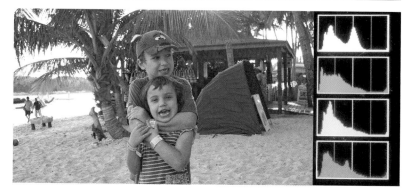

FIGURE 6.5
Knowing where the sun would be coming from allowed me to position myself so the sun was mostly behind me. This greatly reduced lens flares. Photo by Meghan Ryan-Harrington.

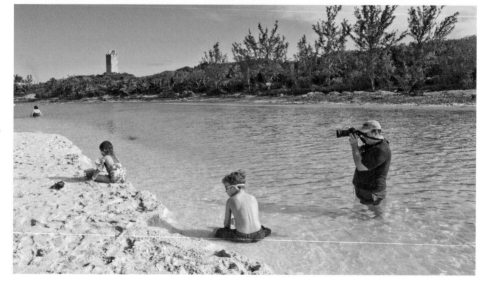

TRACKING THE LIGHT

If the sun keeps moving, how do you track it for your shots? Well, unfortunately, you can't just memorize a bunch of times or general angles. Your geographic location as well as the time of year will impact how close the earth is to the sun (and hence change times like sunrise and sunset). But these times and angles can be calculated (and in fact already have been).

I highly recommend that you add a SunPath style calculator to your smart phone or iPod/iPad. With this software you'll always know where the sun is in relation to your scene, which will help you choose the best shots.

My favorite app is called *Sun Seeker: 3D Augmented Reality Viewer* by ozPDA (**Figure 6.5**). This application uses the GPS on my phone to pinpoint my location and determine sun data based on my position. Alternatively, I can enter any location and date to virtually "scout" a location in advance to plan for the likely lighting conditions. The app also offers visual ways to tell where the sun will be throughout a shooting day. A compass view shows solar position, angle, and elevation for both day and night. My favorite feature is the augmented reality view, which takes a live video feed from the phone's camera and overlays detailed information about the sun. It's great to be able to tell where and when the sun will rise or set, or for that matter pass behind a large building. The augmented reality view makes it much easier to frame shots.

BOUNCING LIGHT

If you have the benefit of a second set of hands, you might try bouncing the light in your scene by using a reflector—a common photography tool. This highly reflective, flexible disc can be folded into a small size and easily carried. Keeping a small reflector (**Figure 6.6**) in your camera bag can be the perfect solution for many lighting problems. Simply bounce the light back onto your subject to help fill in shadows on a face. In a pinch you can also use a piece of white poster board or foam core.

FIGURE 6.6
Using a simple reflector, the light is bounced back on the subject to help fill in facial details.

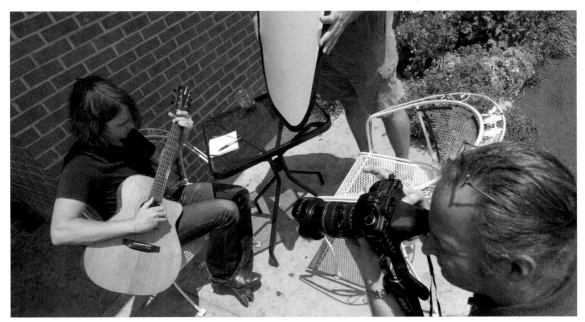

WHY A PARTLY CLOUDY DAY IS A GOOD THING

Although shooting on a nice sunny day can be a pleasant work experience, your camera might find it more difficult to process information. Without clouds, the sun's movement is much more visible. The sun is also likely to produce hard shadows that can make your subjects look less attractive (**Figure 6.7**).

On the other hand, a slightly overcast day is pretty ideal. The light tends to be very even because the cloud cover diffuses it. Video pros love to hear the term "partly cloudy" because it practically guarantees uniform lighting. Of course, if there are too many clouds, your beautiful light can go flat, resulting in a boring, shadowless scene.

Tracking the weather is important when choosing times to shoot. By using a weather tracking application on my smart phone, I can see what the cloud coverage will be, get rain warnings, and more. Knowing the weather lets you make smart decisions about shooting. The goal is to shoot in the best light without your gear getting unnecessarily soaked.

FIGURE 6.7
Without a cloud in the sky, the light is very harsh as are the shadows.

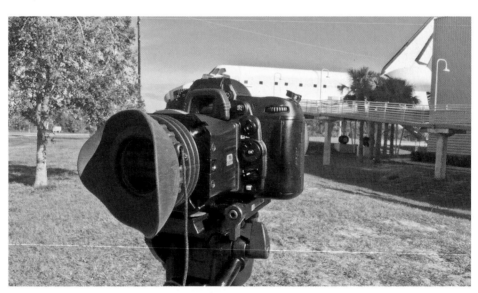

AVOIDING LENS FLARES

The sun is generally incredibly useful to photographers, but it can occasionally be annoying. If the sun hits your lens at an undesirable angle, you can end up with spots or flares that ruin a shot. Flares generally take on a geometric shape and may be easy to miss while recording (**Figure 6.8**). Additionally, a flare can significantly reduce the amount of contrast and saturation in your image.

▶ #21

FIGURE 6.8
Pointing the camera into the sun almost guarantees you'll get lens flares, as in this image of a washed-out area with a geometric flare in the trees. Lower photo by Meghan Ryan-Harrington.

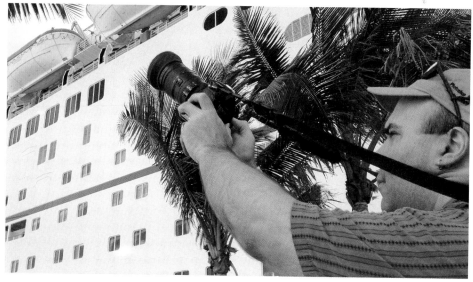

The flare is typically caused by a very bright light source (in most cases the sun). Flares are far more common in zoom lenses because they have multiple surfaces that are prone to light scatter. With a little practice you'll learn to spot flares quickly. Eliminating flares just requires a few strategies and modifications to your shooting style.

USE A HOOD

Most lenses include a hood attached at the end of the lens. Typically, the hood is reversed for shipping (to make the lens shorter and easier to pack). Unfortunately, most people never bother to turn the hood around (**Figure 6.9**).

FIGURE 6.9
When shooting, reverse the lens hood to protect your lens from flares and other issues. You can reverse it again for packing or shipping.

Once a lens is mounted to your camera, you should properly set the hood. With a quick turn (and perhaps a push of a release button) the hood can be removed. Reverse its direction and reattach it to your lens to protect the lens from flare.

Hoods are usually specific to each lens. Some will have notches (called petals) to better accommodate the aspect ratio of your camera's digital sensor. These hood types have an angle of view that is greater in one direction than the other. Others will vary in length to avoid casting a vignette (darkening of the edges) in your final image.

If you lose your hood, I recommend purchasing a replacement. Using a hood is the best way to reduce flares (**Figure 6.10**). It can also help protect the front of the lens from accidental impact as well as contact smudges.

FIGURE 6.10
Sometimes a slight
tilt to your camera
can remove a flare.
Photo by Vanelli.

KEEP THE LENS CLEAN AND CLEAR

Most lenses have an anti-reflective coating to cut
down on lens flare. Of course, greasy fingerprints
and other smudges can also cause problems. When
you clean the lens, be sure to use a proper lens
cleaning cloth to remove smudges without damag-
ing this coating.

If you'll be using additional filters on your lenses
(such as a protective UV filter or a neutral den-
sity filter), make sure you don't skimp on quality.
Cheap filters often lack good anti-reflective coat-
ings. These filters can often cause flare through
the introduction of additional reflective surfaces
(**Figure 6.11**). If you're using filters, make sure you
choose a quality that matches your lens.

FIGURE 6.11
The use of a cheap UV filter accentuated the tendency of my
lens to flare when shooting on a bright sunny day.

FLAG THE LENS

One way to prevent lens flare is to block the light. Typically, the flare is caused by
light entering from the side of the frame. This light is rarely needed for a proper
exposure and can be blocked. If you're using a tripod, you can place your body to the
side of the lens to serve as a wall. You can also reach out and hold a hat off to the
side to block the light.

FIGURE 6.12
I used a Rogue
FlashBender to
protect the lens
from additional
flare while shooting
on a bright day.

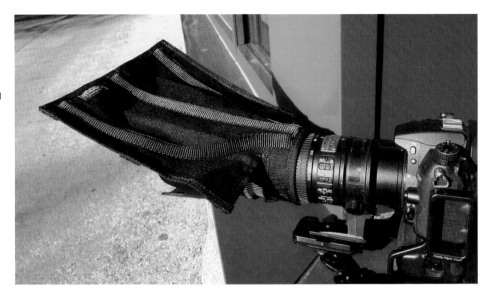

You can, of course, use other devices to block unwanted light. I'll often attach a Rogue FlashBender directly to my lens (www.expoimaging.com). These flexible cards are normally used to shape an off-camera flash, but I find the flexible support rods and bendable surface works well to flag a troubling flare (**Figure 6.12**).

CHANGE YOUR POSITION

If you can't minimize a flare, you have one simple recourse. Move your camera until the flare is gone. Remember that flare is caused by light hitting the lens at an unwanted angle (**Figure 6.13**). Often, a small adjustment can be very effective at removing the flare. You can frame the shot so objects are blocking the sun or light source (or even reposition your subject to block the light for you). You may also find that tilting or panning the camera just a few degrees can remove the flare.

CONTROLLING THE CAMERA IN DAYLIGHT

When it comes to video, you really want to get the shot as close to right as possible in the camera. The reasons for this are twofold: First, rendering color correction filters during editing is relatively time-consuming with video because there are so many frames to process. Second, what you can accomplish in the field and at the computer is relatively limited compared to a raw photo workflow. Always do your best to shoot your footage right from the very start.

FIGURE 6.13
The top shot has the light coming from behind the subject. Not only does the backlighting make exposure difficult, but it creates a nasty flare. The bottom shot shows the same location, but the photographer and subject's positions have been swapped.

BETTER UNDEREXPOSED THAN OVEREXPOSED

Although you can do a lot in postproduction to fix exposure, video files are a lot like working with JPEG images (as opposed to raw photos). Push an adjustment too far and you'll get a posterized image where details are clipped (a reduction in the subtle details, which makes an image look artificial; gradients get flattened and colors become oversaturated). Shoot in conditions that are too dark or too bright and you'll have no information to work with, and possibly quite a bit of noise.

The key is to always protect your highlights. Don't let the bright areas of your image (like skies or faces) get clipped. On your camera, you'll likely have a histogram view. You can typically see this histogram after taking a photo or cycling through your view options (in most cameras you can push the Info button or press your navigation dial from side to side to cycle views). If the histogram is pushed against the right edge, it means you have no information to work with. Blown-out highlights will be pure white, and there is just no way to recover the details.

In **Figure 6.14** you can see the same scene shot two different ways. In the image on the left, I shot the scene a little hot (too bright). By color correcting in postproduction, I was able to recover many details. But you'll notice that a lot of the details in the shadows are clipped.

FIGURE 6.14
Be careful and avoid slamming your histograms to the right.

ISO 125
1/50 sec.
f/14
32mm lens

▶ #25

In addition, I shot the scene and exposed for the "boring middle"—not too much contrast (**Figure 6.15**). In this case the histograms were more balanced, and I had a lot more information to work with. After color correction (a Levels and Saturation adjustment), the shot looks a lot better.

ISO 100
1/60 sec.
f/14
32mm lens

▶ #26

FIGURE 6.15
It's better to slightly underexpose than overexpose when shooting video. Notice how the shadowy details in the rocks are preserved better in this version.

FIGURE 6.16

FIGURE 6.16

If you haven't taken the hint yet, you need one of these. It doesn't matter which brand you buy, just get a loupe. Photo by Vanelli.

I've mentioned the use of a loupe or viewfinder a few times in this book. With outdoor shooting, the addition of this equipment is essential. Bright light on your LCD just makes the shot darn near impossible to judge. If a loupe is out of your price range, wear a hat and use it as a shield from time to time to judge exposure. I can't emphasize enough that a loupe should be one of your first investments if you become serious about shooting video on your DSLR camera (**Figure 6.16**). By removing all light pollution, you can make accurate decisions.

WHY DO MY PHOTOS LOOK BETTER IN THE SAME LIGHT THAN MY VIDEOS?

Recall that in Chapter 3 I discussed some of the differences between raw photos and unprocessed video. Video is a pretty weak medium as far as color fidelity goes, so don't panic. The compression formats used by your DSLR camera throw away a lot of information. Unlike raw photos, which offer great controls to recover highlights and lift shadows, video tends to be lacking in these areas.

When shooting, I tend to aim for the "boring middle." In other words, I don't push my contrast too far when shooting video. Rather, I try to get as much information into the image's histogram. Instead of applying picture or image styles to my footage in-camera, I strongly prefer to add all of my color grading and exposure manipulation during the editing stage. **Figures 6.17** through **6.19** show examples of this method.

FIGURE 6.17

A Shadow/Highlight adjustment lifts the skin tones for better contrast.

FIGURE 6.18
A Curves adjustment lifts the shadow areas and knocks down the highlights. A small saturation boost restores the colors that are washed out.

FIGURE 6.19
A simple Auto adjustment using Curves restored proper contrast per channel.

USING CAMERA CONTROLS TO CONTROL EXPOSURE

In Chapter 4 , "Exposure and Focus," I examined exposure in depth (if you skipped that chapter, I suggest reading it now). Here I'll review my approach to handle exposure when shooting in bright outdoor light. The following steps show the order in which I tackle the problem of getting a proper exposure.

1. Make sure the camera is in Manual shooting mode.

2. Set the shutter speed to a 1/50 of a second for 24 or 25 fps material or 1/60 of a second for 30 fps sources.

3. Set the ISO to 100 to start. This is the base ISO for outdoor lighting.

4. Adjust the f-stop to taste until the correct depth of field is set for the aesthetic look you want to capture.

5. Refine the exposure by either increasing the ISO if the image is too dark or by decreasing the shutter speed to let in less light.

6. Take a still photo for reference, and then examine the image using the built-in histograms to see the relevant details (**Figure 6.20**).

7. Adjust and remeasure the scene until you're happy with the exposure.

WHEN TO USE FILTERS

Sometimes when shooting outdoors, you'll just have too much light (this is particularly true if you're using a full-frame sensor like the Canon 5D Mark II). Even after setting the ISO to a low rating (around 100), you may have issues and still need to lose some additional stops.

FIGURE 6.20
You can use the built-in scopes of your camera to check exposure. Just shoot a reference still before rolling video.

What's the answer? Filters. You can add an additional layer of glass over the lens to get the exposure down to where you need it (**Figure 6.21**). Try using neutral density (ND) filters or polarizers to pull down the overall exposure. You can also use graduated filters to help control exposure in select areas of the frame (like the sky or a bright sandy beach).

A slightly more expensive option that offers the most flexibility is to use a variable ND filter, which screws on to the end of your lens. You can then further rotate it to adjust its density. These types of filters can knock down your exposure an additional 2–8 stops.

FIGURE 6.21
The use of a neutral density (ND) filter can really cut down on exposure problems when shooting outdoors.

Chapter 6 Assignments

Now that you have a better understanding of where to target your exposure, it's time to practice. Remember that your shots may need a little work after the fact, but that's OK.

Download a SunPath Calculator Application

Download a SunPath calculator app to your phone, iPod, or computer. Experiment with its controls and determine where the sun will be a week from today at 3 p.m. for your current location.

Change Your Position

Try shooting a subject from multiple angles in the afternoon sun on a day that is fairly cloudless. Can you find some angles that work better than others? Note where the sun is in relation to your lens.

Fix Your Hood

If your lens has a hood, go outside and shoot in the sunlight. Experiment with the hood facing the right and wrong ways. Determine what impact it had on lens flares.

Share your results with the book's Vimeo group!
Join the group here: vimeo.com/groups/DSLRVideoFSTGS

ISO 1250
1/60 sec.
f/23.2
50mm lens

Shooting in Low Light

Let's continue to explore the skills you'll need to shoot in different situations. This chapter discusses conditions in which low-light levels will pose a challenge. Low light makes focus and exposure difficult. Note that this chapter builds upon what you learned in Chapter 4, "Exposure and Focus." If you've been skipping around the book, it's best to read Chapter 4 before continuing with this chapter.

You'll use low-light shooting strategies when shooting in such situations as trying to capture an indoor performance, like a play or concert; shooting outdoors at night or early in the morning; or shooting a tour of a museum or gallery.

For this chapter, I spent the day shooting at the United States Astronaut Hall of Fame—a museum that showcases the human side of space exploration. I shot the whole day using just a 50mm prime lens, which is an affordable addition to any kit and makes low-light shooting easier.

Shooting a group of stationary objects, I let the shadows and shallow depth of field create an interesting frame.

PORING OVER THE FOOTAGE

The museum first presents visitors with a movie showcase before venturing into the exhibits. Shooting in this environment was tough because the front of the room had lots of light, but the rest was pitch black. This shot matches the conditions you'd find at a concert or performance. I opened my lens all the way, but it still wasn't enough. I needed to push the ISO higher than my comfort level just to get a usable shot. In fact, the shot still had to be brightened in my nonlinear editor to produce an image I was happy with.

Bracing my back against the wall dramatically reduced unwanted camera vibration.

Using a shoulder rig provided stability and flexibility in movement.

Photo by Vanelli.

At this high of an ISO, grain is unavoidable. It's most visible in the darkest areas.

ISO 2000
1/60 sec.
f/1.8
50mm lens

▶ #30

Shooting at f/1.8, the focal depth is very shallow. Only the woman in the center is in true focus.

PORING OVER THE FOOTAGE

Continuing to shoot at the museum, I moved into the exhibit space. More light was available in the exhibit space, although it was fairly low light to accommodate the exhibits (many of which were backlit). Because my subject was relatively stationary, as was I, I was able to slow down my shutter to let more light in. This allowed me to also use a smaller aperture, which increased my depth of field. The shooting conditions were still tricky but easier than the previous shot.

Bracing my camera on the desk helped stabilize it even further.

Photo by Vanelli.

Using details, like the subject's hair, make it easier to check focus.

▶ #31

ISO 1250
1/30 sec.
f/3.2
50mm lens

A smaller aperture let me keep my subject in focus while putting the background out of focus.

THE CHALLENGE OF SHOOTING IN LOW LIGHT

It is essential to first clarify what I mean by low light. Low light does not mean sitting in a room with the shades drawn and the lights off. Low light does not mean a lunar eclipse. Low light means shooting in an environment that has dimmed lights, or candlelight, or perhaps the light of the moon. Just remember that your eyes are *far* better at seeing in low light than a DSLR shooting video.

But perhaps you might want to protest because you've probably taken some great pictures at night using a tripod. I believe you; so have I. However, the exposure time typically ranges between 1 and 10 seconds. Remember that when shooting video, you are capturing upward of 24 to 60 images *every* second. Shooting video in poor light is tough, but it doesn't mean you shouldn't try.

COMMON SCENARIOS

I generally consider low-light shooting to be one of those scenarios where the light is challenging and I can't change it. In other words, I have to make significant changes to my shooting style or equipment (**Figure 7.1**) because I am not allowed to or it would be impossible to modify the venue's lighting. This could include situations such as:

- **Concerts or performances.** These settings can be tricky to shoot in because sometimes stage lighting is dramatic, but more often it is very high contrast.

FIGURE 7.1
When shooting in low light, a tripod is essential. When you've found the shot, lock it off and take your hands off the tripod to reduce any further vibration.

- **Weddings and ceremonies.** Houses of worship are frequently dimly lit or rely heavily on candlelight and natural-light sources.

- **Museums.** Museums can be particularly problematic because many seem to fear tripods.

- **Outdoor shooting at night.** An overcast night, a night camping in the woods, or even just a rural area can be pretty lean on lighting.

- **Sunrise/sunset.** During dawn and dusk, light changes are quick! Be prepared to make rapid changes to your camera settings, or you'll quickly lose the ability to get a proper exposure.

GEAR MATTERS

While shooting under low light, you'll rely heavily on your equipment. With less light to work with, you'll need to get as much light into the camera as possible. When you can't control the lighting, there are three measures you can take to improve your chances of capturing sharp-looking footage.

FULL-FRAME SENSOR

If you need to do a lot of shooting in low light, consider purchasing a camera with a full-frame sensor (or you might already own one). These types of cameras can capture a significant amount of light, but you must also use a higher-quality lens with them. A full-frame camera system (**Figure 7.2**) is definitely more expensive but is often the tool of choice for wedding and event photographers as well as photojournalists.

Full-frame cameras that shoot video include:

- Canon EOS 5D Mark II

- Nikon D3S

- Canon EOS-1D X

FIGURE 7.2
Some DSLR cameras, like the Canon 5D Mark II, offer full-frame image sensors. Image courtesy of Canon.

FAST LENSES

As you've already learned, aperture matters. If you'll be shooting in low light, chances are the kit lens that came with your camera will fail when shooting video in low light.

FIGURE 7.3
The AF-S NIKKOR 70–200mm f/2.8 lens provides a constant f-stop at all zoom levels. Image courtesy Nikon.

If you need the flexibility of a zoom, be prepared to pay a lot of money. Very fast zoom lenses are expensive. Because of the way a zoom lens works, the fastest lens you'll find will top out at f/2.8. These fast zooms are also heavy (**Figure 7.3**). Although I own one and love it, you need to be aware that the lens has its own collar and foot to attach it to a tripod. If you leave one of these lenses hanging off the front of your camera, you risk damaging your camera from the hanging weight.

FIGURE 7.4
The AF NIKKOR 50mm f/1.8D has an MSRP of less than $150 USD. You can skip the more expensive f/1.4 version, which is much more expensive and doesn't really add any benefit to shooting video. Image courtesy Nikon.

A far cheaper option is to use prime lenses. These lenses let in a lot more light, and the f/1.8 models can be quite affordable. Prime lenses are also readily available with speeds of f/1.4 and f/1.2. A 50mm f/1.8 lens (**Figure 7.4**), often called a "nifty-fifty," is one of the cheapest lenses sold by Nikon and Canon.

A STABLE TRIPOD

Shooting in low light gets a lot more difficult when you introduce motion. The viewer will often forgive a blurry subject who zips through the frame when the background is solid and stable (as well as clear). However, if you have extra movement in the whole shot from a bobbling camera, getting the shot gets a lot rougher.

Although a fluid-head tripod is ideal, the truth is that any tripod is a big help for shooting in low light. Remember to get a stable platform for the camera, and spread the tripod legs out wide. The tripod will dramatically reduce the slight camera movements that can destroy your shots.

FINDING FOCUS

Shooting in the dark makes finding focus challenging. Some DSLR cameras will use an autofocus assist light that can help illuminate your subject so the camera can find focus. Of course, using this feature may prove pointless (if you're more than a few feet away) and annoying to others (if you're at a concert or ceremony).

Focusing your DSLR will typically be a manual affair for low-light shooting (**Figure 7.5**). Be sure to switch your camera into Manual focus mode. You can use the zoom button for the Live View panel to see a larger image before you start rolling. If you're dealing with a moving subject, a loupe can really come in handy. Most loupes will magnify the image on screen 2.5 to 3 times, making it easier to see focus. If you are using a dedicated electronic viewfinder or monitor, you may have a focus assist or focus in red option that will work as well.

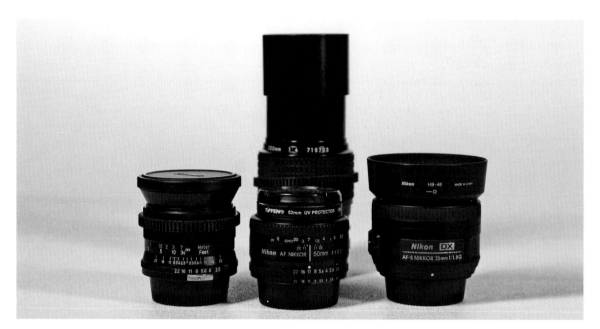

FIGURE 7.6
This old Vivitar prime lens cost me less than $50 from a local camera shop. It also offers great manual control rings for both focus and aperture.

CHANGING YOUR F-STOP

Low-light shooting really pushes your lenses. So, I usually switch to prime lenses in these scenarios (**Figure 7.6**). I typically carry 28, 35, and 50mm prime lenses for low-light shooting. These are affordable lenses and offer a range of coverage. If I know I'll to need to shoot at some distance, I'll add a 200mm prime lens to my kit.

You might think that purchasing these four lenses sounds out of reach until you hear that I bought three of the four from a local camera store as used lenses. Older prime lenses work great for video and are often very affordable. Just be sure to take your camera body with you when you're shopping. Most stores will let you attach the lens and test it out in the store. I'm always on the lookout for older primes with low f-stops, manual focus, and aperture rings.

HOW LOW CAN YOU GO?

Even though your lens may have a very low f-stop, you may not be able to use it. As you open up the lens to let in more light, your depth of field will decrease (**Figure 7.7**). If you're dealing with a stationary subject and have a tripod, open up the lens wide. But if you or your subject is moving, having a focal plane less than a foot deep makes focusing impossible. Remember to use all three sides of the exposure triangle. Set your aperture wide, but also readjust your ISO and shutter speed (more on both next).

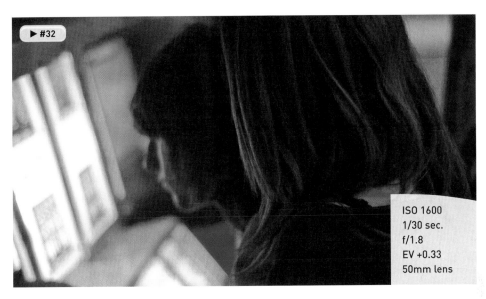

► #32

ISO 1600
1/30 sec.
f/1.8
EV +0.33
50mm lens

FIGURE 7.7
I opened up my lens all the way to let in the most light. Even though I'm only a few feet away from my subjects, I'm only able to keep one of the two in focus at this f-stop. I slowed the shutter speed to allow more light in (because my subjects weren't moving and I was using a tripod), which let me drop the ISO and avoid more noise.

MANUAL CONTROLS

Why would you want to change the camera's aperture in the middle of a shot? Well, there are lots of reasons. Perhaps you're panning from one area to another where the lighting varies. Or maybe cloud coverage is blowing through and your light levels are varying greatly. Or you might be shooting at sunrise or sunset when lighting levels change quickly (**Figure 7.8**).

Most new lenses rely on the camera to control aperture using its dials or menus. The only problem with this approach is that you can't really make a change without stopping the current file that's recording. If you look for prime lenses, or older used lenses, you may find some that have a manual aperture ring, which allows you to make changes to the aperture while shooting.

FIGURE 7.8
These two shots were taken only 20 minutes apart. When the sun goes down, it's often a fast transition. The left shot was shot at f/9.0, whereas the right was at f/2.8. The same lens was used for both shots.

FIGURE 7.9
Most aperture rings
need to be unlocked
in order to rotate
them manually. Look
for a bright tab near
the back of the lens.

The aperture ring may need to be unlocked to work (**Figure 7.9**). You'll often find a notched switch, which can be unlocked so that you can turn the aperture ring freely to change your f-stop.

UNWANTED CHANGES WHEN ZOOMING

Most zoom lenses have a variable aperture, which means that the more you zoom in, the less light that passes through. One of my favorite lenses covers a wide focal range, the 28–300mm lens. This is a great lens for shooting all day long when on vacations or walkabouts because I can travel light. However, it is a terrible lens to use for low-light shooting for two reasons.

First, all zoom lenses will have higher f-stops than primes. Second, as I change composition by zooming, I have to remember to adjust my ISO and shutter speed to compensate for changes in aperture. This constant juggling is necessary; otherwise, there's more color correction to do in post to adjust for the variance in exposure.

If you really want to use a zoom lens and shoot in low light, plan to pony up some money for an expensive lens. You can get lenses with a constant aperture, but these lenses often cost (much) more than your original camera body.

RAISING YOUR ISO

Changing your ISO will be the easiest change you can make when shooting in low light. You won't need to buy a new lens, and you should be able to access the setting easily. Newer cameras are *much* more forgiving than they used to be when it comes to ISO. This is due mainly to improvements in the actual image sensors used. You might have been trained to never use an ISO setting over 800 in the past. However, this rule can often be broken with few repercussions with the new breed of cameras on the market.

CHANGING ON THE FLY

One of the features I look for when shopping for a DSLR is a physical button for ISO (**Figure 7.10**). If your camera has one, it makes it a lot easier to access while recording because you won't have to stop the current clip and go searching through menus. Also, your DSLR may have additional function buttons on the front that can be mapped within your camera's menus. Being able to push a physical button and turn a command dial allows you to make minor changes on the fly. ISO is the most frequent change you'll make while recording video, so make sure you can do it easily.

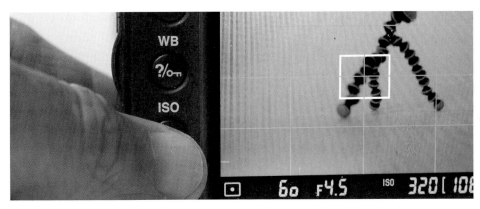

FIGURE 7.10
A dedicated ISO button can really come in handy to make easy adjustments to your camera setting.

HOW HIGH CAN YOU GO?

The only way to know your camera's limits is to push it to its "breaking point." I recommend you perform a simple test to check your camera's capabilities. Ideally, you'll mount the camera to a tripod or set it down on a ledge or table to minimize movement.

1. Place your camera in a mostly dark room or in an area without much light.

2. Set your camera to ISO 100.

3. Make sure your camera is set to record sound.

4. Start to record and call out the ISO settings.

5. After 10 seconds, switch your camera to the next ISO and audibly call out its numeric setting.

6. Continue until you reach your maximum ISO (**Figure 7.11**).

7. Open the file on your computer.

8. Set the file to full-size playback (depending on the resolution of your file some pixels may be cut off). You need to view the file at 100 percent to clearly see the noise.

9. Play back the file and look for noise in the file. Be sure to carefully watch the changes that occur.

 You may notice that ISO settings stair-step each other, meaning that the first ISO that looks bad may not be the highest ISO setting. Often, the higher ISO will result in a clean image. This is due to differences in how the sensor processes the digital signal.

10. Be sure to note how the camera performs in your stress test.

 It's not a bad idea to repeat this test in real-world settings as well. If you know that you have to record your child's recital or a friend's concert, go to the dress rehearsal or even a different performance and try out your camera under the available light at the venue. You'll be glad you did.

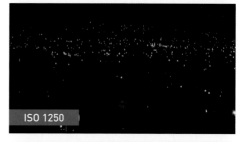

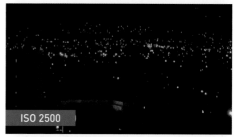

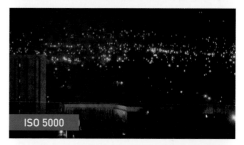

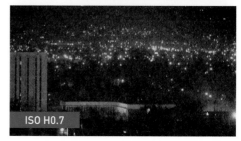

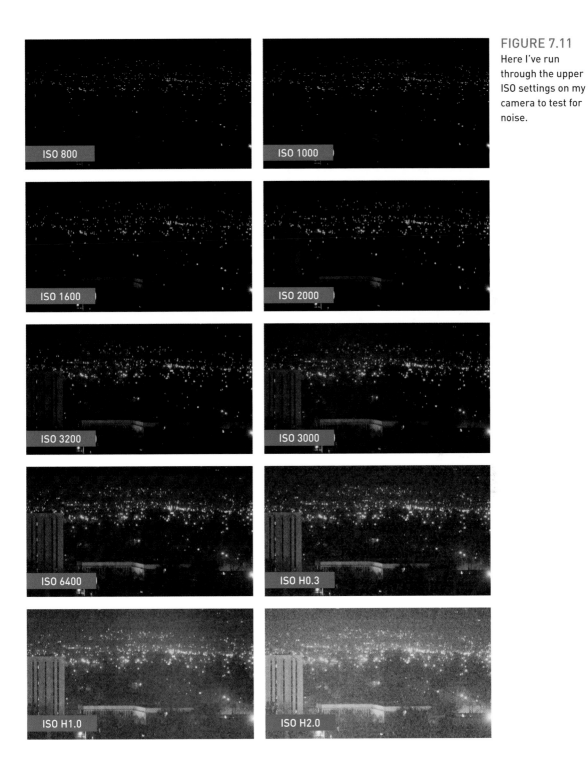

FIGURE 7.11
Here I've run
through the upper
ISO settings on my
camera to test for
noise.

ISO 800

ISO 1000

ISO 1600

ISO 2000

ISO 3200

ISO 3000

ISO 6400

ISO H0.3

ISO H1.0

ISO H2.0

ADJUSTING SHUTTER SPEED

The adjustment you'll make the least when shooting video is shutter speed. Changing shutter speed will either freeze or stretch the action (**Figure 7.12**). In either case, making too big of a change will produce an image that's unusable. Open the shutter for too long and your footage will just look blurry; open the shutter for too short a time and the shot will just get darker (and stutter).

FIGURE 7.12
The amount of motion blur on the moving objects is largely determined by the shutter speed. Notice that the stationary objects are quite sharp, but the faster-moving objects have streaks.

THE TARGET SHUTTER SPEED

Although I discussed the target shutter speed in Chapter 4, the information bears repeating. Remember that you need to shoot in Manual mode with your DSLR if you want to control the shutter speed properly. Here's the easiest way to calculate the correct shutter speed (**Figure 7.13**).

1. Check your frame rate. (In this case let's use 24 fps.)

2. Multiply the frame rate by two. (In this case that equals 48.)

3. Place that number below the number one to make a fraction. (In this case 1/48.)

4. Choose the closest shutter speed to that fraction that's available on your camera.

THE REALITY OF SHUTTER SPEED

Knowing the rules means that you should also know when to break them. Although there is a set shutter speed to produce natural motion, you may need to choose a different speed to get a desirable exposure. After adjusting your aperture and your ISO, the last adjustment at your disposal (that can be made in-camera) is shutter speed.

FIGURE 7.13

Normally, your shutter speed will be set to 1/60 or 1/50 of a second.

Lowering the shutter speed allows more light to reach your camera's sensor. It also may allow you to decrease the aperture (giving you a deeper depth of field). If your subject is not moving much, shooting at 1/30 of a second often works. If you shoot at an even slower shutter speed, your footage will probably look soft.

USE THE SHADOWS

Don't be afraid of the dark. If your light is harsh and directional, your shadows will be sharp and deep (like streetlights on a dark boulevard). On the other hand, if your light is soft and ambient, your shadows will gently fall off into the edges. When designing your shots, be sure to think about the quality and location of the shadows. You can use the shadow as a transition to take you into or out of a scene.

SHOOTING AT SUNRISE OR SUNSET

When talking to photographers or cinematographers, you may hear them talk long-ingly about the golden hour or magic hour. This time refers to the first and last hour of sunlight each day. The golden hour (**Figure 7.14**) is often considered the best light by many and truly offers a unique look that can be very attractive.

FIGURE 7.14
When shooting at sunrise, you'll need to let some items fall into silhouette. Both of these shots were taken at the same location using a fast 28mm lens. The aperture was set to f/2.8 to let in a lot of light.

The lighting during sunrise and sunset tends to be soft and nicely diffused. The hue is often warm with rich shadows as well. The best feature is how the skies can become quite dramatic with varied colors and mellow glows. If you're shooting landscapes, skylines, or nature, this is a great time to get stunning images.

POSITION IS EVERYTHING

So the question is, are you shooting to capture the sunrise and sunset (such as a beautiful shot of the sun cresting over the ocean's edge), or are you just trying to shoot at a time when the sun is the only light you have? In either case you need to know the position of the sun:

- **Shooting a sunrise.** A sunrise is much trickier to catch because you can't always tell where the sun is going to pop up (you need to know more than just "in the east"). The entire horizon may start to glow, but choosing exactly how to compose the shot is challenging. I rely on my compass and SunPath calculator to show me the sun's path. This makes it easier to compose a good shot where the sun rises in my frame, because I generally choose to center the sun.

- **Shooting a sunset.** Attempting to shoot a sunset is pretty easy. You just follow the sun as it goes down. If you lose track of the sun setting, look west.

- **Shooting a subject during these times.** When shooting a subject at sunrise or sunset, try to keep the light in front of your subject (and to your back). You may need to turn or rotate as needed. Eventually, the light may become so diffused and soft that you'll be able to let it backlight your subject.

BE PREPARED FOR FAST CHANGES

Keep in mind that the golden hour may not be an actual hour. This type of light is determined by the altitude of the sun. The closer you are to the equator, the shorter the time will be, and the farther you are from the equator, the longer the time will last. In fact, during certain seasons (like winter), there may not be a golden hour.

Also, realize that the posted sunrise and sunset is when the sun actually crosses the horizon. So the great light will often start before the technical sunrise and last slightly longer than the setting sun.

In all cases, you should have a fast lens attached to your camera and be ready to change aperture settings. If you're shooting a sunrise and don't have much to focus on, make sure the lens is set to the Infinity setting for focus distance.

TIME-LAPSE AS AN ALTERNATIVE

If you need to shoot in very low-light situations, time-lapse photography is a great choice. With this type of photography, you essentially shoot one still image every 1–10 seconds and then assemble those frames as a movie. Because you are taking a lot fewer frames per second, you can open the shutter for a longer time. This means you can even shoot really late at night with affordable lenses and get great exposure (**Figure 7.15**).

FIGURE 7.15
The shot on the top is video. Despite boosting the ISO, I couldn't get a solid exposure on my zoom lens (which stopped at f/2.8). Switching to shooting time-lapse video (bottom), the exposure is much better.

To shoot time-lapse images, you'll need an intervalometer. Nikon cameras often have one built in, but buying one is typically less than $50. You'll also need to lock off the camera on a tripod to avoid any movement between shots.

To learn more about time-lapse photography, be sure to visit my Triple Exposure website at www.3Exposure.com. Here you'll find several free tutorials and videos on making time-lapse movies.

Chapter 7 Assignments

By now you should be feeling pretty comfortable with the exposure triangle (unless of course you've been skipping around the book). So take your gear and head out for some low-light shooting.

Check Your Depth of Field

Experiment with your camera's aperture and determine its impact on your depth of field. Place your camera on a tripod, attach your fastest lens, and focus on an object. Set the aperture open all the way. Increase your aperture and notice how much of your scene stays in focus. Step through your different aperture settings and explore the differences (you may need to stop recording to change aperture).

Test Your ISO Settings

In the section "How High Can You Go?" I provided a detailed ISO test. That wasn't a suggestion; you really need to test your camera and figure out its limits. Go for it.

Shoot the Sun

Get up early or stay up late, it's up to you, but try to shoot a sunrise or sunset. Determine your golden hour and shoot during that time. You can visit http://bit.ly/goldenhourcalc to help you determine the best shooting time.

Share your results with the book's Vimeo group!
Join the group here: vimeo.com/groups/DSLRVideoFSTGS

Shooting Indoors

If you want the most professional-looking footage, you'll need to take control of your lighting. Remember that your camera is nowhere near as sensitive as your eyes, so it takes extra effort to get a great image.

It is necessary to learn how to use the light that you already have in a location. More important, however, is trying to control it by adjusting the lighting or enhancing it by adding more light. If you take the time to focus on lighting, your footage will look its best. It might mean choosing a location with good available light or creating your own environment using lighting instruments.

PORING OVER THE FOOTAGE

A favorite Halloween tradition at our house is pumpkin carving. In this case I had control over where we carved the pumpkin and how I lit the scene. I adjusted the overhead lighting to get a nice base level of lighting. I also drew the window blinds to let in as much light as possible.

A small LED light helped fill in the darker areas of the scene.

ISO 640
1/50 sec.
f/2.8
28mm lens

▶ #37

Using a white tablecloth, I created a custom white balance.

PORING OVER THE FOOTAGE

While shooting a web promo video, I needed to shoot footage to illustrate the product. In this case it was an iPad application. I positioned my subject near a window to get plenty of light in the scene. I also added two small lights to help fill in my subject. Because the screen was essentially a giant mirror, I had to pay attention to and adjust my camera and lighting positions to avoid unwanted reflections.

To preserve some of the shadows, I used directional light from the windows and the extra lights I added to the scene.

ISO 560
1/45 sec.
f/2.8
28mm lens

▶ #38

Carefully positioning my lights, I avoided unwanted reflections on the screen.

USING AVAILABLE LIGHT

There will be many times when you'll have no control over the lighting in your scene. You might be shooting in an office or public building where you are not allowed to touch the light switches. Other times you might not have time to make lighting changes. So, it's important for you to learn to shoot under the light you have. Unfortunately, when dealing with indoor lighting, there are even more variables to consider than when shooting outdoors in the sunlight.

WHAT IS THE LIGHTING SITUATION?

You'll first want to analyze the lighting at your shooting location. Determine if there's mixed lighting, such as sunlight coming through a window combined with overhead fluorescent or incandescent lighting (**Figure 8.1**). Will your subjects be backlit by a bright window that will turn into a wash of white light behind them? Can you reduce the types of lighting affecting your scene by closing the blinds?

You might be lucky and have just a single light source with a consistent color temperature. Determine if the lights are too bright and are making your scene look harsh. If so, perhaps there's a dimmer switch you can control or lights that you can change. The key is to make the best out of the lighting you have to work with.

FIGURE 8.1
This location originally had too many lighting sources, which included fluorescent, incandescent (bulb), and daylight sources. I opened the blinds to let in more daylight. I also turned off the fluorescent light to unify the scene.

WHAT IS THE COLOR TEMPERATURE?

Remember that light often has a visible color, which is even easier to see on-camera. The sky is blue because of the temperature of light. The orange flame of a candle is a different temperature than the flame on a gas stove. In a basic sense, light takes on the following colors:

- Sunlight = blue light
- Standard lightbulbs (tungsten) = orange light
- Fluorescents = greenish light

The color of light can have a huge impact on the look of your scene. The human eye is very particular when it comes to color, so it's important to pay close attention to light and its temperature. It's all about setting up your camera correctly. If you rush or get sloppy, your video can end up looking amateurish. Calibrating your camera ensures that areas like skin tones look natural. Generally, you can solve color problems by white balancing the camera (**Figure 8.2**).

FIGURE 8.2
When a scene is properly lit and the camera is set up correctly, skin tones look consistent across multiple shots.

GETTING THE RIGHT WHITE BALANCE

Your camera has several presets for white balance. More important, however, is that you have the ability to set a custom white balance. You can change the settings on your camera to completely match the environment you're shooting in. Although this process may vary from camera to camera, it typically involves the following steps.

1. Set your camera to a Custom White Balance mode (**Figure 8.3**).

2. Take a picture of an object that has a lot of white in it. Compose the shot so the white fills most of the frame.

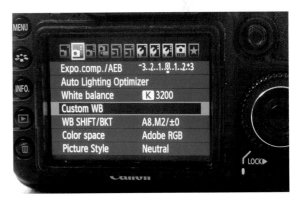

FIGURE 8.3
Most cameras offer the ability to set a custom white balance based on the scene you're shooting.

You can ask a person to hold up a piece of white paper as a quick reference card. White works well because pure white is the proper balance of all colors.

3. Your camera will use the image to calibrate its settings. It will typically notify you via the Live View monitor that the white balance is good.

4. Confirm the proper color temperature by pointing your camera at the scene and visually inspecting the image on your screen.

In some instances you may need to take the reference photo before you set your camera to a Custom White Balance mode, and then choose it as part of the white balance process. For detailed instructions for your camera, refer to your camera's manual.

ADDING MORE LIGHT

To this point, you've made do with the lighting you have. However, just as you might use a flash to add light to your still photography, it is natural to use additional lights for shooting your video. Keep in mind that your eyes are far more sensitive to light than your DSLR camera when shooting video. The use of extra lights can go a long way toward creating a sharper image. Just remember that you'll need to white balance the camera again if you change the lighting in your room or location.

USING PRACTICAL LIGHTS

FIGURE 8.4
Overhead lights like these will impact your location's lighting.

Film and video professionals often refer to the "real" lights at a location as *practical lights* (**Figure 8.4**). They can include floor lamps, desk lamps, or any other indoor lighting you might find at a location. If you're shooting in a dark room, consider adjusting the lighting level. If you're lucky, the lights will have a dimmer or three-position switch so you can adjust the intensity of the light until you have a level that works well for your scene.

CHINA BALL LANTERNS

A highly affordable option to add light to a scene is to use China ball lanterns (**Figure 8.5**). Typically made from heavy-duty paper or silk, these balls diffuse the light from a standard light socket. A lantern can illuminate an entire room with 360-degree lighting. The fixture can create soft natural light that produces pleasing skin tones.

For a China ball lantern kit, you'll need the following items:

- **Paper lantern.** Lanterns range in size from 12 to 30 inches. Cost is usually $3 to $20 depending on the size. You can also get lanterns made of flame-resistant materials, which cost more.

- **Practical light socket assembly.** This is generally a medium socket with an on/off switch. The socket can handle up to 660 watts, terminates with a standard household connector, and costs approximately $6 per unit.

- **Lightbulbs.** Bulbs will range between $5 and $20 for photo-quality bulbs. Be sure you do not exceed the recommended wattage of the fixture.

China ball lantern fixtures are very affordable and are also very easy to travel with. Because they are slightly flammable, however, you should never leave them turned on and unattended. To make them safer to use, consider adding an optional Lanternlock fixture. This unit will fully expand the lantern and helps keep a hot bulb from setting the paper on fire. They run about $60 to $85 and can be added to increase the usefulness of a China ball lantern.

CHINA BALL VENDORS

- Filmtools (www.filmtools.com/chinlan.html)
- Asian Ideas (www.asianideas.com/lanterns2.html)
- Paper Lantern Store (www.paperlanternstore.com)

FIGURE 8.5
A China ball lantern can gently illuminate your location and provide lots of light.

SHOP LIGHTS

If you've ever poked around a hardware store, you may have come across high-power shop or work lights. They are a bit heavy (and can get dangerously hot), but they do put off a ton of light to shoot with (**Figure 8.6**). With a few adjustments, these lights can be adapted to use for video. You will also find newer fluorescent work lights, which also can be useful.

Consider these tips for safely and effectively using shop lights:

- **Remove the grates.** Some shop lights have metal grates over the light cages, which can cause irregular shadows. You'll need to carefully remove these with a screwdriver.

- **Stands and handles.** Adjust the height of the lamp if it has a stand or hang it from a safe position if it includes a handle and hook.

- **Heat and safety issues.** Some shop lights are very powerful (and hot). Be careful to avoid burn injuries by using proper safety equipment like leather work gloves to handle the lights. Also, make sure children and others can't bump the lights or knock them over.

- **Positioning.** Try bouncing the light off a wall or ceiling to soften the light and diffuse it.

FIGURE 8.6
Shop lights are affordable but not ideal for video shooting. Photo by iStockPhoto.

REFLECTOR CLAMP LIGHT

Another cheap type of light that you can use is a reflector clamp light (also called a *scoop*). These types of lights (**Figure 8.7**) can also be found at a hardware store and typically cost about $10. The light features a clamp and light socket with a metal reflector to focus the light.

You can use a standard or compact fluorescent lightbulb to light your scene as well. Because they are not very powerful, you'll need to use a few of them to light a scene. You can also use daylight-balanced lightbulbs to white balance your camera easily.

FIGURE 8.7
Reflector clamp lights are affordable and useful for small lighting jobs.

LED LIGHTS

A very popular choice for video lighting is the use of LED lights. The technology behind LED is light emitting diodes (**Figure 8.8**), which are based on semiconductor diodes. LEDs have been in consumer electronic devices like VCRs, toys, and televisions for years. It is the modern development of white light from LEDs that allows them to be used for lighting your scene. It's only recently that they've become more cost-effective and color accurate.

Although LED lights are some of the most expensive lights you can buy, they are still quite popular for several reasons:

FIGURE 8.8
An individual LED is not that bright, but when combined with others, can be quite effective.

- **Less power use.** LED lights use a fraction of the power that traditional video lights pull. In fact, I have some lights that can run off AA batteries for several hours.

- **Less weight.** LED lights are very compact and lightweight. You can even get small units, which can be mounted right to the camera or a light stand (**Figure 8.9**). These lights are great for when I travel, because airline baggage fees add up quickly.

- **Durability.** Unlike a normal lightbulb, LEDs are very difficult to break.

- **Less heat.** The technology used in LED is solid state, so the lights emit a lot less heat than incandescent lights, making the lights safer to use and more comfortable for your subject.

FIGURE 8.9
LED lights come in many sizes.

As you shop for LED lights, be sure to look at all your options. Many smaller LED lights can be found for around $100–$150 (**Figure 8.10**). Other brands that include several additional features (such as built-in dimmers and color temperature controls) can range between $700 and $1,400 per light.

FLUORESCENT LIGHTS

One type of video lighting that is widely used is portable fluorescent lighting fixtures. Companies such as Lowell, Mole Richardson, Westcott (**Figure 8.11**), Cool Lights, and Kino Flo (**Figure 8.12**) make these fixtures. These lights are also used by photographers, especially in a studio environment.

A fluorescent light can start at around $300 for a single light kit. You'll find that multiple light kits can include several accessories but can run you a few thousand dollars. Purchasing true video lights are an investment, but good lights last for many years.

Fluorescent lights are popular for several reasons:

FIGURE 8.10
The small LED light is easy to hold and cool to the touch. Placing it too close to a subject creates a harsh hot spot (top). Pulling it farther back spreads the light out and reduces its intensity (middle). This light was useful to help fill in the shadows of the scene (bottom).

- **Soft light.** Fluorescent bulbs are a great source of even, soft light. They produce attractive lighting for shooting interviews.

- **Flexible pricing.** Several manufacturers sell them at various price points. They are generally more affordable than many other lighting technologies. You can also use several regular CFL lightbulbs to a similar effect.

- **Cool lights.** The lights run at a cool temperature, which means they can run all day in a small room without turning it into an oven. This is important to keep everyone comfortable.

- **Module based.** Many of the lights are modular, meaning that you can change the number of bulbs used in the fixture and control how intense the light gets.

- **Controlling features.** Many of the lights offer built-in dimmers as well as barn doors that you can bend to help focus the light onto your subject.

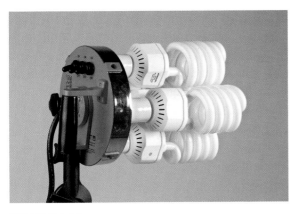

FIGURE 8.11
The Westcott Spiderlite is a popular photography light that also works well for video. The light sells for about $350. Photo by Brad Moore.

FIGURE 8.12
Kino Flo makes several fluorescent lighting fixtures. They tend to be expensive and start at around $600. They are quite popular with video professionals.

BUYING PROFESSIONAL LIGHTS

A number of professional lighting manufacturers exist. Here are my picks for lights that I like to use. Be sure to explore lights from the following brands:

- Adorama (www.adorama.com)
- Arri (www.arri.com)
- Bescor (www.bescor.com)
- Cool Lights (www.coollights.biz)
- Westcott (www.fjwestcott.com)
- Kino Flo (www.kinoflo.com)
- Litepanels (www.litepanels.com)
- Lowell Light Manufacturing (www.lowel.com)
- Zylight (www.zylight.com)

GET GREAT DEALS ON PROFESSIONAL LIGHTING EQUIPMENT

If you'd like to purchase professional lighting equipment at a discount, you can often find used gear for sale. Remember that professional video lights have a long, useful life, so don't avoid looking at older or used gear.

Here are some companies to try (look for a link for used or demo equipment):

- Adorama (www.adorama.com)
- B&H (www.bhphotovideo.com)
- Visual Products (www.visualproducts.com)
- Wooden Nickel Lighting (www.woodennickellighting.com)

THE CONCEPT OF THREE-POINT LIGHTING

Three-point lighting is the standard approach used as a starting point by film and video professionals. For it, you'll use three light sources focused on the subject from different angles. This technique serves as the foundation for more advanced lighting strategies as well. The goal of three-point lighting is to properly light the subject so it looks good while also separating the subject from the background.

KEY LIGHT

The *key* is your primary light source for your subject. Generally speaking, it is the brightest light and is placed between 15 and 45 degrees to the side of your subject. The goal is to use this light to bring out the features of your subject's face (**Figure 8.13**). This is typically a broad light that is also soft. The most common type of light to use is a fluorescent fixture or a light with a softbox diffuser to spread the light.

FIGURE 8.13
The key light is used to fill in the bulk of the facial details.

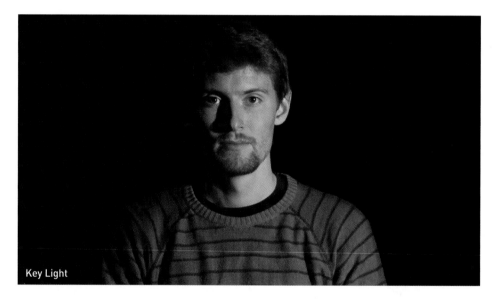

Key Light

FILL LIGHT

The *fill* is your secondary light and is generally opposite the key light. Its job is to fill in the scene and minimize harsh shadows caused by the key light. You can choose to set this light to equal the brightness of the key light, but usually it's a better idea to reduce its intensity a bit (**Figure 8.14**).

To control this light, use a fixture that has a dimmer (hardware stores carry dimmers). If you can, move the light farther away to reduce its intensity.

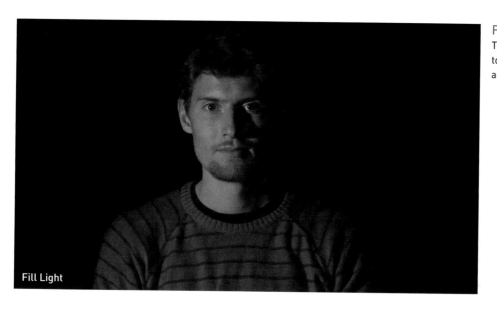

Fill Light

FIGURE 8.14
The fill light is used to remove shadows across the face.

BACKLIGHT

The *backlight* is your third and typically least intense light source. Its role is to highlight the edges of your subject, which helps separate the subject from the background. This can create a more three-dimensional look, which is often pleasing. Placement of the backlight is usually behind and above your subject (**Figure 8.15**). Some will even hang the light from a ceiling or railing. You can also place the backlight close to the floor or off to the side and have it point upward.

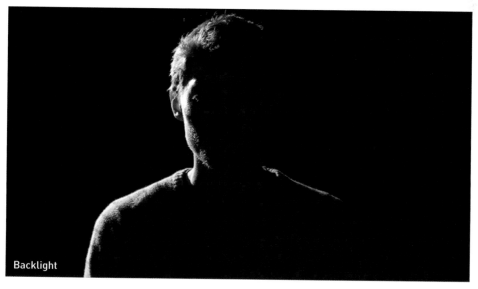

Backlight

FIGURE 8.15
The backlight creates an edge around your subject's hair to help separate the subject from the background.

PUTTING ALL THREE TOGETHER

You should use all three lights at the same time so they combine to create even and attractive lighting (**Figure 8.16**). Mastering the concept of three-point lighting can dramatically help you improve the quality of your subject. When lit correctly, you can often shoot the subject with multiple cameras or angles without having to relight or adjust lights.

FIGURE 8.16
All three lights combine to create a well-lit subject.

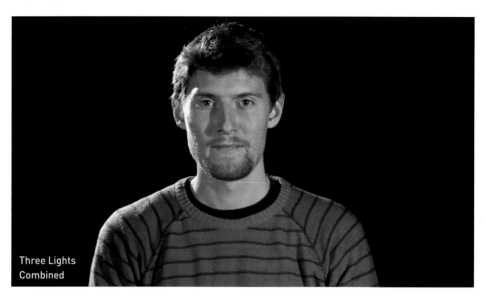

Three Lights
Combined

NEED MORE INFORMATION ON LIGHTING?

Several excellent books and DVDs are available that focus on lighting techniques for video. Here are a few I recommend:

- *Lighting for Digital Video & Television* by John Jackman (Focal Press, 2010)
- *From Still to Motion: A photographer's guide to creating video with your DSLR* by Jim Ball, Robbie Carman, Matt Gottshalk, and Richard Harrington (Peachpit Press, 2010)
- *Motion Picture and Video Lighting* by Blain Brown (Focal Press, 2007)
- *Video Shooter: Storytelling with HD Cameras* by Barry Braverman (Focal Press, 2009)
- *Light It Right–Contemporary Lessons in Video Lighting* (VASST, 2005)
- *The Power of Lighting* by Bill Holshevnikoff (TMW Media Group, 2006)

Chapter 8 Assignments

You've now shot under lots of lighting conditions. It's time to focus on taking control of your lighting. By completing the following exercises, you can practice shooting under more controlled light and see how it improves your project.

Evaluate a Location

Pick an indoor location for shooting video. Carefully examine the location and see what you can do to control the light. Are there window blinds you can open or close? Do you need a custom white balance for your camera?

Add Some Light

Continue working in the same location as you did in the preceding assignment. Add some light to the room to brighten it. You can do this by using practical lights or windows in the room, or by adding your own lighting instruments. Shoot some before and after footage, and compare the difference lighting makes.

Research a Lighting Kit

Investing in lights is an important decision. Research options for lights and compare prices. Design a three-point lighting kit that you can afford (even if that means using lights from the local hardware store). Any additional light is almost always an improvement in your footage.

Share your results with the book's Vimeo group!
Join the group here: vimeo.com/groups/DSLRVideoFSTGS

Recording Sound

An often-repeated mantra in the film industry states that "audio is half the picture." Think about it this way: Although you might be able to tell a compelling story in pictures alone, audio gives your story a voice. The idea is that viewers expect great sound; without it they'll stop paying attention. Then this is easy, right? Just press Record. Well, when it comes to audio, nothing is that simple.

Although the final audio for a project is often crafted during the editing stage, you should never underestimate the importance of capturing good audio in the field. If you record your audio at an improper volume, it can have distortion. Even though you might be new to recording audio, the best practices are relatively easy to learn.

CAPTURING GREAT AUDIO

If you want to record great audio, you need to make audio a priority. What are the sounds you want the audience to hear? Where do you need to place your microphone to capture those sounds (**Figure 9.1**)? Remember that audio completes the experience of the viewer; you need to think about it as much as you do the rest of your shooting. Here are a few guidelines to improve your audio:

- **Start with good sound.** Although you might record a narration track after shooting your footage or use sound effects and music to complete a project, you still need good audio from the field. This is especially true with interviews.

- **Are you listening?** When recording audio in the field, you should actually listen during the recording. Be sure to listen for any audio problems like pops, clicks, or distortion. Always wear headphones, preferably the over-the-ear kind.

- **Minimize noise.** If you're shooting in a loud environment, take action. You may need to move or relocate. Step farther away from a busy street. If there's an air conditioner running, ask if you can turn it off. You need to pay special attention when recording narration or interviews. Fortunately, just like there are filters that can make a photo look better, there are also filters to improve audio quality in postproduction.

FIGURE 9.1
A shotgun microphone mounted on your camera can capture much better background or ambient sound than your camera's built-in microphone. It works well because it records location sounds from where the camera is placed.

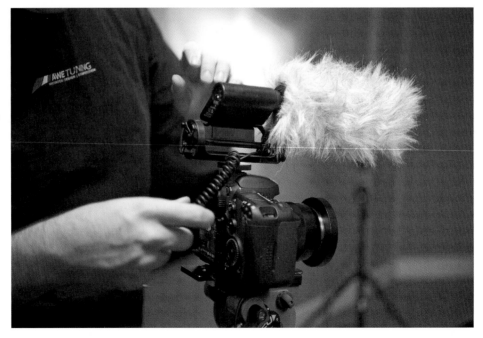

TECHNICAL ESSENTIALS OF AUDIO

Photography and videography have lots in common. After all, video is essentially several still images recorded in rapid succession. However, audio is pretty unique. For most people, the technical aspects of audio are largely foreign (**Figure 9.2**). Let's quickly explore some of the fundamental audio concepts; we'll explore specific techniques later in the chapter.

SETTING YOUR CHANNELS

Are you old enough to remember the days of mono records and tape? Did you grow up listening to AM radio? These days stereo audio is the norm, and even multichannel surround sound is pretty common. Mono, stereo, and surround are all terms that describe how audio channels are configured:

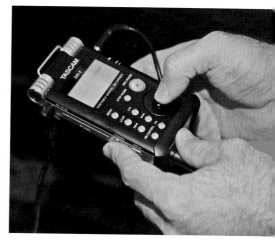

FIGURE 9.2
An external audio recorder offers many options, including channels, sample rate, and file format.

- **Mono.** With mono, only a single channel of audio is recorded. For example, if you plug one microphone into your camera, that microphone is generally recorded to one channel.

- **Dual mono.** Often confused with stereo, dual mono systems record separate mono channels to the left and right channels of a camera. Some single microphones record this way as well.

- **Stereo.** Stereo recording allows for separate left and right channels, and a mix between them. Some microphones are really two pickup devices or a stereo microphone, meaning the microphone will record to both the left and right channels. If you're using an external audio recorder, it's much easier to put a different audio source onto each track.

- **Multichannel.** Multichannel is sometimes referred to as surround sound and usually records two or more channels of audio. This type of audio is typically created during the editing stage.

Most video-enabled DSLR cameras will record either mono (single channel) or stereo mixed audio. You are free to add additional channels when you complete your final edit.

SAMPLING RATE

The *sampling rate* of your audio equipment describes how many times per second the analog audio source is sampled when converted to a digital file. Audio is an analog medium caused by the compression of air, which creates sound waves. This analog noise is converted into a digital file by your microphone and DSLR camera.

When you look at the files created by your camera or by additional audio hardware, you'll often see numbers like 44.1 kHz or 48 kHz, which is the sampling rate of the audio being recorded. As a general rule of thumb, the higher the sampling rate, the better the audio quality. For example, audio made for a Web presentation might use a sampling rate of 22 kHz, and as a result will sound somewhat muffled. But audio recorded at a sampling rate of 48 kHz will sound clear.

WHAT IS KHZ?

The abbreviation kHz (kilohertz) is a fancy way of indicating that the electrical frequency cycles 1,000 times per second. A sampling rate of 48 kHz literally means 48,000 electrical cycles per second.

Chances are your DSLR will record audio at 48 kHz, although some may record at 44.1 kHz. If you choose to use an external audio recorder, you'll find some that can record up to 96 kHz and even 192 kHz. You typically won't use these higher rates, which are usually reserved for professional musicians or audio engineers.

BIT DEPTH

You might be familiar with a photographic concept called *bit depth*, which represents how much information is used to describe color in a file. JPEG images are typically 8 bits per channel, whereas camera raw files can be 10 to 16 bits per channel. Well, the same holds true for audio.

A high bit depth allows for smoother blending between frequencies in the audio portion of your file. A high bit depth can also provide an expanded dynamic range. Most DSLR cameras record at 16 bit. However, you can find external recorders that record at higher bit depths, such as 20-bit and 24-bit audio. These are usually overkill for dialogue but can help to produce quality sound when recording musical performances.

MICROPHONE PICKUP PATTERNS

When you start to explore microphones, you'll discover that they have different purposes. Some are designed to pick up sound at a close range (like a vocal mic), whereas others pick up sound from far away (like a shotgun microphone). All microphones have a directional area that defines where they are most sensitive to sounds. This pickup area has a distinct shape known as a *polar pattern*.

Here are the most common microphone polar patterns:

Omnidirectional. If you need a microphone that picks up a lot of sound, choose an omnidirectional microphone. An omnidirectional microphone's response is equally sensitive to audio coming from all directions. This style of microphone picks up sound in a spherical pattern and works best for controlled sets without much background noise.

Cardioid. The most common style of microphone has a cardioid pickup pattern (named for its heart-shaped pattern). The benefit of this mic is that it is unidirectional, which means it is more likely to pick up the sounds in front of the microphone instead of sounds coming from the back (like the camera operator).

Hypercardioid. This mic pattern is an exaggerated version of the cardioid pattern. It is very directional and eliminates most sound from the sides and rear. Hypercardioid as well as the previously mentioned cardioid pattern are commonly used as vocal or speech microphones, because they are good at rejecting sounds from other directions.

Shotgun. Shotgun microphones are highly directional. They have small areas of sensitivity to the left, right, and rear but are significantly less sensitive to the side and rear than other directional microphones. This type of microphone is often mounted on top of a DSLR camera to pick up sounds farther away.

RECORDING AUDIO WITH THE INTERNAL MICROPHONE

The microphone quality of DSLR cameras falls well below the cell phone in your pocket. It is low quality and worthless for all but the most basic tasks. Because the microphone is too close to the lens and camera mechanisms, it is prone to picking up unwanted noise (**Figure 9.3**). You can use this microphone to record background noise or as a sound bed, but it will fail when you try to capture higher-quality audio like conversations or performances.

Why would manufacturers offer such inferior mics? I have two theories. The first is to save money. Most people buy a DSLR camera primarily for taking photos. So the manufacturer skimps to save a couple of bucks in cost. My second theory is just that they don't know any better. Most DSLR manufacturers have little to no experience recording sound (just taking great images).

FIGURE 9.3
The built-in microphone on a DSLR is virtually useless if you're concerned about recording quality audio. You'll use it for reference and backup, but that's all it's really good for.

AUTO GAIN CONTROL

Many DSLR cameras have an Automatic Gain Control (AGC) option. AGC attempts to automatically adjust your audio levels based on the relative level of sound that the camera "hears." This option does not work well because the camera is constantly adjusting audio. If you can turn off this option, do so.

RECORDING AUDIO WITH AN ON-CAMERA MICROPHONE

One of the most popular purchases of DSLR owners is an external microphone that mounts to the top of your camera and plugs into the audio jack on the side of your camera (**Figure 9.4**). Typically, these mics have a shotgun-style pickup pattern, which means they're good at picking up audio from far away.

External microphones are useful for getting sound in "run-and-gun situations" when you just need to shoot as quickly as possible (or don't have an extra set of helping hands). If you're on vacation, at a sporting event, or roaming around just shooting footage, a shotgun mic is a great choice because it's easy to use and picks up a lot of sound.

The only drawback is that a shotgun microphone can sound a little hollow. If you need to record dialogue, conversations, or interviews, you may want to invest in some additional audio gear like a lavalier microphone.

RECORDING AUDIO WITH A LAVALIER MICROPHONE

If you need to record an interview, the most professional choice is a lavalier microphone (or lav mic). This type of microphone can effectively isolate the sound from a subject you're recording. A lavalier mic is usually placed on the front of a subject's clothing or collar (be sure to keep it from rubbing against anything else) (**Figure 9.5**). It also tends to not pick up as much background noise because it is placed so close to the desired subject. A lav mic sounds *much* different than a shotgun mic because it tends to have richer sounds for vocals (this is largely due to how close it is placed to a subject's mouth).

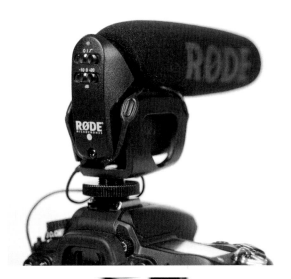

FIGURE 9.4
Using the Rode VideoMic Pro is one way to significantly extend the audio recording capabilities of your DSLR camera.

FIGURE 9.5
Using a lavalier
microphone is a
discreet way to
place a microphone
close to your sub-
ject's mouth. Photo
by Lisa Robinson.

The most affordable lav mics that you can purchase are wired, meaning that you'll have to connect them directly to a recording device (like your camera or external audio recorder) (**Figure 9.6**). You can also use a wireless microphone system that sends audio to a receiver that can be connected to your camera. The advantage of a wireless microphone is that your subject is free to move around.

FIGURE 9.6
Most lavalier
microphones use
a professional-
style XLR audio
connector.

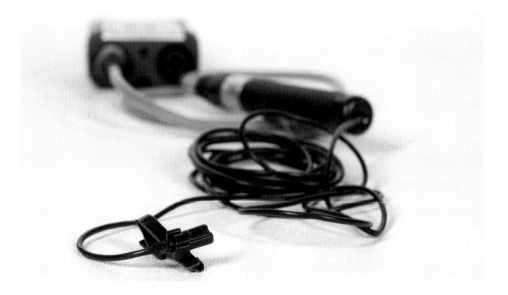

NEED TO HIDE A LAVALIER MIC?

An old trick of the trade is to hide lavalier microphones inside clothing. An easy way to do this is with an adhesive bandage. Just leave the microphone sticking out a bit above the top of the bandage when you adhere it.

THERE'S NO REPLACEMENT FOR MIC PLACEMENT

With any microphone, placement is critical. The closer you can get the mic to the source that you want to record, the stronger (and cleaner) the signal (**Figure 9.7**). Taking the time to place mics accurately is the answer to audio problems, like noise or hollow-sounding audio. Here are a few tips:

- **Microphone rub**. Although lavalier mics allow you to place them very close to your subject, try to avoid having the microphone rub against clothing.

- **Getting too close**. Proximity is important, but there is such a thing as getting too close. When the mic is too close, it can become overloaded, which distorts the sound. Most of the time you should place the mic 6–12 inches away from the source (or the distance between your outstretched pinky and thumb).

- **Work with the pickup pattern of the mic**. If you're using a shotgun microphone, position it so it can capture the directional audio it's capable of recording. Make sure it's pointed directly at the subject, not something else. When using a lavalier mic, make sure it stays pointed near your source's mouth and that it doesn't rotate and turn sideways or upside down.

FIGURE 9.7
Try to place a lavalier microphone within 12 inches of the subject's mouth.
Photo by Lisa Robinson.

RECORDING AUDIO WITH DUAL SYSTEM SOUND

The most popular approach for capturing sound when using a DSLR camera is the same used by the film industry—dual system sound. This means that you have two "systems" for recording: one for audio (a dedicated audio recorder) and the other for video (your DSLR camera). This method is popular because you and the camera can move freely (with no cables connecting the microphone). If audio is critical, the best solution is to record files to a second device (**Figure 9.8**).

Dedicated audio recorders produce higher-quality audio for several reasons:

• Higher-quality file formats can be used.

• Audio can be sampled at a higher frequency for greater quality.

• Professional-grade microphones can be used.

• The microphone can be placed significantly closer to the subject. Generally, the microphone should be within 6–12 inches of the person talking. Untethering the microphone from the camera makes it easier to hide wires and leaves you freer to move around.

FIGURE 9.8
Manual audio recorders offer easy to access controls and audio meters to help accurately monitor and adjust recording levels. Photo by Lisa Robinson.

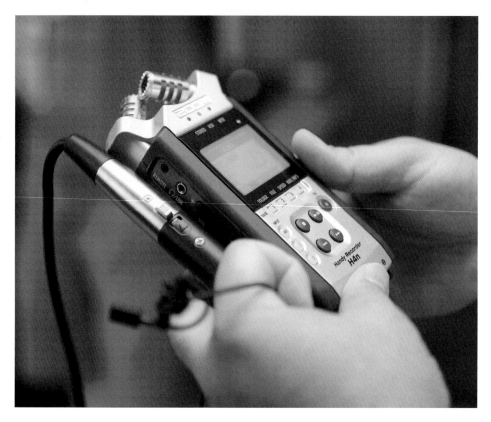

RECORDING WITH A SMARTPHONE APPLICATION

One affordable option to use as a dual system sound device is a smartphone (like an iPhone or an Android phone) to record sound. Several high-quality recording applications are on the market that typically cost between $5 and $50. Do your best to avoid recording to compressed MP3 files, because with these files you'll lose a lot of audio fidelity from the original source. One of my favorite apps is Pro Audio To Go (www.revuptransmedia.com) for the iPhone, which can record to uncompressed AIFF audio files.

For any of these applications, you'll likely need an XLR adapter to connect a professional microphone to your phone. Although some microphones include a 3.5mm plug (the standard connection on a phone), most do not. Cable options run between $10 and $30 depending on the connection type you want (XLR, phono plug).

RECORDING WITH A DEDICATED RECORDER

Several different brands of dedicated audio recorders are on the market (**Figure 9.9**). Most record to either removable media like a Secure Digital (SD) card or to internal flash memory. Be sure to avoid those that use the more heavily compressed options (such as MP3). Most editing applications can accept an AIFF or WAV file that's recorded at 48 kHz and 16 bits per channel.

Many manufacturers of digital audio recorders exist, but I've had great experiences with the following:

- H4n and H2n from Zoom (www.zoom.co.jp)
- DR and HD series from Tascam (www.tascam.com)

FIGURE 9.9
The Zoom H4n is a popular external audio recorder that allows for pro-quality audio connectors and sampling rates.

SYNCING AUDIO IN THE FIELD

If you choose to use a sync sound approach (where you record on two devices), you'll need to actually provide the sync point. When you edit your footage, you'll want to have audio on both your camera's sound track (using the built-in or better yet an external shotgun mic) and on the audio recorded (with the dedicated audio device and a professional mic). Additionally, you should have a visual sync point on the video clip. Having multiple reference points makes it easier to synchronize the different sources (a process covered in Chapter 11, "Editing Essentials"). Here are a few tips for syncing sound in the field to make editing your audio and video together easier:

FIGURE 9.10
A clapboard is a traditional film and video production tool that's been used for many years.

- **Use a clapboard.** There's a reason film productions use a clapboard (**Figure 9.10**). When picture and sound are recorded to two different systems, it makes it easy to synchronize when editing, because there are visual and audio cue points (**Figure 9.11**). The slate can also display information about the shot or production. A quality clapboard will run you about $35, and it's money well spent (plus you'll feel official). This well-proven syncing method has been used in film production since its start.

FIGURE 9.11
The clap of the clapboard produces an easy-to-see spike in the audio waveform. You'll use this when editing to help sync up your higher-quality audio with the original video.

- **Use a slate application.** Several applications exist for smartphones or tablets that allow you to load information about the production (**Figure 9.12**). They can also generate a countdown and a sync point. These applications will typically make a noise and flash the screen white for an instant to make syncing easier when editing.

- **Use your hands.** A clapboard is nice to have, but it often gets forgotten or misplaced on set. In a pinch you can make your own visual and audio reference sync points. The easiest way to do this is simply by clapping your hands and recording the sound to video and audio (**Figure 9.13**).

FIGURE 9.12
A slate application (like DSLR Slate) can help you clearly sync and organize your production in the field.

FIGURE 9.13
Your hands (or a colleague's) can create a sync marker as well. Just be sure your camera is securely attached to the tripod before you let go of it.

MONITORING YOUR AUDIO

Could you take great pictures with your eyes closed? Probably not. Well, the same holds true for audio. Just because you're recording sound doesn't mean you're capturing good sound. You need to hear what you record, while recording, if you want to be confident that it's right.

How else would you notice if the battery in your microphone died, or if the cable you were using had a short in it? Don't assume that all you have to do is plug in a microphone, set levels, and walk away. That is a recipe for disaster! Fortunately, you can purchase a good set of headphones for under $100 (**Figure 9.14**).

Although you might be tempted to use the earbuds from your iPod, their design will prevent you from isolating the audio of your recording. I strongly recommend over-the-ear headphones. By actively monitoring your audio, you'll be able to adjust for problems when they occur (instead of trying to solve problems after the fact).

When recording audio, make sure the sound is not too loud; otherwise, the audio will be distorted. Some audiometers use colors to show distortion (which can result in clicking, popping, or buzzing in the audio track): Yellow is a warning, and red means the audio is distorted. Additionally, some audio recorders use a numbered system. The maximum target on a digital scale is -6 dBFS (**Figure 9.15**), but you should average levels around -20 dBFS to -10 dBFS for the best sound.

FIGURE 9.15
Most audiometers will bounce continuously in time with your audio. However, they will leave a trace mark to show the peak levels recently achieved. The trace marks will typically hold for a few seconds or until a louder sound pushes them higher.

Share your results with the book's Vimeo group!
Join the group here: vimeo.com/groups/DSLRVideoFSTGS

Backing Up and Organizing Your Footage

After shooting great footage, the last thing you probably think about is backing up that footage (but for the 5 percent of you who do, you're smart and well organized). But the truth is, if you lost your footage, it might be impossible to replace it. Taking the time to make sure your footage is safe is essential. Additionally, a little organization before you import your footage into your editing software will go a long way toward speeding up the tasks at hand.

Photo by Lisa Robinson.

A PRACTICAL WORKFLOW

When video pros talk about their process, they call it a *workflow*. Although that
may seem like an inflated term, it's actually very fitting. The goal is to literally make
the work process flow more smoothly. Having a clear path that's easy to follow and
backing up your footage ensures that this will happen. The last thing you want to do
is accidentally erase a card before it's been properly backed up (**Figure 10.1**). So, let's
explore a simple workflow that should work for DSLR video projects:

- **Mount memory cards.** You should use a dedicated memory card reader or a USB
 cable between your computer and camera to mount the cards on a computer. Both
 will let you read the cards like any other disk and use the data on your computer.

- **Transfer footage to a backup drive.** After you mount a card for the first time,
 transfer the footage to your backup drive. This drive should be a dedicated drive
 that you only use to keep a copy of your footage. Maintaining a copy on a sepa-
 rate drive (that you don't work with) ensures that you're protected against a drive
 crash or accidental data loss. Be sure to leave this drive plugged in. Drives left
 unpowered for a long time can experience data loss.

- **Transfer footage to an edit drive.** When you return to your primary computer,
 transfer your footage to a drive dedicated to video editing. This should be a drive
 that's separate from your computer's built-in hard drive.

- **Archive data for long-term storage.** If you really want a true backup, consider archiving your data using a long-term media format (such as DVD or Blu-ray discs). This process can be a bit time-consuming and can be performed slowly over time.

IN THE FIELD OR ON A TRIP?

When I go on a long trip, I always bring two drives with me. I make sure I transfer all of my footage to both drives so I have two copies. If I have enough memory cards, I also try to avoid erasing them until I return home. If that's not an option, I still have both drives. Be sure to pack one drive in your carry-on and one in your checked luggage to reduce the chance of losing your footage.

CHOOSING A CARD READER

There are two reasons to invest in a good memory card reader (**Figure 10.2**). The first is speed; you'll want to get the data off the card as quickly as possible. Video files are much bigger than still photos (after all, you're shooting 24–60 frames per second). Having a fast card reader will speed up the process of transferring data to your drive or computer.

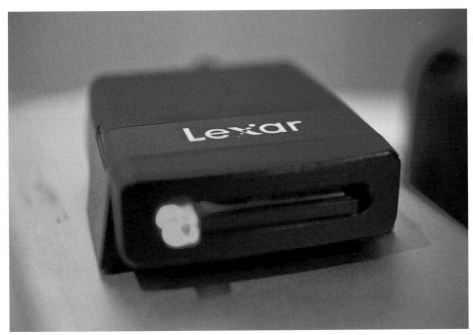

FIGURE 10.2
A fast card reader will speed up the transfer of your footage. This device from Lexar connects to your computer via a FireWire 800 connection. Photo by Lisa Robinson.

The second reason is to avoid wear and tear on your camera. Although most manufacturers include a USB port on their cameras, you don't want to risk damaging your camera's mini-USB connection because it's directly attached to the main circuitry of your camera.

Here are some considerations to think about when choosing a card reader:

FIGURE 10.3
Make sure your memory card reader is firmly connected to your computer. If it unplugs accidentally while data is transferring, you can corrupt files. Photo by Lisa Robinson.

- **Connection type.** Make sure you use a fast connection port. Although a USB 2.0 or 3.0 connection is very fast, you can also turn to FireWire for speedy transfers (**Figure 10.3**). If your computer offers an ExpressCard or Thunderbolt connection, these are quite speedy too.

- **Bus power.** Choose a reader that's bus powered, which allows for the card reader to operate without the need for external power. It can simply run by using the connection bus to your computer, like FireWire or USB.

- **Speed.** Transferring footage quickly mostly depends on card speed, but a slow card reader can handicap even a fast card. I use a FireWire 800 reader to transfer my footage.

- **Multiple slots.** Some card readers offer two or even four slots, which are handy for loading additional cards. These readers let you load multiple cards and then walk away while the computer works.

CHOOSING HARD DRIVES

As you start to shoot more and more video, you'll notice that your need for more hard drives will increase because video files are fairly large. You'll fill up a 16 GB memory card in about an hour of shooting. At this rate, it's no wonder that you'll outgrow your existing drives quickly.

Additionally, video editing places extra demands on your storage. For the best computer performance, you should store your video files on a separate hard drive. This allows your computer to access its applications and operating system while reading large video files from a separate dedicated drive (**Figure 10.4**). Toss in the additional problem that many editing software applications convert your video to a larger file format (to make it easier for the computer to use), and you'll quickly see your hard drive usage spike.

BETTER DRIVES

If you can afford it, using a performance RAID (Redundant Array of Independent Disks) can really help. With a RAID 0 configuration, two hard drives work in tandem to handle the increased demands of editing video.

FIGURE 10.4
Both of these drives offer RAID 0 performance: One is a desktop drive, and the other is meant to be portable for laptop use. RAID 0 means that two drives are in each case and split data evenly across the two disks (referred to as *striped*) to work more efficiently for the higher data throughput demands of video editing.

FIGURE 10.5
Many higher-
performance drives
offer multiple con-
nection types. This
drive has USB 2.0,
FireWire 400, and
the faster FireWire
800 and eSATA
connections.

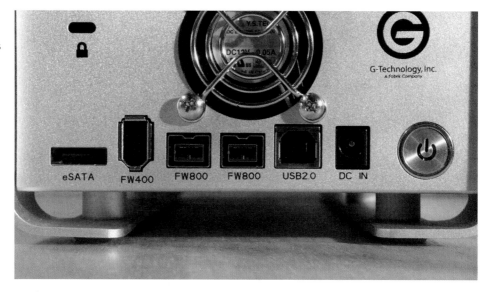

INTERFACE TYPES

The first factor to consider when choosing a hard drive is its interface type. Make sure your computer can connect to the drive; if not, it won't be very useful. Additionally, different interface types offer different data transfer speeds (**Figure 10.5**). Because video editing involves working with large files, you'll want to use the fastest one available to you.

Let's take a look at the most common connection types.

FIREWIRE

FireWire has become the most common standard connection type for those editing video (you may also hear it referred to as iLink or IEEE 1394) (**Figure 10.6**). Currently, two varieties of FireWire are in wide use: 400 and 800 (IEEE 1394b). The number refers to the data transfer speed: 400 and 800 Mb/second.

Additionally, there are three types of connectors: 4pin, 6pin, and 9pin. The 6pin and 9pin options are most common for hard drives. You may also need to get a special 6pin to 9pin converter cable to make the drives work on your computer. An advantage of FireWire drives and laptop computers is that both the 6pin and 9pin connectors can carry power to run a bus-powered drive from your laptop's internal battery or your computer's power supply. This means that you can edit without having to find additional outlets to plug your drives into (which improves portability).

FireWire

FIGURE 10.6
Look for the official
FireWire logo when
choosing a drive.

USB

The Universal Serial Bus (USB) port has emerged as the most common computer connection in use. USB comes in three varieties: 1.1, Hi-Speed 2.0, and Super-Speed 3.0 (**Figure 10.7**):

FIGURE 10.7
If you're considering a USB drive, look for the newer USB 3.0 interface for the best performance. It's also backward compatible with USB 2.0.

- **USB 1.1** has a transfer speed of 12 Mb/second. This connection speed is OK for mice and keyboards, but not OK for data transfers unless you want to wait all day for data on a memory card to transfer to a drive.

- **Hi-Speed USB 2.0** has a much more respectable transfer rate of 480 Mb/second. In practice, USB 2.0 is not as fast as FireWire due to the way computers handle the ports.

- **Super-Speed USB 3.0**, the newest standard, is just starting to emerge. It supports transmission speeds up to 5 Gbit/sec. This specification is very fast and works well for video editing. At the time of this writing, Apple has not added USB 3.0 to the Mac platform, making it a Windows-only solution for now.

Keep in mind that a USB connection is subject to slowing down if there is a slower device on the bus. So, be sure to use a hub with multiple ports and keep your slower peripherals, like your printer, keyboard, and mouse, plugged into a different port.

SATA

Serial ATA (SATA) is the most common drive interface available today and is widely used in desktop and laptop computers (**Figure 10.8**). If you want to use an external drive with SATA, you may need to add a special card to your computer to expand its ports. If you have an open slot in a tower computer that you want to fill with a drive, SATA is the likely connection type.

FIGURE 10.8
The SATA logo identifies devices that adhere to the Serial ATA standards.

Additionally, SATA comes in a few flavors. The original spec referred to as SATA I runs at 150 MB/second. SATA II, which is most common today, runs at 300 MB/second and is backward compatible with SATA I. SATA III has been announced but is not commercially available yet. SATA III units will be able to run at up to 600 MB/second. However, real-world speeds will often be slower due to compromises made by drive manufacturers in regard to the quality of all the other components of the drive.

DRIVE SPEED

The speed of a drive is another important factor you need to consider when selecting a hard drive. The rate at which a drive spins is typically measured in revolutions per minute (rpm). Portable field drives that use mechanical drive units will usually come in one of two speeds: 5400 or 7200 rpm. Desktop drives are available at those speeds or faster speeds (such as 10,000 and 15,000 rpm). The faster a drive, the more expensive it is in a general sense. Be sure to select a faster drive speed (like 7200 rpm) to accelerate the transfer of your camera memory cards as well as to improve performance when editing.

SELECTING A PORTABLE DRIVE

If you plan on editing your video on a laptop, or you need to carry your drive between locations, you'll want to invest in a portable drive. This class of drive is typically a laptop-sized drive in a bus-powered case (**Figure 10.9**), which makes the drive small and easy to transport.

FIGURE 10.9
This portable USB 3.0 drive provides fast enough speed for most DSLR editing tasks.

Here are a few details to look for when choosing a portable drive:

- **Bus power.** You don't want to lug around extra power adapters with you, so be sure to select drives that can be bus powered from your computer's battery or power supply.

- **Speed.** Portable field drives that use mechanical drive units (unlike newer solid state drives) will usually come in one of two speeds: 5400 or 7200 rpm. Select the faster speed to facilitate rapid transfer of camera memory cards.

- **Connectivity.** Be sure to select a drive with varied connectivity. Drives with connections for FireWire 400 and 800 or USB 2.0 and 3.0 are good choices for portable drive units.

SELECTING AN INTERNAL DRIVE

If you're using a desktop computer, especially a tower, you may have an open slot that can hold a second drive. You can add additional storage on your own pretty easily on most computers (or have it serviced by a professional). When choosing an internal drive for video editing, be sure to purchase one with a fast rpm option (either 7200 or 10000 rpm) (**Figure 10.10**). Additionally, you should avoid the lower-power solutions (often labeled or advertised as green drives) because they are not as efficient for editing large video files.

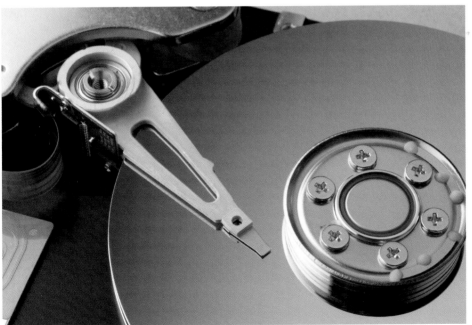

FIGURE 10.10
Internal drives come in several classes. For video editing tasks, make sure you choose a server-class drive. These are often referred to as black drives, but you'll find the drive class on the packaging or in the manufacturer's description. Photo by iStockphoto.

SELECTING AN EXTERNAL DRIVE

If you've maximized your internal storage options, you may still need some external space. Adding a full-sized external drive lets you easily expand your storage choices. If you choose a drive that uses its own power supply, you can get a drive that is even higher in performance than your internal storage.

Most of the same suggestions for portable drives apply to external drives. However, you can also take advantage of a RAID (**Figure 10.11**).

Basically, RAID is a technology that allows multiple drives to act as a single drive. This combination has two major benefits (which can be exclusive of each other). First, a RAID can offer a big boost in drive performance because the drives work together. Second, you can set up a RAID so that data is redundant, which means that a drive can fail with no loss in data.

Here are the simple options when choosing a RAID:

- **RAID 0** is a striped array, meaning there is no redundancy, but speed and through-put are at their maximum.

- **RAID 1** is a mirrored array, meaning that if you have two 2 TB disks for a total of 4 TB, you'll actually only have 2 TB of storage; the other 2 TB is used as a mirrored drive.

- **RAID 5** allows for parity data spread across disks, meaning that you can have one disk fail and you won't lose any data. Because the data lives on both drives auto-matically, you can have one of the two drives fail. After a failure, you can rebuild the RAID array.

- **RAID 6** is similar to RAID 5. The data is automatically spread across the array. But unlike RAID 5 with one backup drive, you can actually lose two separate drives.

FIGURE 10.11
A Drobo Pro pro-vides redundancy and speed, which makes it a great combination for video editing.

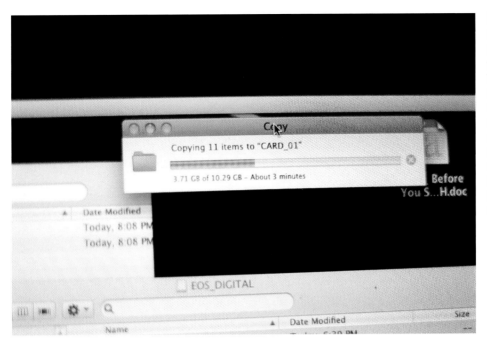

FIGURE 10.12
Make sure you take
the time to verify
your copied data.
Visually inspect
the copied files and
make sure the file
count and the size
match the original
source. You should
also spot check a
few files and open
them to make sure
the data is valid.

TRANSFERRING YOUR FOOTAGE

Although you're probably in a hurry to start editing your video, I recommend that you slow down when transferring your footage (**Figure 10.12**). You want to be certain that the data has successfully been copied to multiple drives before you clear a memory card. After all, this is the only chance to get things right. Once you've erased a card, the data is gone.

Here is a practical data transfer workflow I recommend.

1. Take a quick assessment of the cards that you need to transfer. How many cards do you have? About how much data do you need to transfer?

2. Make sure you have enough drive space to hold the files once they're transferred.

3. Place all of the cards to be transferred into one pile with the label side facing down.

4. Make a new folder on your backup drive for each project. Copy each card to your backup drive. Be sure to copy the entire card folder structure (not just the video files). The metadata created by your camera to describe the clips may be contained in other folders and may be needed by your software tools to properly use the video files.

5. Place each card you've finished copying into a new pile (moved a noticeable distance from the initial pile) with the label side up.

6. Make a new folder on your second drive (used for editing) for each project. Copy the cards (and their entire folder structure) to your editing hard drive.

7. Reformat each of your memory cards in your digital camera.

8. Place each memory card back into its case or a card wallet.

COPY ALL FILES AND FOLDERS

Be sure that when you're copying your memory cards, you copy all of the folders and files off the original memory card. Although you could just copy the video files (usually located in a DCIM folder), it wouldn't be a complete backup of the original memory card.

ORGANIZING YOUR FOOTAGE

After copying all your footage from your memory card to your hard drives, you should have a folder for each memory card if you followed my advice. This means you are partially organized.

Now you need to review your footage and identify which shots you like as well as those that are garbage. In the pro video world, this is known as *making selects*. The benefits of choosing the best video clips early on is that it reduces how much footage you need to import (and possibly convert) for your editing application. The less footage you have loaded, the easier it is to find the clips you're looking for.

VIEWING FOOTAGE

The best way to view your clips is at full size and by playing them back in real time (**Figure 10.13**). This makes it easier to judge issues like focus and exposure (your two greatest problems with DSLR video). There are two ways to do this: through your operating system or your editing software.

THE SYSTEM LEVEL

The easiest way to view your footage is by using your computer's operating system. If you're working on a Mac, you can watch video clips by using the Quick Look option (just select a clip and press the spacebar). This lets you watch a clip in real time. You can then use labels to color code the keeper clips. With Windows you'll find a similar Quick Preview feature in Windows 7 and later.

FIGURE 10.13
Looking at your footage on a computer lets you see the footage at a higher resolution. You can also use evaluation tools like scopes to measure color.

You can also use your built-in media player to view the clips. For most DSLR media, I recommend the QuickTime Player software. If you don't have this application, you can download the free version from www.QuickTime.com.

YOUR EDITING SOFTWARE

If your editing software can work natively with the footage (that is, without converting its file format), you can import all of the transferred footage to view it. You can then use the built-in organization features of your editing software, like folders (bins), labels, keywords, and so on. Be sure to actually delete (or hide) the unwanted clips from your project (don't worry; they'll still be on your hard drive if you need them).

MAKING SELECTS

After viewing your footage, the next step is to make selects. The goal here is to further refine the clips you actually want to use in your editing project. The reason for doing this is simple: By the time you start editing your project, you don't want to have to search through a huge amount of footage to find exactly what you want. Being discriminating earlier on will make the editing easier because you won't be inundated with too many choices.

THE COMMON MEDIA FOLDER

Working with video for nearly 25 years, I've noticed one common trait. You can quickly amass a lot of footage without a lot of inherent organization. So, I've developed my own method to tame the beast; it's called the *Common Media* folder (**Figure 10.14**). Although this workflow is optional, I highly recommend it.

Essentially, you'll create a series of folders to help organize each project. Each subfolder is assigned to a specific part of a project. This approach works with all editing software. Here's the basic subfolder structure of the Common Media folder and how it works:

- **01 Original Footage.** This folder is where you copy footage from your memory cards.

- **02 Selects.** After viewing your footage, you can copy selects to this folder. If you can work with camera native footage in your software, this is the presorted footage that should be imported into your editing application

- **03 Transcoded Footage.** If your workflow needs it, you'll transcode footage to this folder (see "The Option of Transcoding" section). You can then import this folder directly into your editing application.

FIGURE 10.14
Setting up a standard folder structure for each project helps you stay organized.

- **04 Project Files.** Save project files from editing and other applications here. Also, use an Old Projects folder to keep older versions separate from your current project.

- **05 Graphic Sources.** This folder contains any graphics project files for your project. You can use applications like Photoshop, After Effects, or Motion to create logos, titles, backgrounds, and more.

- **06 Graphic Exports.** This folder contains any animations you've generated.

- **07 Audio Sources.** If you've recorded audio to a separate recorder, place those files here.

- **08 Stock Footage.** If you've purchased any footage from a stock company, place it here. You can also put footage that comes from older projects here.

- **09 Exported Files.** I like to keep all of my exports in one place. Any Web, DVD, or portable media files should be placed in this folder.

- **10 Production Paperwork.** Most projects will have additional files, like scripts, log notes, and more. Store these in one location for easy reference.

THE OPTION OF TRANSCODING

The practice of transcoding essentially converts the footage shot in your camera into another file format. This is typically done to make it easier for the computer to work with the footage during editing. Formats like H.264 are highly compressed, and as such, can require a lot of computer-processing power to decompress the files as they are transferred.

To improve performance, many pros transcode to a new file format optimized for video editing. This process often increases disk usage by six to ten times but reduces the load on the computer's processors. Compressing footage often uses RAM or your computer's graphics card. So, converting your footage up front by transcoding gets that step out of the way.

DO I NEED TO TRANSCODE?

A few years ago, transcoding was an absolute necessity. All footage had to be transcoded into another file format just to be able to work with it in an editing application. Typically, this transcoding task was and still is done by the nonlinear editing software, but stand-alone utilities also exist (see the next section).

You may need to transcode your footage if your computer or editing software meets any of these conditions:

- **32-bit operating system.** If you're using a 32-bit operating system, each application can only use 3 GB of RAM (which can be a problem because video can be very RAM-intensive). Editing video typically involves playing back multiple streams of picture and sound. So, if you don't have a lot of RAM, editing can be very tough (and lead to the picture skipping, audio drifting out of sync, or even crashing).

- **Slow processors.** Working with camera native footage requires the video to be decoded on the fly. This task is much easier if you have multiple processors in your computer.

- **Older/feature-limited software.** Newer software applications are more likely to support camera native editing than older or feature-limited applications. Programs like Final Cut Pro X and Adobe Premiere Pro offer support for video shot with many DSLR cameras. If you're using software targeted to consumers or hobbyists, you're more likely to need to transcode your footage prior to editing.

SOFTWARE TOOLS FOR TRANSCODING

When it comes to transcoding, most editing tools offer their own solutions. For example, when you import into Final Cut Pro X, you can choose to optimize media, which is just another way of saying transcoding. The editing software will start to convert your footage in the background while importing.

FIGURE 10.15
Apple Compressor.

Although this is a valid workflow, many pros look for other software tools to make transcoding faster and easier. Using a dedicated transcoding application can let you set up multiple computers to tackle the job. It can also avoid the delay caused by some nonlinear editing software, which blocks you from working during the import process.

Here are some of my favorite tools:

FIGURE 10.16
Cineform
NeoScene.

- **Apple Compressor.** This Mac-only application is available in the Mac App Store for $49 (**Figure 10.15**). It is a full-featured compression and transcoding application that allows you to easily transcode footage from your DSLR. If you're using Compressor, you'll most likely use the Apple ProRes codec (compressor decompressor) to transcode to.

- **Cineform Studio or NeoScene.** Cineform makes compression utilities as well as its own video codec (**Figure 10.16**). The Studio bundle is a free utility for H.264 media that you can download from www.GoPro.com. The more robust NeoScene suite (www.cineform.com) costs $129 and supports more file formats. Both utilities convert files to the Cineform codec, which can be used by the Windows and the Mac platform.

FIGURE 10.17
MPEG Streamclip.

- **MPEG Streamclip.** MPEG Streamclip offers two benefits (www.squared5.com) worth noting (**Figure 10.17**). First (and foremost), it's free. Second, it's also very fast. The only downsides are that it does not offer any easy-to-use presets, and it relies on you to find or use your own video codecs.

HOW TO MINIMIZE TRANSCODING

I recommend avoiding transcoding if at all possible. The process is very time-consuming and can essentially tie up your computer completely for hours or even days. It also gets very expensive due to the increased use of hard drive space.

Here are a few simple strategies to avoid transcoding:

- **Choose your software wisely.** Many editing tools offer the ability to work with the material in the same format as that recorded by your camera. Be sure to look for the label "native editing" and check the tool manufacturer's website to see if your camera model is listed.

- **Be aware.** Try to shoot short clips. Instead of letting your camera roll freely, start and stop the camera often. This will make editing a lot easier and avoid wasted footage.

- **Be picky.** Chances are you'll shoot more footage than you need. By carefully screening your footage and preselecting your shots, you can reduce the amount of footage you import into your nonlinear editing software.

Share your results with the book's Vimeo group!
Join the group here: vimeo.com/groups/DSLRVideoFSTGS

Editing Essentials

The process of editing video takes your footage from simply living on your hard drive and turns it into something that you can share. Just as computers revolutionized photography, the process of editing video has changed drastically in recent years. Editing video on a computer is typically referred to as *nonlinear editing* because you can work on sections in any order (as opposed to the original tape or film style of editing that required a program to be built one shot after another in a linear fashion).

In this chapter you'll learn how to choose an editing tool and discover essential techniques for editing picture and sound. You'll also learn how video can be color corrected or even manipulated to improve its appearance. Learning how to edit takes time, and you'll likely need to choose a dedicated book or video for the specific editing tool you select. However, I'll attempt to give you a solid understanding of the core steps and technology that relate to editing video.

Photo by Lisa Robinson.

PORING OVER THE EQUIPMENT

Planning your edit system is a matter of balancing your budget and equipment. If you need to enhance the equipment you already own, you'll want to evenly spread your dollars to find affordable yet efficient devices. For example, a top computer that has very little RAM will just cause a bottleneck when it comes to editing. The same holds true if you skimp by using slow hard drives. Be sure to balance your budget and get the equipment you can afford while focusing on performance.

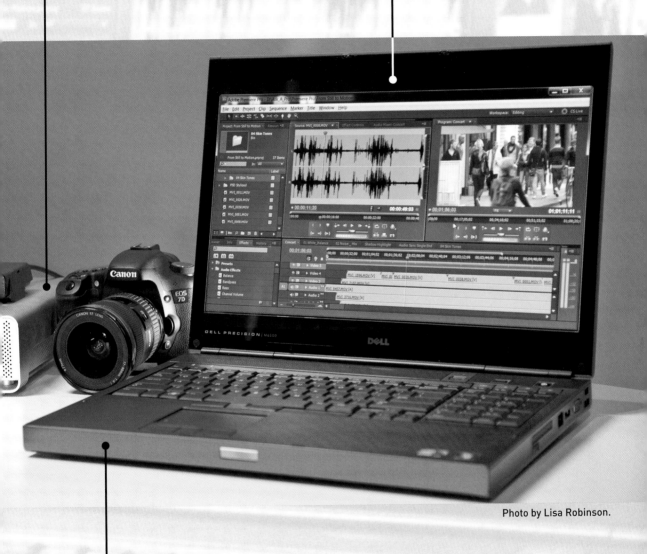

A FireWire 800 card reader speeds up footage transfer.

To make editing faster, the computer features lots of RAM (16 GB) and a fast graphics card (1.5 GB).

Photo by Lisa Robinson.

Instead of editing footage from an internal drive, a faster RAID 0 configuration is used, which pairs two hard drives together for better performance.

FIGURE 11.1
Final Cut Pro X is
a major revision to
traditional video
editing tools. It
offers a unique
approach to editing
video that many
new users find very
approachable.

CHOOSING EDITING SOFTWARE

Choosing which software to use for editing is a very personal (and sometimes dif-
ficult) choice. The process of editing requires a lot of thought and the ability to
make decisions. Because people think (and work) quite differently, several tools have
emerged (**Figure 11.1**). When choosing software, remember that there is no one-
size-fits-all solution. You'll need to balance your needs to select the right tool. The
following sections provide some selection criteria that you should be aware of.

COST OF SOFTWARE

When you're looking at editing tools, you'll quickly discover that they vary dramati-
cally in cost. For example, iMovie and Windows Movie Maker are included with Apple
and Microsoft's operating systems. Other tools that you can purchase for only a few

hundred dollars are quite powerful as well. And for the most advanced tasks of editing feature films or network television, systems can spiral into tens of thousands of dollars (and much higher). Always look at what you get for your money and weigh the benefits of speed and file support when choosing an editing tool.

EASE OF USE

Editing software programs often vary in their approach to the task. Some use the typical drag-and-drop method, whereas others require you to be more precise and carefully choose your shots. Tasks that seem easy to some will seem difficult to others. Ease of use is very subjective and depends on the individual user.

The key is to try out different applications before you buy. Most manufacturers offer time-limited demos (**Figure 11.2**). You can also use training materials like books, online video, and hands-on classes to try out the tools. Don't read too much into reviews or online forums; you need to find the tool that's right for you.

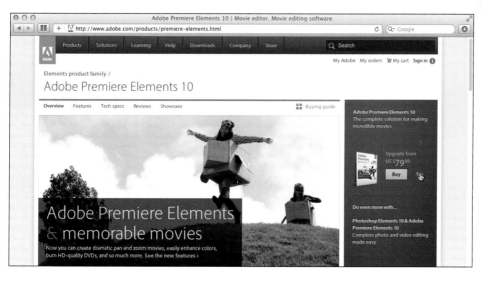

FIGURE 11.2
Adobe Premiere Elements is available as a free, 30-day trial download so you can see how it performs. Most manufacturers provide similar offers.

The biggest mistake I see is when people choose to go it alone and try to teach themselves how to edit video. Although you probably could have learned to drive a car on your own, it might have gotten really expensive if you had numerous crashes and fender benders. The same holds true with video editing. If you are going to invest in equipment and software, invest your time and money in learning how to get the most out of both.

FIGURE 11.3

Apple iMovie is a very easy-to-learn and use editing application. You will experience significant delays, however, when you first import your DSLR footage because the application converts its file format.

SUPPORTED FILE FORMATS

When you're looking at editing software, be sure to weigh your options. Most of the free tools will need to convert your DSLR footage into an optimized format (**Figure 11.3**). This means lost time and the expense of using up much more hard drive space. Some editing applications (such as Final Cut Pro X and Adobe Premiere Pro) offer support for native editing (meaning that footage can be used direct from the camera with no conversion).

NONLINEAR EDITING SOFTWARE OPTIONS

Many editing tools are on the market for you to choose from. They vary greatly in cost and feature set. Here are a few of the most popular choices that you should explore:

Adobe Systems (www.adobe.com)

- Adobe Premiere Elements (Microsoft Windows, Mac OS X)
- Adobe Premiere Pro (Microsoft Windows, Mac OS X)

Apple Inc. (www.apple.com)

- iMovie (Mac OS X)
- Final Cut Pro X (Mac OS X)

Avid Technology (www.avid.com)

- Avid Xpress Pro (Microsoft Windows, Mac OS X)
- Avid Media Composer (Microsoft Windows, Mac OS X)

Microsoft (www.microsoft.com)

- Windows Movie Maker (Microsoft Windows)

Sony (www.sonycreativesoftware.com)

- Vegas Movie Studio (Microsoft Windows)
- Vegas Pro (Microsoft Windows)

Grass Valley (www.grassvalley.com)

- Edius (Microsoft Windows)
- Edius Neo (Microsoft Windows)

CUSTOMER SUPPORT

Video editing can often be challenging because it requires you to master several skills. Therefore, you'll want to choose a product that offers extensive customer support options. Look at the software company's website for an active user forum. Does the company offer certified training classes? How many books or DVDs are published on the tool? Can you find a video podcast to learn new skills? Are there any local user groups sharing ideas and support? Are there any online communities to help you dig deeper (**Figure 11.4**)?

ESSENTIAL EDITING CONTROLS

Although every editing application behaves a bit differently, most have a lot in common. But be prepared to read and use the online help or documentation from the manufacturer (or pick up a dedicated book from Peachpit Press). In this section, I'll explore how most video editing applications work in a general sense. By understanding some of the tasks involved in editing, as well as the key terminology, you will find it easier to jump in and start editing.

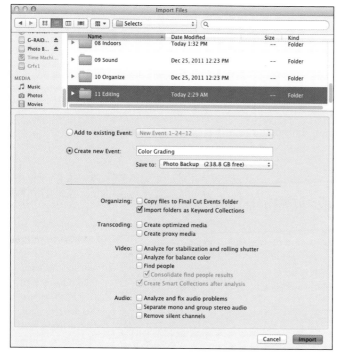

FIGURE 11.5

Final Cut Pro X gives you several controls when importing footage. You can choose how to organize the media, whether or not to transcode on import, as well as to analyze and automatically fix several audio and video problems on import.

IMPORTING MEDIA

Before you can edit your DSLR footage, you'll need to import it into the editing software. In the previous chapter you learned strategies for organizing footage at the hard drive level with a system of folders. These folders can often be imported by dragging them into your editing tool or choosing File > Import (**Figure 11.5**). The exact steps tend to vary greatly from tool to tool. This is one task for which you'll need to break out the software owner's manual or look for a specific tutorial from the manufacturer.

SELECTING AND LOADING A CLIP

Once the footage is in your newly created project, you can start to select and load clips. This is really the first step to editing. Typically, you'll browse through folders in a project (often called *bins*). You can often view thumbnails or preview images in the folder as well. You can then select the clips you want to use.

Usually, there are two ways to load clips for editing:

- Double-click a clip in your Project panel (**Figure 11.6**).

- Drag a clip from the Project panel to the Source Monitor or editing window where you can preview or view your footage.

Loading a clip lets you specify what part of the clip you want to use. In some editing applications you drag handles to specify a clip's range or duration. A more precise way is to use buttons or keyboard shortcuts to set In and Out (usually using the I and O keys on the keyboard) points.

FIGURE 11.6
The Source Monitor is typically located on the left when looking at two-monitor-style editing applications. It lets you control or prepare a clip before you add it to your sequence, as well as modify the clip later during editing.

TARGETING TRACKS

Once you've selected the part of a clip you want to use, you then need to set a destination (**Figure 11.7**). Video editing applications use tracks to hold clips. You can stack clips on top of each other to create composited images (such as text over a video shot) or complex audio tracks (such as music, sound effects, and narration). Precisely targeting tracks is essential.

FIGURE 11.7
A patch panel interface is common in many editing tools. It lets you route source tracks into specific destinations.

The technique you choose for adding clips to a track will vary based on your editing approach:

- **Dragging.** If you prefer to edit by dragging clips to tracks, you can target tracks by simply dropping a clip where you want it. This method is the least accurate and can lead to clips ending up in unintended places in your footage.

- **Pasting.** You can copy clips from one part of a sequence to another by using the Copy and Paste commands. You can often target specific tracks using the track headers at the edge of the Timeline panel or window.

- **Source Monitor.** The most precise way to edit is with the Source Monitor. You can use both audio and video source track indicators at the edge of your Timeline as well as target where you want the edit.

- **Three-point editing.** Knowledgeable editors know that the most precise edit they can make is a three-point edit. Ultimately, the three-point edit is defined by using a total of three marks. For example, you can mark an In and Out point in the Source Monitor to define the range of a source clip to use, and then in the Timeline (or Program Monitor) you can choose where that clip will start *or* end with a third point. Or, you can mark an In and Out point in the Timeline to define the range where the clip goes, and then mark an In *or* Out point in the source clip to define where it starts (**Figure 11.8**). There is no need to set a fourth point, because the application determines it for you. This method lets you set a range for the edit. You can define either what portion of the source you use or how long the clip should be in the Timeline. You can then choose a starting or ending point.

THE DANGER OF DRAGGING CLIPS

Do not get lazy and just drag and drop media into your Timeline when you need a precise edit. Taking the time to master a three-point edit ensures that you've accurately chosen your video source frames and a destination. Dragging and dropping, on the other hand, leads to a disorganized Timeline and can easily result in unwanted gaps.

ARE YOUR HARD DRIVES FAST ENOUGH FOR EDITING?

Do you plan on editing high-definition (HD) footage? If so, you'll likely need some fast hard drives. Here are a few simple tips when editing HD footage:

- Use the fastest drive available on your system.

- Never use the system boot drive; it is usually too cluttered with other applications and files to perform well.

- Investigate RAID 0 style hard drives, which have two drives striped together (splitting data evenly across the two drives) for efficient performance. This setup is essential for most HD formats.

- If your system supports serial ATA (SATA) drives, add two of them and stripe them together for the best performance.

FIGURE 11.8
By setting an In and Out point in the Source Monitor, I determined what part of the clip would be used in the Timeline (also called sequence). An In point set in the Timeline defines where the clip will be edited. The bottom figure shows the result of adding the clip; the sequence is now longer and has the chosen shot added to it.

OVERWRITE EDITING

The Overwrite edit is the most common command you'll use in most editing applications. Essentially, the selected video or audio frames are added to the Timeline, and if any existing material is already in place, the new material replaces it by overwriting it. The Overwrite edit is a fast way to quickly assemble your edited footage. The key with an Overwrite edit is to remember to accurately patch your tracks so the targeted tracks line up. This way the audio or video ends up in the correct location in the Timeline, and you don't accidentally erase a clip. For example, you would want to overwrite a speaker title graphic on top of a video clip, but not likely overwrite and remove the video clip of the speaker.

Here's how to create an Overwrite edit:

1. Open a sequence or project that you want to edit.
2. Select a clip and load the clip into the Source Monitor.
3. Mark a duration that you'd like to use as discussed previously (**Figure 11.9**).

FIGURE 11.9
In Adobe Premiere Pro (top), you'll set your In and Out points in the Source Monitor. Final Cut Pro X (bottom) has you set points on the clip thumbnail while browsing. Both use the standard I and O shortcuts for In and Out.

4. Place the playhead (or current-time indicator) in the sequence where you'd like to add the media. The playhead is a vertical line that acts a lot like a cursor but defines the location in time.

5. If necessary, make sure the tracks are properly patched to their correct destination.

 Drag the source clip track indicators so they map to the headers of the tracks where you want to overwrite the media.

6. In the Source Monitor, click the Overwrite button. If you're using Final Cut Pro, this button is labeled Append.

 The audio and video media are overwritten to the targeted tracks in your sequence (**Figure 11.10**).

INSERT EDITING

The Insert edit command is similar to an Overwrite edit command in that you must select part of a clip and choose a clear destination. The major difference is that an Insert edit will push any existing footage further down the Timeline (instead of overwriting it).

The Insert edit is best used when you want to preserve previously edited content but need to make an addition. For example, you might need to add an extra sound bite or add a shot to a series of clips that illustrate your story (often called *b-roll*).

Here's how to create an Insert edit:

1. Open a sequence that you want to edit.

2. Load a clip into the Source Monitor. Mark a duration that you'd like to use.

3. Place the current-time indicator in the sequence where you want to insert the media (**Figure 11.11**).

FIGURE 11.10
In Adobe Premiere Pro (top) and Final Cut Pro X (bottom) the selected clip is added to the Timeline. Any Timeline marks as well as patching will affect the duration of the edited material.

FIGURE 11.11
In Adobe Premiere Pro (top) and Final Cut Pro X (bottom) the editing result is the same. Simply place your playhead where you want the Insert edit to occur.

FIGURE 11.12
Adobe Premiere
Pro (left) and Final
Cut Pro X (right)
call the edit an
Insert edit. This
terminology is
in fact common
across most editing
applications.

Insert (,)

00:00:30:00

Insert the selected clip in the primary storyline
or the selected storyline - W

Typically, this will be between two clips, but you can also split an existing clip.

4. If needed, click to select the headers of the tracks where you want the Insert
 edit to occur. This specifies where the footage will be placed in the Timeline,
 vertically.

5. If needed, drag the source clip track indicators so they map to the headers of
 the tracks where you want to insert the media. This patching is simply connect-
 ing where the incoming video clip will be routed.

6. In the Source Monitor, click the Insert button (**Figure 11.12**).

 The edit occurs. The audio and video of the source clip are added to the sequence
 (**Figure 11.13**). Existing media is typically pushed to the right to make room for the
 new footage.

FIGURE 11.13
The media is
inserted and
pushes other clip(s)
further down the
Timeline. This
behavior is similar
in Adobe Premiere
Pro (top) and Final
Cut Pro X (bottom).

SYNCING SOUND

As you learned earlier (in Chapter 9), video-enabled DSLRs are capable of recording beautiful HD video but only barely usable audio. If you've chosen to employ a sync-sound approach to record sound, you'll need to merge the audio from your recording device to the footage recorded by your camera. For this process, you can take three different approaches.

MANUALLY SYNCING CLIPS

You may choose to manually synchronize audio in your nonlinear editing application. In this case you'll ingest your DSLR video footage (usually with reference or camera audio) and your high-quality audio from a digital audio recorder. You then must line up the audio.

Here's how the process typically works.

1. Load the desired video clip into the Source Monitor for your project.

2. Determine an In point where you want to sync the clip.

 Look for an easy-to-spot reference point, such as the use of a slate (**Figure 11.14**), clapboard, or hands clapping. You can look for a visual point in the video clip or for a spike in the clip's audio waveform.

3. Switch the video clip to clearly see the audio waveform. This may be in a tab in the window or an option on a pop-up menu.

4. Using the advance one frame buttons (or the common arrow shortcut keys), move the playhead to refine the In point (**Figure 11.15**). If needed, re-mark the clip's In and Out points.

FIGURE 11.14
The slate application counts down, and then has a one frame white flash (and a loud audio beep) to help with syncing footage.

FIGURE 11.15
The original In point was one frame off. Using the audio waveform view can help you edit more precisely.

5. Edit the video into your Timeline.

6. Load the sync-sound audio clip into your Source Monitor.

7. Using the techniques you used earlier, determine the correct position for an In point for the sync-sound audio track (**Figure 11.16**).

FIGURE 11.16
The audio sync point should be easier to see on the sync-sound track because it should be a better audio track (due to the microphone being closer to the subject).

8. In your Timeline, target an empty audio track and set a new In point that matches the start of the corresponding video clip (**Figure 11.17**).

FIGURE 11.17
Make sure you've accurately targeted your source and destination tracks before making the edit.

9. Edit the audio from the digital audio recorder into the open sequence, placing the high-quality audio on the lower audio track (**Figure 11.18**).

FIGURE 11.18
The better audio is added to your sequence below the reference audio source.

10. The clips are now in sync.

You can test this by disabling the reference audio tracks and checking sync (**Figure 11.19**).

FIGURE 11.19
Play back the sequence with only the video and sync-sound audio tracks enabled. Make sure that the picture and new sound do not drift apart and lose synchronicity.

11. You can then trim or cut away any extra audio.

Feel free to delete the original camera audio and just leave the higher-quality audio in use. If your editing application supports linking (**Figure 11.20**) or merging these synced clips, this can make editing easier when you need to move or reposition the clip in your editing Timeline.

FIGURE 11.20
I first unlinked the original audio and deleted it. The new audio was then trimmed to match the duration of the video clip and moved immediately below it in the Timeline. The new audio and original video sources were then linked so they'd behave as a single clip that can be moved around the Timeline.

BUT I HAVE A *LOT* OF CLIPS

If you have lots of footage that you need to sync and merge, you'll have to do so on a shot-by-shot basis. This can take some time so budget accordingly. An alternative is to use specialized third-party tools. Refer to the next section, "Automatically Syncing Clips."

AUTOMATICALLY SYNCING CLIPS

As you read through (or completed) the prior exercise, you might have been struck by how time-consuming the syncing process is. Although it only takes about a minute to sync each clip, that time can still really add up. For this reason, many software tools have emerged to make the process easier.

FIGURE 11.21
Final Cut Pro X can analyze clips in an Event (top). The newly synced clips can then be aligned and added to your project (bottom).

- **Built-in tools.** Editing tools are starting to include some built-in syncing tools. For example, Apple's Final Cut Pro X can analyze audio and line up clips in a project. Adobe Premiere Pro uses markers to quickly sync clips and merge them to create new clips that are easier to edit with (**Figure 11.21**).

- **Singular Software PluralEyes.** The most popular syncing application is PluralEyes from Singular Software (www.singularsoftware.com). The tool works with software from Adobe, Apple, Avid, Grass Valley, and Sony. The tool sells for $149, and you'll need a version specific to your editing tool of choice. The software automatically analyzes the audio track and syncs multiple tracks of sources with little to no work (**Figure 11.22**). Detailed tutorials are on the Singular Software site. PluralEyes also works well for multi-camera editing.

FIGURE 11.22
PluralEyes can sync multiple video and audio tracks at the same time, which works great if you're shooting an event like a concert, wedding, or play with multiple cameras simultaneously.

CREATING NEW CLIPS WITH DUALEYES

Although syncing software that works in an editing Timeline is useful, I prefer to sync sound clips before I even edit. Fortunately, the folks at Singular Software introduced DualEyes (**Figure 11.23**) to specifically address the needs of a DSLR sync-sound workflow. DualEyes is a dedicated application that processes your sound files before you edit the footage. Here are the basics on how DualEyes works.

1. Launch DualEyes. You can download a demo from www.singularsoftware.com.

2. Choose to create a new project, and then save the project to a location of your choice.

3. In the main DualEyes window click the plus (+) button to add your DSLR video (with reference audio) and high-quality audio from your digital audio recorder. Browse and select the files on your hard drive that you want to use. You can also drag files directly into the window (**Figure 11.24**).

4. Click the Options menu to choose how the program performs, and select the Replace Audio for MOV Files option. If you're using a Windows machine, this option will be Replace Audio in MOV and AVI Files.

 This option replaces the reference audio in the clip on disk with the high-quality audio while syncing the clips at the same time.

5. When you're ready, click the Scissors button to process the footage.

 The files are analyzed and new media is created. When you import the footage into an editing application, the clips will use the high-quality audio and will act like any other clip. Keep in mind that the synced clips will be placed in the same location as your source files (but with a modified name).

FIGURE 11.24
The DualEyes project window lets you add as many audio and video clips as needed to process. The clips can be different lengths or even repeated (such as a single audio file for an entire musical performance or interview).

ADDING TRANSITIONS

As you build your sequence, you may choose to add transitions between some of the shots. The proper use of wipes and dissolves can smooth the change of time and space between two video clips. You can also use audio dissolves to help clean up edits or smooth over sound beds. The key to using transitions, however, is (and will always be) restraint. Do not add transitions to simply make your video "more interesting" or to "add excitement."

TRANSITIONS NEED HANDLES

If you plan on using transitions, you need to understand the concept of handles. The transition between two shots needs additional media beyond what's used in your Timeline (**Figure 11.25**). The reason is that two pieces of media need to overlap to create the new transition effect. This overlap is called *handles*. If your shots don't have enough overlap, they may be shortened when you add a transition

FIGURE 11.25

A video clip with handles. The ghosted area in the Timeline simulates the handle area and would not be visible normally when you looked at your editing software.

A Media start
B Handle
C In point
D Out point
E Handle
F Media end

(and you can get unwanted changes in a clip's duration or your desired editing). Some editing tools won't let you add a transition at all if there's not enough media overlap. Make sure when you're shooting that you let a shot roll a few seconds before and after the critical action; this will become your handle once you set In and Out points.

ADDING VIDEO TRANSITIONS

Video transitions can be applied between two shots. Effects like a Dissolve or a Dip to Color can be used to create a gentle transition (**Figure 11.26**). Other effects like Wipes and Pushes can be used to reveal graphic elements or signify a bigger change as you transition from one section of a video to another.

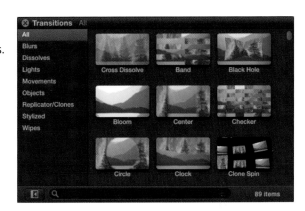

FIGURE 11.26
You'll find several effects to choose from built into Final Cut Pro X.

Applying a transition may vary between applications, but the process usually looks like this:

1. Locate two clips that are immediately back to back on the same track.

 You can also usually apply a transition to a clip's starting or ending point to create a transition to black or a lower track in the Timeline.

2. Effects are usually applied in one of two ways:

 • Place the playhead at the location where you want to apply the transition. Then choose the desired effect from the Effects menu.

 • Drag the desired effect from the Effects panel or window onto the targeted clip in your Timeline.

3. Refine the clip settings as needed using your Effects controls. These are usually visible by clicking on the effect to select it first. You may then need to look for an Effects tab or control list.

4. Preview the applied effect and adjust its settings as need.

ADDING AUDIO TRANSITIONS

Transitions can also be quite helpful when working with audio tracks. You can use audio crossfades to smooth out volume changes in audio tracks. Or, you might have an abrupt upcut in the editing of a sound bite (that leads to a word sounding clipped or interrupted) that can be solved with a quick dissolve. You may also want to add a slow transition to gently fade out the music at the end of your video. In addition to using audio effects, some editing tools give you control handles or points that you can use to adjust the volume in your video sequence.

ADJUSTING EXPOSURE AND COLOR

Throughout this book you've learned how important color correction is. When shooting video, it's difficult to get perfect color. This is especially true when lighting conditions are mixed (such as daylight mixed with interior lighting) (**Figure 11.27**) or when shooting in changing conditions (like sunrise or mixed cloud cover). In this section I'll explore some of the most useful effects you should look for in your nonlinear editing application. I'll also discuss some common color correction scenarios and how to approach and fix them.

FIGURE 11.27
Using the Analyze clip feature in Final Cut Pro X, I was able to get the shot close to being properly exposed. I lifted the midtones a little to brighten the exposure. A vignette and a Vibrancy adjustment (selective Saturation) completed the color correction repair.

ESSENTIAL EFFECTS FOR COLOR AND EXPOSURE

Although different software tools will vary in the features they offer, many features will overlap between them. In this section I'll provide you with an overview of some common tools that exist across software applications. I'll show you some before and after shots, as well as some interface shots from different software applications. Although the interfaces may vary, you'll see that similar results can be achieved.

AUTO EFFECTS

If you are in a rush for time, many tools offer auto filters for color and exposure correction (**Figure 11.28**). You may find options for Auto Color, Auto Contrast, or Auto Levels. Typically, auto effects can be applied and then reduced in intensity (often called *fading*). To gain confidence correcting color and exposure, be sure to use these options when you start editing your footage. You may also find auto buttons or check boxes within certain effects that will give you a similar outcome.

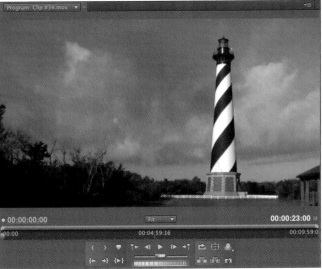

FIGURE 11.28
The image at the top is the original shot. After applying an Auto Contrast effect (bottom), the contrast in the scene improves.

SHADOW/HIGHLIGHT

The Shadow/Highlight effect is a filter that you'll find in some applications (especially Adobe tools). The effect works well to adjust the light and dark areas of a shot simultaneously. It can also fill in the washed-out color that often results from exposure adjustments.

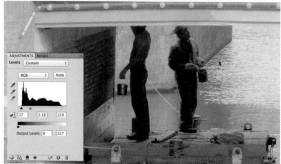

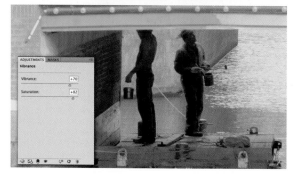

LEVELS

A Levels adjustment is one of the most useful effects you can apply. It lets you adjust the black-and-white points in an image (**Figure 11.29**). You can also adjust a middle slider to affect the midtone (gamma) levels. Many applications let you adjust Levels on a per channel level, letting you affect the Red, Green, and Blue channels separately, which allows you to fix exposure and color at the same time.

FIGURE 11.29

The original image (top) is rather dark in the shadows and midtones. I lifted the midtones by dragging the gray slider to the left. Contrast was restored by pulling the Black and White input sliders inward. The Output levels for white were lowered to reduce the overall brightness. The shot was then finished (bottom) with a Saturation and Vibrance boost to enrich the color.

CURVES

A Curves adjustment is similar to a Levels adjustment; it is primarily used for exposure. It also can be used for a color adjustment when applied to individual channels. Where Curves differs is that it offers more control (16 control points versus only 3 for Levels).

The idea behind Curves is simple. The entire tonal range of the image is mapped to a diagonal line that runs from left to right, black to white, or dark to light. You can click on the line and pull up or down to make an adjustment to a particular part of the tonal range (**Figure 11.30**). The Curve adjustment is an effective tool for fine-tuning contrast corrections made with other filters or for a shot on its own.

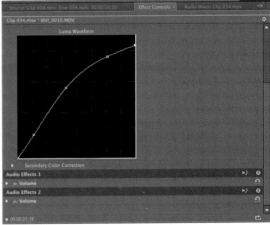

FIGURE 11.30
The Curves adjustment is often the most precise exposure adjustment you can make.

COLOR CORRECTOR OR FAST COLOR CORRECTOR EFFECT

Most video editing tools contain a color correction effect that is a combo effect. The Color Corrector (often called Fast Color Corrector) can fix exposure and contrast issues (**Figure 11.31**). Simultaneously, it can also adjust the overall color balance and saturation in a clip. This effect is often a one-stop, fix-all effect.

FIGURE 11.31
The original image (top left) lacks contrast and is washed out. After adjusting the color temperature for the midtones, I lifted the Exposure and boosted the Saturation (bottom). The final image (top right) is more pleasing to most viewers.

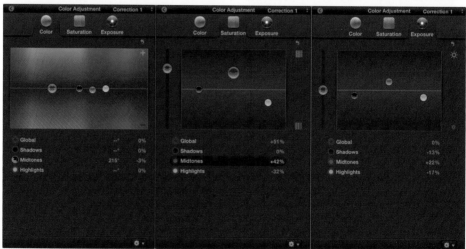

THREE-WAY COLOR CORRECTOR

The Three-Way Color Corrector is an effect that most people "graduate" to at some point in their workflow. It is similar to a normal color corrector except it offers individual controls for adjusting color in the shadows, midtones, or highlights independently (**Figure 11.32**). This effect is very useful for fixing color casts in an image. The effect also offers additional controls for limiting adjustments based on a color or exposure range (typically called *secondary color correction*).

FIGURE 11.32

The Three-Way Color Corrector allows you to adjust exposure and saturation for each of the three tonal ranges. The top-left image shows the original footage, and the bottom-left is corrected for color and tone.

COLOR CORRECTION VS. COLOR GRADING

You'll often hear the terms color correction and color grading tossed around interchangeably. Technically speaking, color correction means to fix a problem. For example, if a shot is too dark, you can fix it (**Figure 11.33**). If colors are undersaturated, you can correct that too.

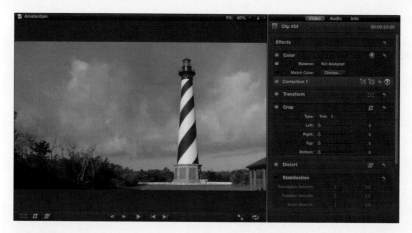

FIGURE 11.33
For this shot, exposure was adjusted and colors were boosted.

Color grading is a step beyond and refers to the artistic manipulation of color. For example, you can stylize a shot to make it match others in your program. More likely, you'll manipulate color to create a feeling or a mood for the scene (**Figure 11.34**). The goal is to elicit a certain emotional feeling from the viewer.

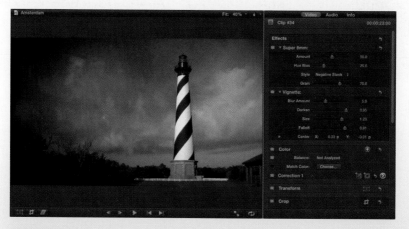

FIGURE 11.34
To create a moody look, I used the Super 8mm and Vignette effects in Final Cut Pro X to age the footage and make it feel grittier.

EXPOSURE PROBLEMS

Exposure problems frequently plague video. As you've learned throughout this book, it is better to expose properly or slightly underexpose your footage. Capture a shot that is too dark and it's difficult to lift the shadows. The more you brighten a dark shot, the more likely you'll introduce excessive video noise or grain. If you dramatically overexpose a shot, the blown-out areas are lost forever. However, a slight overexposure issue can often be compensated for and fixed.

FIXING UNDEREXPOSED FOOTAGE

If a clip is underexposed, one of the easiest ways to fix it is with a Curves adjustment. This works well for low-light or evening shooting. Here's an approach that will work in most cases.

1. Select a clip in your sequence that needs adjustment.

2. Apply a Curves adjustment to that clip (**Figure 11.35**).

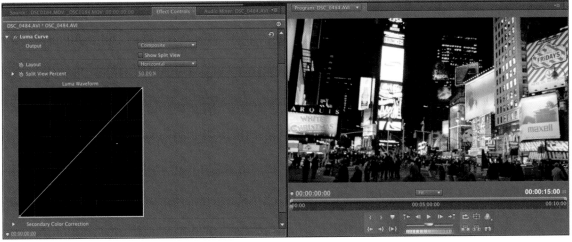

FIGURE 11.35
The original shot is underexposed.

3. Click on the line of the Curve to add a control point.

 For an underexposed shot, click in the lower 25 percent (toward the top) of the curve. A control point is added to the line that will affect the luma values.

4. Drag upward slightly to remap the darker areas to a lighter luma value (**Figure 11.36**).

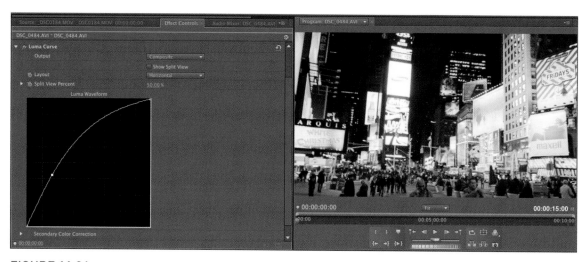

FIGURE 11.36
Lifting the shadowy areas helps the overall exposure.

The picture may now start to look washed out a bit from the brightening of the image.

5. To fix the washed-out picture, add another control point in the upper 25 percent of the curve and drag down slightly to restore some highlight detail (**Figure 11.37**).

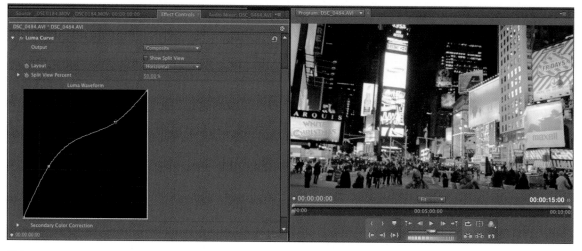

FIGURE 11.37
Restoring highlight detail to a washed-out image.

6. You may need to refine the image slightly with a Saturation or HLS adjustment as well to restore the washed-out color (**Figure 11.38**).

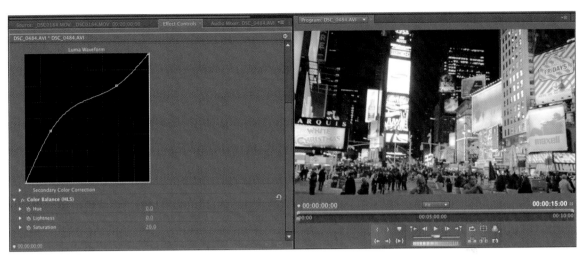

FIGURE 11.38
A slight Saturation adjustment to the image restored the washed-out color.

FIXING OVEREXPOSED FOOTAGE

Repairing overexposed footage is similar to underexposed footage. You can use a Curves effect to tackle the problem (just pull the Curves adjustment in the opposite direction). Alternatively, you can use a Levels adjustment to repair the footage.

1. Select a clip in your sequence that needs adjustment (**Figure 11.39**).

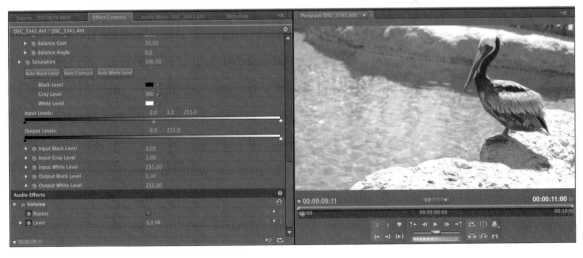

FIGURE 11.39
The original shot is overexposed.

2. Apply a Levels adjustment to that clip. Depending on your application, the Fast Color Corrector or Three-Way Color Corrector may also work.

3. Drag the white Output slider to lower the white levels (**Figure 11.40**).

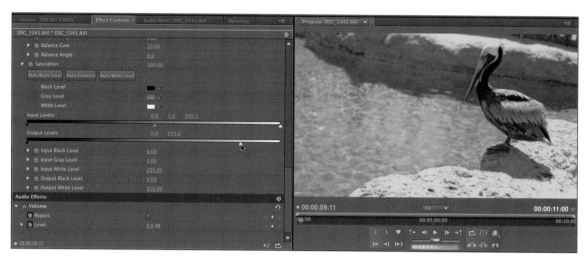

FIGURE 11.40
Lowering the white Output slider reduced the intensity of the white areas of the image.

4. Drag the middle (gray) Input slider to the left or right to adjust the exposure of the midtones (**Figure 11.41**).

Dragging to the left will darken the midtones; dragging to the right will brighten them.

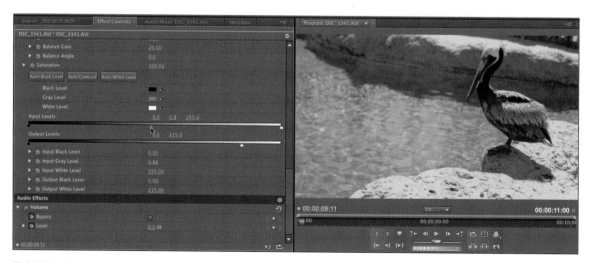

FIGURE 11.41
Changing the gray slider changes the overall exposure of the image.

5. Drag the black Input slider to the right to improve contrast (**Figure 11.42**).

FIGURE 11.42
The black Input slider adds contrast to the image.

6. You may need to refine the image slightly with a Saturation adjustment as well to restore the washed-out color (**Figure 11.43**).

FIGURE 11.43
Increasing Saturation helps with the overall image quality.

FIXING COLOR CASTS

Color casts occur in images for several reasons. It may be because you improperly white balanced your footage. Or, perhaps you were shooting in light with a strong color and you want to change the scene. No matter what the reason, color can be dramatically adjusted when working with video, whether it's simply boosting color with a Saturation adjustment or by taking a more in-depth approach of tackling adjustments to the hue of the scene to achieve more natural-looking color.

USE YOUR VECTORSCOPE

If your editing tool offers a Vectorscope, it is the most useful tool when working with color. A Vectorscope measures hue and saturation for each video clip. As you look at the scene, it will map the color on different vectors. The angle around the Vectorscope represents the hue of the color. You can actually see the colors on the scope; there are marks for primary video colors—red, green, blue—and secondary video colors—yellow, magenta, and cyan.

Take a look at the shot of the pink flamingo in **Figure 11.44**. In this scene there is a very saturated pink tone to the bird. The pink can be seen as trace falling between red and yellow on the Vectorscope. To a lesser degree, there is some green vegetation in the scene. You can see a small spike in trace pushing toward green on the Vectorscope.

FIGURE 11.44
The Vectorscope helps you see critical color details in your image.

The middle of the Vectorscope represents pure white (or no color). The farther the trace distance from the center, the more saturation there is for a particular color. If you think there is too much of a particular color in a shot, you can look at the Vectorscope to analyze the trace (**Figure 11.45**). Also on the Vectorscope is a line that falls between the yellow and red targets that is referred to as the *flesh tone line*. This can be helpful when adjusting skin tones because it gives you a target to aim for (**Figure 11.46**) (no matter what the ethnicity of the subject is, this is the color of blood and flesh tone).

FIXING CONTRAST FIRST

Before you adjust the color in an image, repair any contrast issues. As you lighten a shot, colors will tend to lose saturation and appear washed out. Similarly, if you darken a shot, you might boost the intensity of color. The goal is to fix the exposure issues first, and then restore a saturation level that is pleasing. Because DSLR video cameras tend to compress the colors a lot, a saturation boost is very common.

FIGURE 11.45
This image has a bluish tint. You can see unwanted trace pushing toward cyan and blue on the Vectorscope.

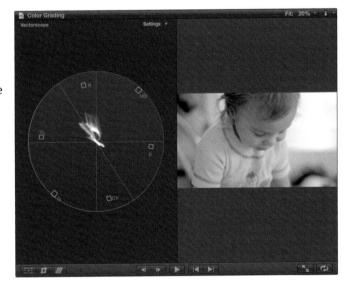

FIGURE 11.46
After the image is corrected, the bulk of the trace falls onto the flesh tone line on the Vectorscope.

FIXING UNWANTED COLOR

If your scene has unwanted color, it can often be removed by employing several strategies. None of these strategies are exclusive of each other; rather, they may become a matter of personal preference. You also might find that you have some limited options in less expensive editing tools. Here are some options to try to fix unwanted color:

- **Use an eyedropper.** Many effects feature an eyedropper so you can click an area with unwanted color casts (**Figure 11.47**) to fix it. Usually, the black and white eyedroppers are the easiest to use to set a proper black-and-white point in the image. You'll find these controls in many Levels adjustments as well as color corrector filters.

FIGURE 11.47
You can use eyedroppers to white balance your footage with effects.

- **Adjust the channels.** You can often make adjustments on a per channel basis. If you see a shift in the color, you can adjust one or more channels of the image with a Curves or Levels effect (**Figure 11.48**).

- **Use the wheels.** In most color corrector effects you'll find Hue wheels. There may be single wheel (for all ranges) (**Figure 11.49**) or three wheels (for shadows, midtones, and highlights). Simply pull the color wheel away from the color you want to remove. For example, if a shot is too blue, just pull it toward orange.

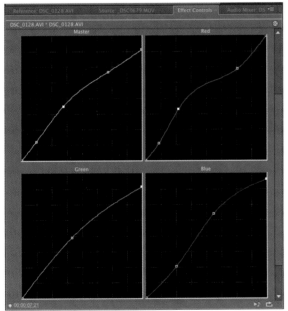

FIGURE 11.48

The original image's (top-left) color casts have been manipulated using the RGB Curves effect. This allowed for a unique adjustment in each channel.

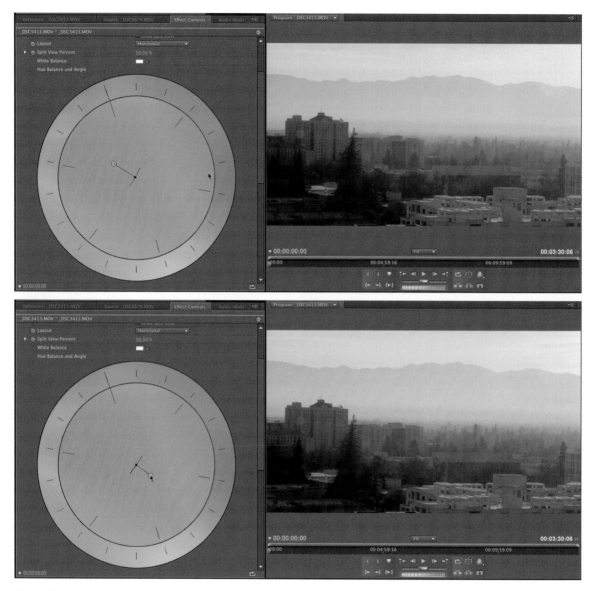

FIGURE 11.49
Adjusting the Hue wheel can control the color temperature of your footage.

Chapter 11 Assignments

Editing is an enjoyable process once you get the hang of it. I invite you to explore editing by completing the following exercises.

Perform Three-point Editing

Practice making precise edits. Using In and Out points, precisely select the range of a clip. Then use a sequence and edit clips precisely into the Timeline using the Insert and Overwrite commands. Repeat this exercise until you have assembled a short sequence of shots.

Adjust Exposure

Using some footage from your low-light shooting and from shooting outdoors, adjust the exposure of your footage until you have even midtones. After adjusting midtones, restore proper saturation levels to your clips.

Color Grade a Shot

Try color grading some of your footage. Select a handful of shots and adjust their color. Attempt to unify the shots first so they feel like they were shot at the same time. Then adjust the appearance of the shot to create an emotional feel.

Share your results with the book's Vimeo group!
Join the group here: vimeo.com/groups/DSLRVideoFSTGS

12

Publishing and Sharing Video

One of the best feelings you'll have when you enter the world of DSLR filmmaking is finishing a video-editing project. You'll have a sense of accomplishment for the practical reason that it probably took you longer than you expected, as well as for more personal reasons.

Chances are you'll be ready to share your video with an audience. This exciting process allows you to receive not only praise for your work, but more important, criticism. It is through the feedback loop that you'll become a better creator. In this chapter I'll explore several different digital delivery scenarios you can use to post your work for others to see.

Photo by iStockphoto.

FIGURE 12.1
Letting others you
trust view your
work is part of the
creative process.
Heeding a little
criticism can often
make a good video
great. Photo by
iStockphoto.

QUALITY CHECKS

When you think you're done with a video, you need to stop and check it again. You can literally blink and miss a mistake in your video (like a split-second gap that causes a black flash frame). The reality is that it's best to watch your video a few times with a fresh set of eyes (and maybe even a few trusted outside opinions) (**Figure 12.1**).

WHAT YOU WANT TO CHECK

It's important that you have specific goals in mind during your quality check. You and any others you invite to review the video should be checking for the same things. Although all feedback is helpful, you should target feedback to certain objectives so you can take action when it comes in. Critiques on your shooting location or subject matter won't help much if you actually want feedback on pacing and audio. I'm a big fan of soliciting feedback throughout the creative process rather than getting it all at the completion of the project.

Here are some areas to pay attention to (and communicate with others about) when performing a quality check:

- **Content or story review.** Feedback about the content or story is useful early in the editing stage, so you may want to post a first draft for critique and stick to the basics. For example, does the story you've edited make sense to the viewer? Without having a lot of details, can viewers jump in and follow along? Let the folks reviewing the draft know that you are just looking for comments on structure, and that there are still technical issues you need to address.

- **Rough cut review.** Show your first polished version to a trusted collection of peers or friends. At this point you should be looking for feedback on the video as a whole. Elements like music and graphics should be placed (but some elements may still be missing). A rough cut is usually 80 percent done (or more). Encourage feedback on all elements, but be sure to identify those that are still missing from the piece in your request for feedback.

- **Fine cut review.** At this stage, all elements are placed and the video is 98 percent done. All that is left is to make final tweaks to color and sound as well as ensure that no little mistakes have slipped through. This is your chance to catch any minor issues, no matter how small.

A PRODUCTIVE REVIEW

To ensure a successful review, be sure to tell everyone on your review committee the goals for the review session. Let reviewers know what sort of feedback you're looking for and that you appreciate them taking the time to offer their critique. Here are a few guidelines to keep the review moving in the right direction:

- **Keep it positive.** Be sure to keep all your reactions calm and civil. Chances are the criticism is meant to make your video better. Responding to criticism or feedback negatively will change the tone of the whole conversation. Think about comments made on your work as furthering the project, not as a personal attack.

- **Keep comments specific.** Ask people to be specific in their reactions. It is helpful to know which parts felt slow or where the audio was unclear. Ask reviewers to identify specific times in their comments (for example, at 1:13 the audio was muffled and too quiet).

- **Take action on feedback.** If people took the time to comment on your project, do something with that information. Remember that you can always duplicate the project or sequence so you have two different versions as you experiment with the suggested changes.

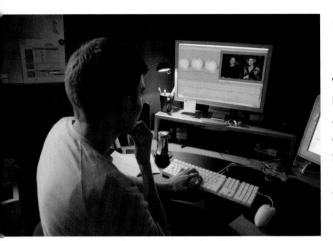

FIGURE 12.2

When you're done editing your project, be sure to save a high-resolution copy to future-proof it.

OUTPUTTING A BACKUP COPY

When a project is done, you'll want to create a high-resolution backup copy. Ideally, you'll create a movie file that matches (or even exceeds) the quality of the original source footage (**Figure 12.2**). Sure, you should back up all your assets and your project files too, but a self-contained backup of the finished project is very convenient for creating new derivative files (like web-shared videos or DVDs). Most of the time you'll start out with a full-resolution, full-frame rate, final QuickTime or AVI file that you back up.

The format you use for the backup will vary based on several factors:

- **Editing platform.** Your editing software may install its own video formats (or codecs). For example, if you've installed Apple Final Cut Pro, you'll have access to Apple's ProRes codec family, which offers a range of choices for creating high-resolution video files. When working with DSLR video, the most popular choice is Apple ProRes 422, but the lower-quality Apple ProRes LT codec is also acceptable for DSLR video projects if total storage space is a concern or limited.

- **Third-party codecs.** You can also purchase and install dedicated video codecs. For example, the Cineform codec family is quite popular. It is owned by the same company that makes GoPro video cameras. Multiple versions are available, including several packages. The Cineform Studio Professional package sells for $129 and offers a suite of useful tools for creating high-quality master files and transcoding footage for editing tools that require it. The Cineform codec is cross platform, so the files can be created and used on a Mac or a Windows machine.

- **Match source settings.** Many people will simply choose to output their backup quality footage to the same format they shot on—for example, creating a high-quality H.264 file as either an MPEG or MOV file. Although this is an acceptable solution, it can introduce issues. Most noticeably, you will likely see a shift in color because the compression format causes the images to lose some color details. Choose this option if it is all you can afford to do. However, I strongly encourage you to use the method suggested by your editing software or to purchase a third-party mastering codec.

DELIVERING VIDEO
TO THE WEB

Online video viewership continues to boom (in fact, more than half of all people in the United States watch online video regularly). Originally, web video was an expensive and complex venture. In just the last few years, delivering HD video through a website has become a common occurrence. Whether it's through a popular website like YouTube or Vimeo, or posted directly to social media outlets like Facebook or Google+, people are watching video online (**Figure 12.3**).

But just because it's everywhere doesn't mean that everyone is doing it "right." If you want to create video files for the Web, you'll need to balance three factors: file size, the creation process, and final quality. This is not unlike the old adage of *good, fast, cheap—pick two*. Unfortunately, you (and the world) want all three:

- **File size.** Producing a small file size with good image quality is not easy to do. Fortunately, advances with formats like H.264 have made this process substantially easier.

- **Creation process.** You'll need to consider how difficult it is to create the web video files you want and determine if you need a dedicated software application that you buy separately.

- **Final quality.** It's easy to choose presets to create files, but the files may be unnecessarily large and take too long to download (especially on mobile devices). Of course, you can create small files quickly by just throwing away information. But these fast encoding methods don't deliver great-looking files.

FIGURE 12.3
Delivery to mobile devices, like smartphones, continues to become more important. These days, more people are buying tablets and phones than computers (by far).

Don't worry; there are solutions. By taking the time to understand video compression and Web delivery, your files will look great and be ready to publish to the Internet.

DETERMINING A FILE FORMAT

When it comes time to post your video online, you'll first need to decide which file format you will use. Different websites often restrict your choices. Similarly, not all video will play on different computers, mobile phones, or consumer electronic devices. There are a ton of different formats on the Web.

For example, if you are targeting a work environment, the two most popular choices are Windows Media and Flash Video. On the other hand, if you want people using Macs and those using mobile phones and iPods to see the file, MPEG-4 is the clear leader. Don't make the mistake of lumping online video formats together; they often have very unique properties.

Here is an explanation of the most popular file formats:

- **MPEG-4.** The MPEG-4 file format is a collection of multiple files (called *parts*). Each part offers a set of rules about how the audio and video should be formatted. The standard was first introduced in 1998 but continues to evolve with important new changes. The two most common parts of MPEG-4 are Part 2, which is used in codecs, such as DivX and QuickTime 6; and H.264, which is part of QuickTime 7 and QuickTime X as well as Blu-ray Discs. When you see MPEG-4, it typically refers to the older version, which ensures broader compatibility with devices.

- **H.264.** The H.264 format is a smaller part of the MPEG family and is also called MPEG-4 Part 10, or AVC (Advanced Video Coding). It is widely used by DSLR video cameras when recording video. It can also be optimized for the Web and consumer electronic devices. Apple uses it across their iOS line of products, as does Sony. This is currently the most popular HD video format for delivery of video over the Internet.

- **HTML5.** Although it's more than just a video format, the use of HTML5 is gaining popularity. The format originally led to a platform war between Adobe and Apple (that extended to the iPhone and Droid product lines). HTML5 won, and Adobe announced in 2011 the discontinuation of Flash Video for mobile devices. Several websites use HTML5 video players, including YouTube, Vimeo, and DailyMotion.

- **QuickTime.** Apple Computer invented QuickTime as a video platform (it's been around for more than 20 years). It is tightly integrated into Apple's software and operating system. It's also available as a stand-alone media player and plug-in for the Windows operating system. QuickTime is installed on many users' computers when they install the Apple iTunes software. The native format for QuickTime is a .mov file, which is used by popular video-editing tools, like Final Cut Pro X, iMovie, and Adobe Premiere Pro. The MOV format can contain video that uses a variety of codecs. Some of these codecs are suited for the Web, whereas others are designed exclusively for video editing.

- **Flash Video.** Flash Video is a popular format because it supports interactivity (such as adding advanced controls or advertising features into a video). Flash as a platform has continued to evolve in recent years and appears to be moving more toward being a tool for creating web content that can output to multiple formats, including H.264 and HTML5 for video.

- **Windows Media.** The default media player for the Windows operating system is Windows Media Player. The application can play back many formats but is optimized for the Windows Media file format. This format is quickly losing popularity, because it is primarily designed for computer-based viewing only.

CHOOSING A VIDEO COMPRESSION TOOL

Many video compression (or encoding) tools are on the market. Most video-editing tools have some built-in capacity for creating files. But several dedicated applications offer better control and speed. For most of you, a compression tool should offer broad support for presets, as well as the ability to resize your video for different devices (**Figure 12.4**).

Here are the top features to look for in a compression tool:

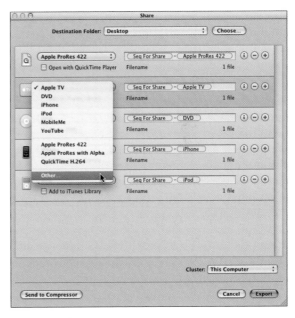

- **MPEG-4 and H.264 support.** The MPEG-4 format (and H.264 subset) is the most popular way to deliver video online that is broadly compatible. Be sure to look for this feature. Older versions of encoding tools may not offer this feature, but the newer versions generally do.

- **Apple and Droid compatible presets.** Between the Apple iOS and Google Droid operating systems, your video can reach most of the people who are on the go. Presets will make it easier to create compatible files for the many different phones, tablets, and portable media players in use.

- **Customizable presets.** You'll want the ability to modify presets or create your own. By storing customized presets, you can ensure consistent results that match your needs.

FIGURE 12.4
Using a tool like Apple Compressor, you can create video formatted for multiple devices and websites.

- **Compression preview.** A preview can show you what the compressed video file will look like as you adjust its settings. This is a useful way to visualize what changes to the file's settings will do to its appearance, quality, and file size.

- **Batch processing.** The ability to batch process files is an essential time-saver. It allows you to add multiple files to your software compression tool and choose output formats. You can then walk away and let the computer work on its own, saving you time and effort.

AFFORDABLE COMPRESSION TOOLS

Essentially, all compression tools do the same thing. They take large video files and make them smaller. What differs from one tool to the next are factors like speed, supported file formats, and user interface design (**Figure 12.5**). Fortunately, most of these tools are either free or inexpensive. You'll also find demo versions that you can try out before you buy.

FIGURE 12.5
Several tools are available for compression that range in price and features, including (from left to right) Apple QuickTime Pro ($29), Apple Compressor ($49), Adobe Media Encoder (bundled with Adobe Premiere Pro), and MPEG Streamclip (free).

Here are some recommended tools to try:

- **QuickTime Pro (www.apple.com/quicktime/pro).** This versatile application lets you convert video from one format to another. QuickTime Pro is a cross-platform solution and lets Mac and Windows users convert video files to work with Apple's portable media players. It can also produce files using the Apple TV spec, which matches the HD requirements of most video-sharing sites. The app sells for $29.

- **iMovie (www.apple.com/ilife).** Apple's entry-level video-editing tool can publish QuickTime and H.264 files directly. It can also publish video directly to YouTube, Vimeo, and Facebook. The app is sold separately for $15 through the Mac App Store or bundled with four other apps in the iLife suite.

- **Adobe Premiere Elements (www.adobe.com/products/premiereel).** This versatile editing tool also contains a versatile compression tool set. With it, you can create movies in several formats, including MPEG-4 and Flash, and post directly to social media and video-sharing sites. The app sells for $99 new and is available for both Windows and Mac.

- **MPEG Streamclip (www.squared5.com).** MPEG Streamclip is a multipurpose video converter, player, and editor that works on both Mac and Windows. It can encode to many formats; it can also cut, trim, and join movies. The biggest benefit is that it's free!

- **Microsoft Expression Encoder and Expression Encoder Pro (www.microsoft.com/ expression/products/Encoder4_Overview.aspx).** This Windows-only tool comes in a free and a Pro version. It replaces the Windows Media Encoder, which was retired in mid-2010. It can create Windows Media Video files and Silverlight files. The Pro version can also output H.264 files.

- **Apple Compressor (www.apple.com/finalcutstudio/compressor).** This powerful compression tool used to be bundled with Final Cut Studio but is now sold separately in the Mac App Store for $49. It allows you to create Apple-compatible files and is optimized for computers with multiple processors.

- **Adobe Media Encoder (www.adobe.com).** This compression tool is not a standalone product. Rather, it is a core technology in the Adobe Creative Suite products that works with video. You can easily access it through products like Adobe Premiere Pro. It supports several web video formats and offers excellent control.

AUTOMATIC VIDEO COMPRESSION

For many web video and social media sharing sites, your video will be recompressed when you upload it to the hosting site (no matter what you do). This is generally referred to as *server-side encoding*. Because the file will be compressed a second time, you need to take some important steps to ensure that you produce good results:

- **Be sure to look at upload limits**. Often, there is a cap on runtime and file size. Be sure your video is lower than the limit for both, or it will likely be rejected. Most often, it's the file size that will give you problems for HD video.

- **Pre-compress an HD intermediate file**. The use of a high-quality H.264 file is a popular workflow. You'll often find presets labeled YouTube HD, Vimeo HD, or Apple TV that work well. These create a file that looks great but tends to be a fraction of the original size.

- **Test post**. Before you upload several clips, be sure to test post. Try out a compressed file and see how it looks. Find the right balance of image quality to file size to maximize the video's appearance online.

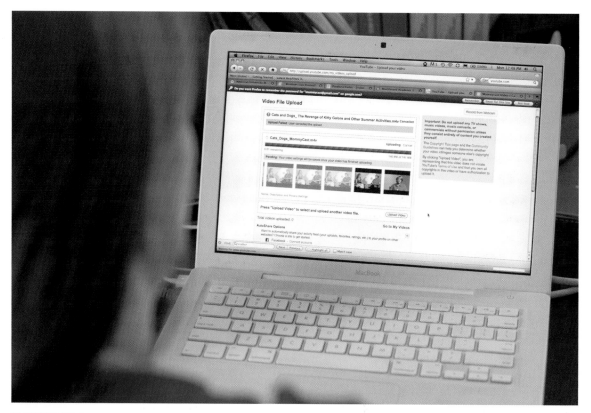

FIGURE 12.6
Publishing to video-hosting services is typically straightforward; they can extend your audience greatly and make it easier for them to watch.

SPECIFIC HOSTS FOR WEB VIDEO

To make sharing your videos a little easier, I'll give you some specific tips for publishing to video-sharing websites. I'll tackle the "big four." If you post a video to YouTube (**Figure 12.6**), Facebook, Vimeo, and Twitter, you will safely reach the vast majority of potential viewers.

All four services are either free or have a free version available. There are benefits to each (as well as drawbacks) that are worth discussing. I recommend that you publish to at least two of these sites, but publishing to all four can broaden your reach even further.

PUBLISHING TO YOUTUBE

The most popular video-sharing site in the world is YouTube (**Figure 12.7**). Now owned by Google, YouTube was launched in early 2005. It quickly rose to the top of the video-sharing websites, offering both user-generated and professionally created video content. The service uses Flash and H.264 video as the underlying architecture, and has recently started experimenting with HTML5.

FIGURE 12.7
YouTube has emerged as the top video-sharing site.

YouTube is so popular because it is easy to use and search. It also works well on most mobile phones. Although it is expected that YouTube would be a solid platform for the Droid operating system (which is owned by Google), even Apple and other manufacturers offer broad support for the popular service.

Even though YouTube is very popular, many web creators avoid it. The site has a "flea market" feel to it and has a free-for-all approach. Your content can get grouped with other content that is off topic or a direct competitor. I recommend using YouTube, but you'll need to market the video on your own. The YouTube service integrates well into social networks like Facebook, Twitter, and Google+. YouTube also offers easy-to-use embeddable players for blogs and websites. Be careful when using embeddable players. Always deselect the Show Related Content option; otherwise, viewers will be encouraged to leave your video and website to explore other videos on YouTube.

To post a video to YouTube manually (remember that many editing tools can upload for you):

1. Sign up for a YouTube account at www.youtube.com/signup.

2. Be sure to closely read the terms of service to understand what you are allowed to do and what rights you grant Google. You can view the terms at https://accounts.google.com/TOS.

3. Visit www.youtube.com/my_videos_upload to post a video (**Figure 12.8**).

FIGURE 12.8
YouTube's upload
page makes it easy
to just drag a file to
upload it.

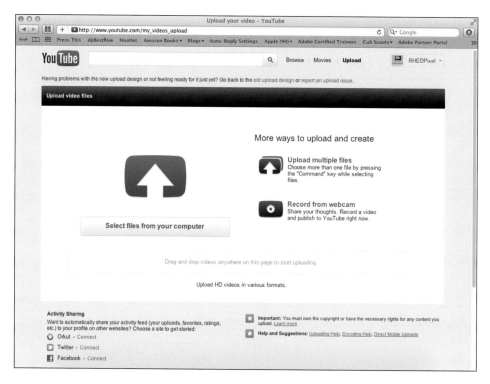

4. Drag a properly formatted video onto the upload page.

 Ideally, your video will be a compressed HD file, which allows for a high-quality file with reasonable upload times. Use these specs:

 • Keep the video shorter than 15 minutes (unless your account has been approved for longer uploads).

 • Save the file as an H.264 formatted video saved as an .mp4 file.

 • Upload at 1920x1080 or 1280x720.

 • Use a high-quality, variable bitrate (vbr) setting. Your compression application probably has a preset labeled YouTube HD (or similar).

5. Complete all the fields that ask for information about your video (**Figure 12.9**).

 Be as detailed as possible, especially with keywords, so your video is easy to search for and find.

6. Choose a category to help organize your video and group it with similar videos.

FIGURE 12.9
Be sure to fill in
all the details
about your video to
make it easier for
people to find using
searches.

7. Choose a privacy level that matches your needs:

 • Public is best for videos you want to share with the whole world.

 • Unlisted is like an unlisted phone number. All viewers can see the video; they
 just need its URL.

 • Private allows you to create a list of authorized users who can log in and view
 the file.

8. Assign a license type that controls how the video can be used and attributed.

9. Click Save to complete the process (although the page will usually auto save
 for you).

 Depending on the duration of your video and site traffic, it can take a few min-
 utes for your video to process and become available online (**Figure 12.10**).

FIGURE 12.10
A video presented
on a YouTube page.

FIGURE 12.11
Vimeo is a new service that's popular with filmmakers
and artists.

PUBLISHING TO VIMEO

Many video professionals and enthusiasts have
flocked to Vimeo (**Figure 12.11**) for its high-quality
video hosting (www.vimeo.com). The site caters to
video professionals, artists, and enthusiasts with
terms that respect copyright. Vimeo offers free and
paid accounts with different levels of service.

You'll find that support for Vimeo is widespread. For
example, iMovie and Final Cut Pro X can export and publish directly to Vimeo. Adobe
Premiere Pro can export to Adobe Media Encoder with very accurate Vimeo presets.

To post a video to Vimeo manually (remember that many editing tools can upload
for you):

1. Sign up for a Vimeo account at www.vimeo.com/join (**Figure 12.12**).

2. Choose between a Basic (free) account or a Plus (paid) account. The page clearly
 lays out the benefits of each.

3. Enter all of the required information about you.

FIGURE 12.12
Vimeo's signup
page.

4. Be sure to read the terms of service to understand what you are allowed
 to do and what rights you grant Vimeo. You can view the terms at
 www.vimeo.com/terms.

5. Also, read the Vimeo community guidelines at www.vimeo.com/guidelines.

 Vimeo takes these rules quite seriously, so I suggest you follow them.

6. Visit www.vimeo.com/upload or click the "Upload a video" button on any page.

7. Choose a properly formatted HD video to upload. Use these specs:

 • Save the file as an H.264 formatted video saved as an .mp4, .m4v, or .mov file.

 • Upload at 1280x720.

 • Use a high-quality, variable bitrate (vbr) setting. Do not exceed 5000 kbps
 (kilobits per second). Your compression application probably has a preset
 labeled Vimeo HD (or similar).

 • You'll find detailed tutorials for all major editing and compression tools at
 www.vimeo.com/help/compression.

8. Complete all the fields that ask for information about your video (**Figure 12.13**).

 Be as detailed as possible, especially with keywords, so your video is easy to search
 for and find.

FIGURE 12.13
Be sure to complete all the details about your video.

9. Click the Save Changes button to store your information.

 You'll also find additional controls in the left column for thumbnails, photos, privacy, and more.

10. Click the "Go to video" button to see your clip.

 Depending on the duration of the video and site traffic, it can take a few minutes for your video to process and become available online (**Figure 12.14**). Basic account members have to wait longer for their video to process.

FIGURE 12.14
A video presented
on a Vimeo page.

PUBLISHING TO FACEBOOK

Facebook is the most popular social networking site in the
world. In fact, in many countries more than 50 percent of all
adults have an account. Facebook (**Figure 12.15**) is a free ser-
vice that makes it easy to share video and news with friends,
family, and colleagues. Most editing tools can publish
directly to Facebook, and it supports all major video formats,
like QuickTime and Windows Media, but converts all these
formats to Flash Video (and HTML5 for mobile versions) after
you upload.

FIGURE 12.15
Facebook is the largest social network in most
countries.

To post a video to Facebook manually (remember that many editing tools can upload for you):

1. Sign up for a Facebook account at www.facebook.com (**Figure 12.16**). If you're already a member, just log in.

2. Near the top of the page, click the Add Photo/Video button (**Figure 12.17**).

FIGURE 12.16
Facebook's signup page.

FIGURE 12.17
You add a video as a status update.

3. Click the Upload Photo/Video button.

4. Enter a description into the field labeled "Say something about this."

5. You can use the buttons along the bottom of the post to tag people in the video or add location information (**Figure 12.18**).

FIGURE 12.18
Be sure to give details about your video to help the viewer understand the scene.

6. Click the Choose File button to select a video on your computer for posting.

 Facebook claims it supports more than 30 different formats, but it prefers an HD MP4 file. I find that using the YouTube preset works great for Facebook. The upload limit on your account will vary, but to increase it, just verify your account on your profile page.

7. Click Post to add the video.

8. A status window opens to show you the progress of the upload.

 Depending on the duration of your video and site traffic, it can take a few minutes for your video to process and become available online.

9. The video is added to your video collection and is posted to your timeline. You can use Facebook's standard sharing features to tell your friends about it.

WHAT ABOUT FACEBOOK HD?

Although videos you've posted to Facebook can be embedded on other sites, they will only play in HD on Facebook.com.

PUBLISHING TO TWITTER

Twitter is a popular micro-blogging platform that allows people to share short status updates (**Figure 12.19**). It works particularly well for mobile devices (phones and tablets). Twitter is most popular with the tech-savvy, because it makes it easy to keep in touch with a private network or public forum for those who share the same interests.

Accounts are free, and you can sign up at www.twitter.com by clicking the "Sign up for Twitter" button on the home page.

Although the mobile application version of Twitter for most smartphones supports video upload, the home page does not. The easiest way to post a video to Twitter is by using a helper service; YouTube and Vimeo have this ability.

FIGURE 12.19

Twitter allows you to share short messages and attach photos and video.

To add a video, you can:

- Paste the link of the video's page into a tweet (your update) (**Figure 12.20**).

FIGURE 12.20

Tweets are generally short (fewer than 140 characters). The link to your video will be shortened but will still work.

○ ○ ○	Post a Tweet on Twitter		

◄ ► | + | https://twitter.com/intent/tweet?source=webclient&text=Wat Twitter, Inc. ○ | Q▾ Google | ●

Press This dpBestflow Hootlet Amazon Books ▾ Blogs ▾ Auto-Reply Settings Apple (95) ▾ »

twitter

rhedpixel ▾

What's happening?

My video – watch a Corner at Night| http://vimeo.com/35707164

84 Tweet

- Click the Twitter button on your video's page, which will be in a section labeled Share above or next to the video (**Figure 12.21**).

- If you're logged into Vimeo or YouTube, you can connect your Twitter account in your account settings. This will automatically tweet any video that you post.

Once the video is posted, it will appear in your update (**Figure 12.22**). People who read the tweet can see the video play inline with the update or on their mobile device.

THE END OF THE ROAD?

Congratulations; you've reached the end of this book. However, it is not the end of your journey; rather, it is the beginning. Video is a fun and challenging medium to create in. To explore more information about video, I recommend checking out the following books and online resources:

- *From Still to Motion: A photographer's guide to creating video with your DSLR* by Ball, Carman, Gottshalk, and Harrington (Peachpit, 2010)
- *From Still to Motion: Editing DSLR Video with Final Cut Pro X* by Harrington, Shapiro, and Carman (Peachpit, 2012)
- *The Visual Story* by Bruce Block (Focal Press, 2007)
- Richard Harrington Blog (www.RichardHarringtonBlog.com)
- Triple Exposure (www.3Exposure.com)

Share your results with the book's Vimeo group!
Join the group here: vimeo.com/groups/DSLRVideoFSTGS

Index

Numbers

32-bit operating system, 205
180 degree rule, 106
720p high-definition, 50, 51
1080p high-definition, 50, 51

A

AC adapter, 36
adapter rings, 80–81
add-on gear, 13–14
adjustable tension controls, 44
Adobe
 Media Encoder, 257
 Premiere Elements, 213, 256
 Premiere Pro, 205, 220–222
Advanced Video Coding High Definition
 (AVCHD) format, 28
AGC (Automatic Gain Control) option,
 60–61, 180
Analyze clip feature, 230
angles
 composition and, 92–97
 from multiple cameras, 108
 for shooting video, 17
 types of, 101–103
aperture
 adjusting for video, 48–49, 60
 depth of field and, 22, 41, 84, 138–139
 features of, 38, 73–74
 focus and, 5, 23, 84
 prime lenses and, 74
 rings/manual control, 144–146
 zoom lenses and, 40
Aperture Priority mode, 59
Apple
 Compressor, 206, 255, 257
 iMovie, 212, 214, 256
 QuickTime, 203, 254, 256
archiving video data, 193
aspect ratio, 51
audio, recording
 adjusting levels, 60–61
 bit depth, 178
 dual system sound, 184–187
 guidelines, 176
 improving, 11, 14
 internal microphone, 180
 lavalier microphone, 181–182, 183
 microphone placement, 183
 microphone polar patterns, 179
 monitoring, 188–189
 on-camera microphone, 181
 sampling rate, 178
 setting channels, 177
audio syncing
 automatic, 226

DualEyes, 227
 manual, 223–225
audio transitions, 229
audio waveform, 223
audiometers, 189
auto filters, 231
auto white balance, 55, 57
autofocus, 83, 143
Automatic Gain Control (AGC) option,
 60–61, 180
automatic video compression, 257
AVCHD (Advanced Video Coding High
 Definition) format, 28

B

background
 creating soft, 5, 7–8, 12, 139
 techniques for, 79–80
backing up footage
 card reader for, 193–194
 of finished project, 252
 hard drive for, 195–201
 organizing footage, 202–204
 transcoding option, 205–207
 transferring footage, 201–202
 workflow for, 192–193
backlight, for three-point lighting, 171
backup drive, 192
ball leveling, 44
batch processing, 256
batteries, 35–36
bit depth, 178
black drives, 199
blurring
 causes of, 78
 shutter speed and, 72–73, 150
 stylized. see bokeh
body size, camera, 26
bokeh. see shallow depth of field
brightness, LCD screen, 27
built-in syncing tools, 226
bus power, 194, 199
bust shot, 100

C

camera configuration
 assignments on, 65
 frame rate, 52–53
 frame size, 50–51
 Picture Styles/Controls, 61–64
 shooting mode, 59–60
 for shooting video, 48–49
 volume controls, 60–61
 white balancing, 55–59
camera settings
 depth of field and, 22, 41, 73–74, 84
 exposure and, 131–132
cameras
 LCD screen, 26–27
 prior investment in, 25

recording format, 27–28
 recording length, 28–29
 sensor resolution, 30
 sensor size, 30–31
 size/weight of, 25–26
Canon
 EOS-1D X, 141
 EOS 5D Mark II, 141
 EOS 7D, 51, 62–63, 81
cardioid pickup pattern, 179
ceremonies, lighting at, 141
CF (CompactFlash) cards, 33
challenge, of video, 7
channels
 for recording audio, 177
 unwanted color and, 244, 245
chargers, 35–36
China Ball lanterns, 165
Cineform Studio/NeoScene, 206, 252
cinematic composition
 180 degree rule, 106
 eye line and, 104
 rule of thirds, 104–105
 sequencing shots, 106–107
clapboard, 186, 223
clapping hands, 187, 223
clips
 adding to tracks, 217–219
 selecting/loading, 216–217
close-up shot, 100
cloud coverage, 122
cloudy white balance preset, 56
color
 correction vs. grading, 236
 tools for adjusting, 230–236
 Vibrance adjustment, 71, 232
 video vs. photo, 54
color cast adjustment
 contrast repair, 243
 unwanted color, 244–246
 Vectorscope for, 242–243
Color Corrector effect, 234
color temperatures
 Hue wheel control of, 246
 indoor shots and, 163
 sunlight and, 118
 white balancing, 58, 118, 163–164
Common Media folder, 204
CompactFlash (CF) cards, 33
composition
 assignments on, 111
 cinematic, 103–107
 defined, 91
 multiple cameras for, 108
 repeating action, 108–109
 shot angles, 92–97, 101–103
 shot list, 110
 shot types, 98–100

compression
 automatic, 257
 preview, 256
 in recording format, 27–28
 tools for, 255–257
 video vs. photo, 54
concerts, lighting at, 140
connection port, for card reader, 194
connectivity, portable drive, 199
content/story review, 251
contrast
 creating, 8–9
 Curves adjustment for, 68–69
 for outdoor shots, 130–131
 repairing, 243
Controls, 61–64
convenience, of DSLR cameras, 6
cost consideration
 choice of lens, 36, 41
 compression tools, 256–257
 DSLR value, 6
 editing software, 212–213
 electronic viewfinders, 88
 fast zoom lenses, 142
 lower f-stops, 74
 tripod heads, 43
Creative COW website, 215
cropped sensors, 31, 32
Curves adjustment
 for contrast, 68–69
 features of, 233
 lifting shadows, 71, 131
 underexposure and, 237–239
Custom White Balance mode, 163–164
customer support, editing software, 215

D
data transfer
 to backup/edit drives, 192
 workflow, 201–202
daylight-balanced lightbulbs, 166
daylight shooting
 assignments on, 133
 challenges, 113
 clouds and, 122
 color correction for, 114–115
 contrast for, 130–131
 filters for, 132
 lens flares, 123–126
 location choice, 119–120
 proper exposure, 131–132
 sunlight issues, 116–122
 underexposure and, 127
daylight white balance preset, 56, 57
depth of field
 aperture settings and, 22, 41,
 73–74, 84
 control over, 7–8
 in low lighting, 136–139

sensor size and, 30–31
 shallow. see shallow depth of field
Digital Photography Review, 38
digital recorders. see external audio
 recorders
dimmer, for fill light, 170
diopter, 85
direct sunlight white balance preset,
 56, 57
dragging technique, 217, 218
drive speed, 198
Drobo Pro external drive, 200
dropping frames, 34
DSLR video cameras
 add-on gear, 13–14
 aesthetic benefits, 7–9
 assignments on, 19
 drawbacks, 11–12
 popularity, 6–7
 technical benefits, 9–10
dual mono audio system, 177
dual system sound
 advantages of, 184
 dedicated recorder for, 185
 smartphone application for, 185
 syncing audio, 186–187
DualEyes, Singular Software, 227
Dutch angle shots, 103

E
earbuds, monitoring audio and, 188–189
edit drive, 192
editing, nonlinear
 adding transitions, 227
 adjusting color/exposure, 230–236
 assignments on, 247
 automatic audio sync, 226
 DualEyes syncing audio, 227
 exposure problems, 237–241
 fixing color casts, 242–246
 importing media, 216
 Insert edit for, 221–222
 manual audio sync, 223–225
 overview, 209–211
 Overwrite edit for, 220–221
 selecting/loading clips, 216–217
 software choice, 212–215
 targeting tracks, 217–218
editing software
 for backup copies, 252
 cost, 212–213
 customer support, 215
 ease of use, 213
 options, 214
 supported file formats, 214
 for viewing footage, 203
electronic viewfinders, 87–88, 143
emotional impact, of sequencing, 107

equipment
 AC adapters, 36
 assignments on, 45
 batteries/chargers, 35–36
 camera features, 25–31
 full-frame sensors, 30–31, 141
 lens features, 36–41. see also
 lens(es)
 loupes, 14. see also loupes
 memory cards, 31, 33–34
 monopods, 22–24
 tripods, 14, 42–44, 114, 142–143
ergonomics, camera, 25–26
exposure
 aperture setting and, 60
 assignments on, 89
 control over, 131–132
 external monitors and, 86
 fixing overexposure, 239–241
 fixing underexposure, 237–239
 loupes improving, 84–85
 sunlight and, 119–120, 127–130
 tools for adjusting, 230–236
 viewfinders and, 87–88
 zoom lenses and, 40
exposure triangle
 aperture in, 73–74
 ISO in, 75
 for low lighting, 144–145
 overview, 72
 shutter speed in, 72–73
extension cables, 86
external audio recorders
 advantages of, 11, 14, 177
 bit depth, 178
 for dual system sound, 185
external drives, 200
external microphones, 11, 14, 181
external monitors, 86
eye level recording, 102
eye line, 104
eyedroppers, 244–246

F
f-stops. see aperture
Facebook, publishing on, 265–267
facial details, key light and, 170
Fast Color Corrector effect, 234
feature-limited software, 205
field monitors, 86
file formats, 254–255
fill light, 170–171
filmic images, 8–9, 72, 74
filters, 125, 132
Final Cut Pro X
 editing tool, 212, 220–222, 229,
 230, 236
 importing media, 216
 transcoding and, 205, 206
fine cut review, 251

FireWire interface, 194, 196, 211
fixtures, China Ball, 165
Flash Video file format, 255
flash white balance preset, 56, 57
Flat option, in Picture Styles, 63–64
flesh tone line, 243
flexibility, LCD screen, 27
fluid-head tripods
 features of, 14
 for low-light shots, 143
 selection of, 43–44
fluorescent lights, 166, 168–169
fluorescent white balance preset, 56
focal lengths, 32, 39, 40
focus
 aperture settings and, 23, 60,
 138–139
 assignments on, 89
 challenges, 12
 external monitors and, 86
 light/motion impacting, 78
 loupes and, 84–85
 for low lighting, 143
 maintaining, 83–84
 manual, 143
 rack focusing, 80–81
 setting, 81–82
 shallow depth of field, 76–77, 79–80
 viewfinders and, 87–88
footage
 backing up. see backing up footage
 Common Media folder, 204
 importing, 216
 selecting, 203
 transferring, 192, 201–202
 viewing, 203
foreground, 79–80
Fotodiox, 80–81
frame rates, 52–53
frame size, 50–51
framing subjects, 104–105, 135
full-frame sensors, 30–31, 141
Full HD, 50, 51

G
getting coverage, 98

H
H.264 file format, 28, 254, 255
handles, 18, 228–229
hard drives
 editing and, 218
 external, 200
 importance of, 195
 interface types, 196–197
 internal, 199
 portable, 198–199
 speed, 198
HDMI cables, 86
headphones, 188–189

heads, tripod, 43–44
height, tripod, 44
Hi-Speed USB 2.0, 197
high angle shots, 102
high-definition (HD) video formats, 50–51
highlights, 69, 70, 127, 130
histograms, 127–129
hood, for lens protection, 124–125
HTML5 file format, 254
Hue wheels, 244, 246
hypercardioid microphone pickup
 pattern, 179

I
incandescent white balance preset, 56, 57
indoor shooting
 additional lighting, 164–169
 adjustments for, 160–161
 assignments on, 173
 available lighting, 162–163
 information sources, 172
 overview, 157–159
 three-point lighting, 170–172
 white balancing, 163–164
Insert edit command, 221–222
interface types, hard drive, 196–197
internal drives, 199
internal microphone, 180
intervalometer., 154
investment, on camera, 25
ISO settings
 adjusting for video, 48–49
 changing for focus, 84
 dedicated button for, 147
 high, for low-light shots, 136–137
 raising for low lighting, 146–147
 testing upper limits, 148–149
 visible noise and, 75

J
JPEG files, 54

K
Kelvin scale, 118
key light, 170
kilohertz (kHz), 178
Kino Flo fluorescent lights, 168, 169

L
Lanternlock fixture, 165
lavalier microphone, 181–182, 183
LCD screens
 criteria for, 26–27
 loupes and, 84–85
 swivel, 85
LED lights, 167–168
lens flares
 blocking light, 125–126
 causes of, 123–124
 filters and, 125

hood protection, 124–125
 positioning and, 126, 127
lens(es)
 aperture, 38. see also aperture
 clean, 125
 focal length, 32, 39, 40
 for low lighting, 141–142, 144
 manufacturers, 36–38
 used, 41, 80–81
 zoom vs. prime, 40–41, 74
Levels adjustment, 232, 239–241
Lexar memory card reader, 193
light. see also sunlight
 backlight, 171
 fill, 170–171
 for focus, 78, 84
 for indoor shots, 162–164
 key, 170
 loupes and, 85
 low, 10
 temperatures, 58, 118, 163
lights
 China Ball lanterns, 165
 fluorescent, 168–169
 overhead, 164
 practical, 164
 professional, 169
 reflector clamp, 166
 shop/work, 166
Live View function, 26, 35, 163–164
location, daylight shots and, 119–120
long-term storage, 193
loupes
 focus/exposure and, 14, 84–85
 low lighting and, 143
 outdoor shots and, 130
 viewfinders with, 87–88
low-light shooting
 adjusting for, 136–139
 assignments on, 155
 common scenarios, 140–141
 with DSLR cameras, 10
 equipment, 141–143
 lowering f-stop, 144–146
 overview, 135
 raising ISO, 146–149
 shadows and, 151
 shutter speed adjustments, 150–151
 sunrise/sunset, 152–153
 time-lapse photography, 154

M
manual aperture ring, 145–146
Manual mode, 59–60, 72, 143
manually set white balance, 56, 58
manufacturers
 audio recorder, 185
 lens, 36–38
 professional lighting, 169
 tripod head, 44

master shot, 98
material, tripod leg, 44
medium close-up (MCU) shot, 100
medium shot (MS), 99
medium wide shot (MWS), 99
megapixel count, 30, 54
memory cards
 format, 33–34
 function of, 31
 mounting, 192
 need for, 11–12
 number of, 33
 reader for, 193–194
 speeds, 34
microphone(s)
 external, 11, 14, 181
 internal, 180
 lavalier, 181–182, 183
 on-camera, 181
 placement, 183
 polar patterns, 179
 rub, 183
 shotgun, 176, 179, 181
Microsoft
 Expression Encoder/Expression
 Encoder Pro, 257
 Windows FAT32 file system, 28
 Windows Media file format, 255
monitors, 86, 217–219
mono audio system, 177
monopod, 22, 23, 24
motion
 blurring, 72–73, 78, 150
 impact on focus, 78
 sequencing of, 15–16
 shutter speed and, 72–73, 150
 zooming in, 98
Motion JPEG format, 28
MPEG-4 file format, 254, 255
MPEG Streamclip, 206, 257
MS (medium shot), 99
multichannel audio system, 177
multiple cameras, 108
multiple slots, in card reader, 194
museums, lighting at, 141
MWS (medium wide shot), 99

N

National Television System Committee
 (NTSC) standards, 53
neutral (ND) density filter, 125, 132
Neutral option, Picture Styles, 63–64
nifty-fifty lenses, 39, 142
night shooting, outdoor, 141
Nikon
 D7000 frame rates, 53
 full-frame sensor, 141
 NIKKOR lenses, 142
 older prime lenses, 81

Picture Styles options, 62–63
 prime lens, 74
noise
 ISO settings and, 75, 148–149
 minimizing, 176
nonlinear editing. see editing, nonlinear
NTSC (National Television System
 Committee) standards, 53

O

older prime lens, 81
older software, 205
omnidirectional pickup pattern, 179
on-camera microphone, 181
online video, 253–257
operating system, for viewing
 footage, 203
original equipment manufacturer
 (OEM) lenses, 36–38
outdoor shooting
 daylight and. see daylight shooting
 at night, 141
over-the-ear headphones, 188–189
overcranking, 53
overexposure, 119, 127–130
overhead lights, 164
overhead shots, 103
Overwrite edit command, 220–221

P

paper lanterns, 165
pasting technique, 217
patch panel interface, 217
performances, lighting at, 140
Phase Alternating Line (PAL)
 standards, 53
Photo JPEG format, 28
photography tripods, 43, 44
photos
 in setting focus, 81
 videos vs., 54, 130–131
Picture Styles, 61–64
PluralEyes, Singular Software, 226
polar (pickup) patterns microphone,
 179, 183
popularity, of DSLR cameras, 6–7
portable drives, 198–199
portable Super-Speed USB 3.0, 198
positioning
 for composition, 108
 lens flares and, 126, 127
 shop lights, 166
power, 35–36
practical lights, 164
practice, in focusing, 83
presets
 in compression tools, 255
 white balance, 55–57
prime lenses, 41, 74, 142, 144

Pro Audio To Go application, 185
Program shooting mode, 59

Q

quality checks, 250–251
Quick Look option, 203
Quick Preview feature, 203

R

rack focusing, 80–81
recording devices. see external audio
 recorders
recording formats, 27–28
recording length limitations, 28–29
recording sound. see audio, recording
Redundant Array of Independent Disks
 (RAID) configuration, 195, 200, 211, 218
reference image, for white balance,
 58–59
reflections, 160, 161
reflector, 121
reflector clamp light, 166
repeating scenes, 18, 108–109
resolution, 27, 30, 54
resources, 172, 270
Rode VideoMic Pro, 181
Rogue FlashBender, 126
rough cut review, 251
rule of thirds, 104–105

S

safety issues, 165, 166
sampling rate, 178
scoops, 166
Secure Digital (SD) cards, 33–34
selects, 203, 204
sensor(s)
 cropped, 31, 32
 full-frame, 30–31, 141
 resolution, 30
 size, 30–31
Serial ATA (SATA) interface, 197, 218
server-class drives, 199
shade white balance preset, 56, 57
Shadow/Highlight adjustment, 130, 231
shadows
 Curves adjustment, 71, 131
 fill light for, 170–171
 preserving, 161
 sunlight and, 116–117, 119–120, 122
 utilizing, 151
shakiness, 40
shallow depth of field
 challenge of, 12
 for close-ups, 100
 creating, 76–77
 desirability of, 4, 7, 30, 38
 foreground/background, 79–80
 for framing, 41, 135

shop lights, 166
shotgun microphones
 polar patterns of, 179
 pros and cons of, 181
 recording with, 176
shots
 list of, 110
 sequencing, 106–107
 types of, 98–100
Shutter Priority shooting mode, 59
shutter speed
 adjusting for video, 48–49, 60
 guidelines, 72–73, 151
 for low lighting, 150–151
 lowering for focus, 84
 unique adjustments, 151
Singular Software, 226, 227
size
 camera, 26
 LCD screen, 26–27
 sensor, 30–31
 video, 253
slate application, 187, 223
sliding base plates, 44
slow-motion effects, 53
slow processors, 205
smartphone application, 185
softbox diffuser, 170
software tools, for transcoding, 206
Source Monitor, 217–219
speed(s)
 card reader, 194
 hard drive, 198
 memory card, 34
 portable drive, 199
spreader bar, 44
stability
 loupes and, 85
 shoulder rigs and, 136
 tripods and, 14, 44, 114, 142–143
standard-definition video format, 50, 51
Standard option, Picture Styles, 60, 63–64
stereo audio system, 177
Sun Seeker: 3D Augmented Reality Viewer, 120, 121
sunlight. see also daylight shooting
 bouncing, 121
 challenges of, 116–117
 color temperatures and, 118, 163
 explained, 117
 location and, 119–120
 tracking, 120–121
sunrise/sunset, lighting at, 141, 152–153
Super-Speed USB 3.0, 197, 198
surround sound, 177
swivel LCD screen, 85
sync-sound audio track, 224–225

synchronizing audio
 automatically, 226
 DualEyes for, 227
 in field, 186–187
 manually, 223–225

T
tapeless workflow, of DSLR cameras, 11–12
Technicolor CineStyle, 62
temperature, color, 58, 118, 163
tension controls, adjustable, 44
third-party codecs, 252
third-party lenses, 36, 38
three-point editing, 218–219
three-point lighting, 170–172
three-stage tripods, 44
Three-Way Color Corrector, 235
time-lapse photography, 154
Timeline, 218–219
timing, shooting video and, 17–18
transcoding
 minimizing, 206–207
 need for, 205
 software tools, 206
transitions
 handles for, 228–229
 video/audio, 229
tripods
 fluid head for, 43–44, 143
 low lighting and, 140, 142–143
 need for, 42
 photo head vs. video head, 43
 selection of, 44
 stability of, 14, 114, 142–143
tungsten white balance preset, 56
Twitter, 268–269
two-stage tripods, 44

U
Ultra Direct Memory Access (UDMA) rating, 34
underexposure, 127–130, 237–239
Universal Serial Bus (USB) interface, 197
used lenses, 41, 80–81, 144
used professional lighting equipment, 169
UV filters, 125

V
variable ND filter, 132
Vectorscope, 242–243
vendors, China Ball lantern, 165
Vibrance adjustment, 71
video compression. see compression
video footage. see footage
video publishing/sharing
 backup copy, 252
 feedback and, 249–250, 251

quality checks, 250–251
 for Web viewing. see web video files
video quality vs. photo quality, 54, 130–131
video transitions, 229
video tripod heads, 43
viewfinders, 14, 87–88, 130
Vimeo, 262–265
visual interest, of sequencing, 106
Vivid option, Picture Styles, 63–64
Vivitar prime lens, 144
volume controls, 60–61

W
wall power, 36
web video files
 compression tools for, 255–257
 Facebook hosting, 265–267
 file format for, 254–255
 overview, 253
 Twitter hosting, 268–269
 Vimeo hosting, 262–265
 YouTube hosting, 259–262
weddings, lighting at, 141
weight, camera, 26
Westcott Spiderlite, 168, 169
white balance
 automatic, 55
 color temperatures for, 58, 118, 163–164
 for indoor shots, 163–164
 manually setting, 56, 58
 presets, 55–57
 reference image for, 58–59
wide shot (WS), 99
work lights, 166
workflow
 data transfer, 201–202
 footage organization, 204
 video project, 192–193

X
XLR audio connector, 182

Y
YouTube, publishing to, 259–262

Z
Zacuto Z-Finder, 85
Zoom H4n recorder, 185
zoom lenses
 features of, 40
 lens flares in, 124
 in low lighting, 142, 146
zooming in, 82, 98